SECRETS OF
AUTOMATA

INGENIOUS DESIGNS
FOR MECHANICAL
LIFE

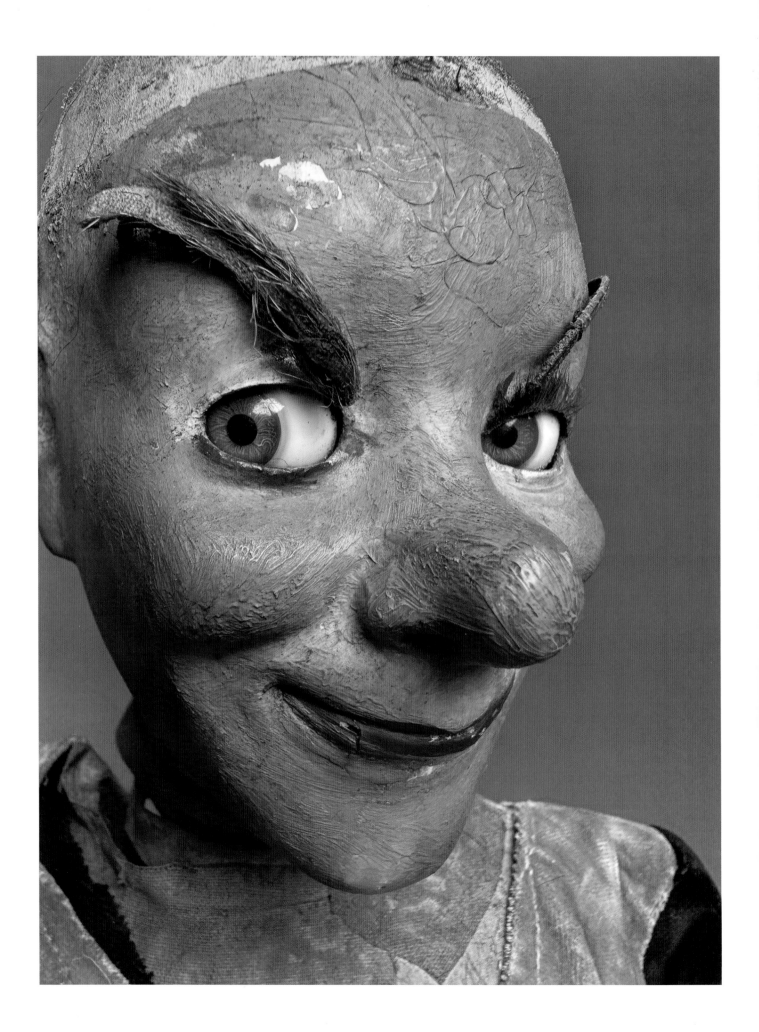

MICHAEL START

SECRETS OF
AUTOMATA

INGENIOUS DESIGNS
FOR MECHANICAL
LIFE

THE CROWOOD PRESS

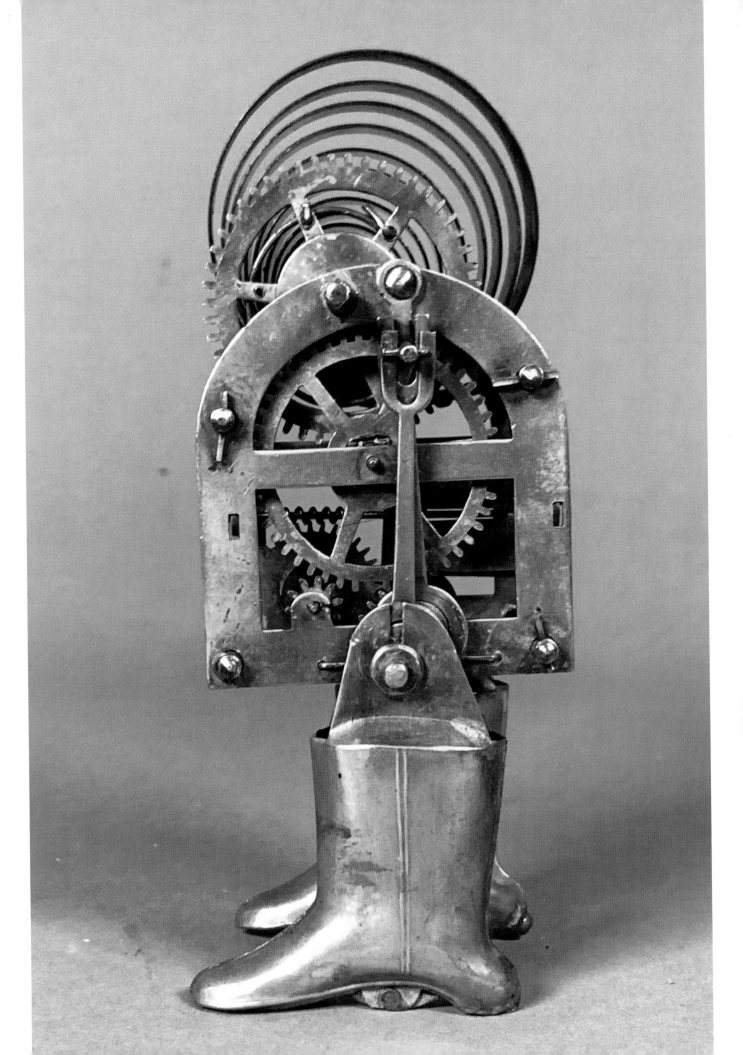

CONTENTS

INTRODUCTION

The information in this book will provide inspiration and ideas based on the secret mechanisms hidden inside amazing automata from history. Automata are mechanical models of animals, people and places, each automaton vividly portraying some aspect of life and nature in physical form. Whether it be a chess-playing Turk, a dancing doll or a waterfall under a radiating sun,

A variety of skills are needed to restore antique automata. Michael Start is a trained clockmaker, which helps, but here he channels the skills of a taxidermist in order to repair the damaged fur on this 'Leaping Tiger' automaton, worn away by 100 years of use. The team of restorers at The House of Automata includes a horologist, a sculptor and a fine artist.

the design of the mechanism is crucial to convincing you, the viewer, that you are not just looking at a machine but at a convincing interpretation of the living thing as an automaton. In this book I will reveal to you the secrets of automata mechanism which were developed over generations, by makers who closely guarded their designs in the competitive business of automata making.

As a restorer of automata with over thirty years' experience, I get to see inside hundreds of automata every year and I constantly marvel at the ingenuity of the best makers in history. I regularly reach for my pencil and notebook to document these often-unlikely arrangements of cams, levers and springs which bring the automaton to life. These mysterious mechanisms are hidden and undocumented; they often see the light of day for the first time in a century when I open up a dusty torso or prise open a sealed compartment. Inside each of them lies the secret of that automaton's life and movement and I want to share these discoveries with you.

This is not a 'how to' book. I don't attempt to provide the reader with measurements and step-by-step instructions on how to make an automaton. By using real examples I want to show the unique principle by which an action works. Once the secret is understood the principle can be transferred to any number of designs and interpretations.

Making working automata can be quite complicated and I often see modern examples where a lot of time and effort has been spent 're-inventing the wheel' to portray a particular movement, not always successfully. Nearly every possible movement of life and nature has been replicated in the past using a variety of mechanical methods; some are very successful and lifelike, the designs benefiting from generations of experience within the same company. Never before have these methods been documented in one place.

As a restorer of some of the finest rare automata, I have been privileged to enter the mechanisms and hence the minds of long-lost artisan mechanics. Every automaton reveals something about its maker: some mechanisms were economical designs, but the best makers combine technical skill with artistry, and like magicians, were devoted to keeping the secrets of mechanical life.

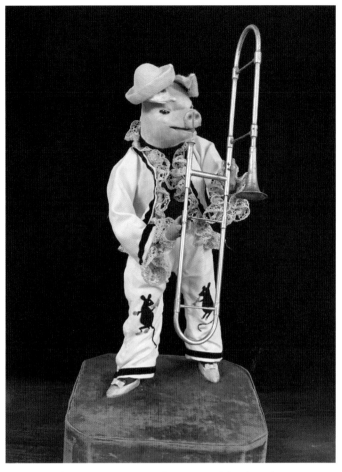

Automata offer the opportunity to take an impossible subject from a fantasy or dream and then bring it to life. This trombone-playing pig dates from c.1900 and has a human body with trotters instead of hands. What inspired this porcine musician is not known today, but the notion of an anthropomorphic pig is quite common in film and literature.

The work of today's artists and makers will hopefully be accelerated to a more satisfying conclusion by seeing the examples in this book, the 'secrets' of portraying movement as developed by the master automata makers of history.

More than 100 automata are described and pictured in this book. The many different movements illustrate a huge range of actions, from walking and drinking to birdsong and wind. I have grouped the actions across seven chapters in arbitrary categories that allow me to feature the most successful and realistic automata mechanisms (as well as my own particular favourites). The essential chapters on humans and animals are accompanied by whole chapters on entertainment and magic, which reflects the purpose of many automata created purely to entertain. Please forgive me for including whole sections on smoking or 'flitting'

(birds); these may be niche activities but sometimes they were done so well with mechanism that I simply had to include them.

Most of the automata described can also be seen working in films on the Internet. 'The House of Automata' YouTube channel features a specific playlist, 'Secrets of Automata', and guidance on search terms to find other examples is included at the end of this book.

It is rather an exciting moment for me to share the thrill of discovery in this book. In a small way every rare automaton that comes to my workbench is opened up, like the door to an Egyptian tomb, and amazing intricate mechanisms are revealed in the dust and cobwebs. I take great pleasure in sharing with you the secrets of automata mechanisms.

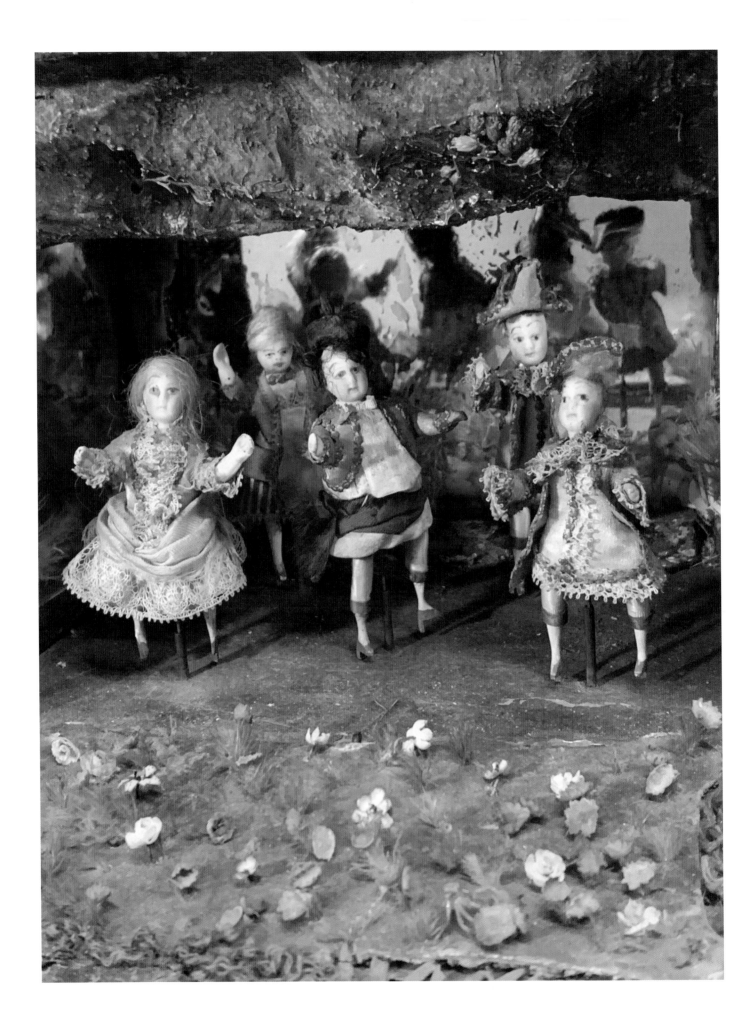

MAKERS AND MECHANISMS

The aim of this book is to reveal mechanical secrets – the special mechanisms dedicated to a particular function and hidden from sight within the automaton. Most of these are innovations that have never been explained or published. This secrecy was necessary to preserve the livelihood and commercial advantage of the makers in what was a very competitive 'high tech' market.

To understand the circumstances in which these mechanisms were invented and refined it will be useful to know a little of the history and to introduce some of the makers.

When looking back at the surprisingly long history of automata it is apparent that expertise in the subject usually resides in one country or region at a time, lasting for a century or more before fading away only to resurface again in a completely different place. This 'passing of the baton' between countries and civilisations is probably true for many subjects but is very evident over the 3,000-year history of mankind's urge to make automata.

Each of these eras could probably be claimed as a 'Golden Age' of automata for different reasons but French automata of the nineteenth century stand out in technical, artistic and commercial terms. This book focuses on them in particular. I am helped by the sheer number of French automata that still exist in museums and private collections, many in working order, which allow me close examination when they come to my workshop for repair or restoration. For me to restore well, it is essential I research the automaton and understand its history. This is a part of the restoration process I particularly enjoy. In doing this I have become fascinated by particular makers and periods, but let us start at the beginning.

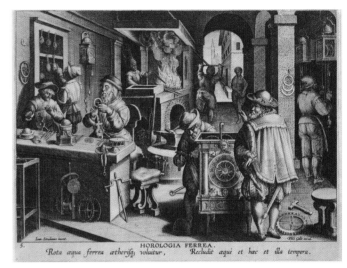

The Invention of Clockwork, c.1580, showing many of the processes and items of equipment that are needed to make geared mechanisms. The furnace that smelts the metal is shown close by, allowing recipes for brass and steel to be adjusted to suit the qualities required in the finished product in a much more direct way than is possible now.

AUTOMATA TIMELINE

This timeline shows how I see the western tradition of automata shifting over the centuries.

800BCE to 200CE	Greece and Italy
800 to 1200	Turkey and Iran
1500 to 1700	Germany
1750 to 1830	England and Switzerland
1830 to 1930	France
1950 to present	USA and Europe

Dancers in a Mirrored Grotto, Paris, c.1880. The secret of an automaton's success can be as simple as a mirrored backdrop. These tiny dancing figures are multiplied by their own reflection, spinning and swirling so fast they are difficult to count. The musical scene is slowly revealed by the front garden folding down in front of the grotto – magical.

THE MAKERS

The first automata

The first automaton is to be found whirring and clicking away in the classic texts of ancient mythology. As far back as 2,800 years ago, automatic moving machines performing human tasks are described by the Greek poet Homer. The 'maker' according to Homer was Hephaestus, son of Zeus, who served as blacksmith to the Gods. Hephaestus (or Vulcan in the Roman tradition) made various life-sized automata to labour in his workshop working the bellows and forge. For the celestial hall of the Gods he made twenty golden tripod servants that trundled about on wheels. He also created an elaborate golden throne for his estranged mother which deliberately entrapped her, presumably mechanically, the moment she sat on it.

Of the many devices that could be described as automata in mythology, most have some divine or magical aspect to their creation or operation. Magic aside, the main reasons for creating them were for utility purposes like mechanical serving machines and death-proof armour.

It is the discovery of the Antikythera mechanism, a scientific instrument dating to perhaps 200BCE, which provides us with the first example of a real mechanism to start our discovery of mechanical automata. Brought up from the seabed in 1902 as a corroded green metal blob about the size of a large cake, over time it has been 'conserved' into eighty-three separate pieces revealing several gears, the largest 5.1 inches in diameter with (perhaps) 223 teeth. It is generally thought to be a machine to predict astronomical events, a sort of analogue computer.

The first technically viable theoretical automata of which we have a more complete knowledge are the work of Heron of Alexandria. Heron was a mathematician and engineer who was active around 60CE. Heron's many designs for automated temples and figures were described and illustrated in his works *Pneumatica*, *Automata* and *Mechanica*.

For the next 1,000 years automata makers are quite sparse in the history books although the odd explorer and traveller does come across them and write about the experience. This is how we know that in 835CE the

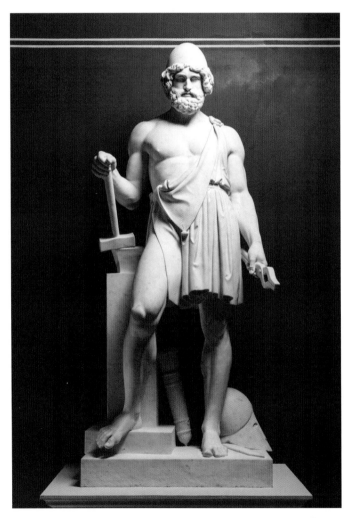

The automaton maker can look up to their own deity, the Greek God of fire and forge, Hephaestus. His ability to make mechanical automata was demonstrated in many of the myths of ancient Greece. Here he poses with his hammer and tongs, with the magical armour of Achilles at his feet. The statue is by the Danish sculptor Bertel Thorvaldsen.
(PHOTO: JAKOB FAURVIG, THORVALDSENS MUSEUM PD)

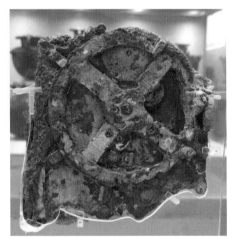

The Antikythera mechanism is the earliest known geared machine. Dating from around 200BCE, the device was found in a Roman era shipwreck near the island of Antikythera. Corroded and fragmented, it is the perfect combination of age and ambiguity. These qualities continue to excite scientists and theoreticians who work with the certainty that this mystical machine must have done something. (TILEMAHOS EFTHIMIADIS, ATHENS, CC BY 2.0)

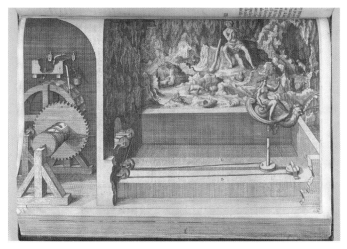

The Grotto, 1615. In the seventeenth century Heron of Alexandria's newly reissued first-century work *Pneumatica* inspired Salomon de Caus in this design for a water grotto. Galatea, a sea nymph, rides to and fro on the surface of the water, powered by a water wheel, while music plays. Water gardens with automata were popular across Europe at this time.
(PHOTO: THE METROPOLITAN MUSEUM OF ART, NEW YORK, CC0 1.0)

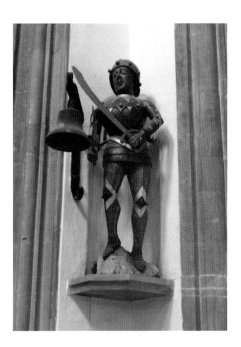

Jack the Smiter, fifteenth century, St Edmund's Church, Southwold. This Jack is (unusually) not connected to a clock but is used to announce services and weddings in this English church. For most people their only experience of automata would be in places of power like the church where clocks might feature quite complex parades of automata to announce the hours.
(PHOTO: ANDREWRABBOTT, CC BY-SA 3.0)

Byzantine Emperor Theophilos had a throne made, flanked by mechanical lions which roared and were shaded by a golden tree filled with mechanical singing birds. He was probably competing with the Caliph Abd-Allah-Al-Mamun in Baghdad, whose mechanical birds sang beautifully on a silver tree, reported in 827CE.

The next big moment for automata comes from Mesopotamia in 1206 when Ismail al-Jazari compiled his *Book of Knowledge of Ingenious Mechanical Devices*. Known as the al-Jazari manuscripts, these collate existing knowledge and add new designs for automaton water clocks, fountains and devotional machines. All these inventions pre-date the advent of true clockwork whose birth is about to take place in the steeples, spires and homes of the rich across fourteenth-century Europe. This early clockwork often incorporated the ringing of bells as most people could not tell the time from a dial. What better way of ringing a bell can there be, than by having a mechanical man hit it with a hammer?

Augsburg

The gold and silversmiths of Augsburg (Germany) in the sixteenth and seventeenth centuries were making beautiful mechanical automata for export around the world. The automata were extravagant table ornaments in the form of animals, mythological figures and silver model ships called Nefs. Some Nefs were animated to 'sail' down the banquet table on eccentric wheels while a small band paraded on deck playing music. The ship would then stop and fire its cannons.

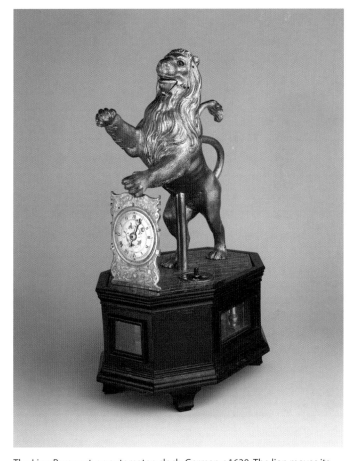

The Lion Rampant, an automaton clock, German c.1630. The lion moves its eyes continuously and opens and closes its mouth at each strike of the hour bell. A large number of animal automata clocks were made in Augsburg in the seventeenth century; subjects read like a Disney parade of bears, camels, dogs, monkeys and elephants, full of exaggerated character.
(PHOTO: THE METROPOLITAN MUSEUM OF ART, NEW YORK, CC0 1.0)

The clockwork automata made in Augsburg are rare treasures and most of the remaining examples are to be found in museums today. Almost totally handmade, these refined and complex mechanisms were not at all crude, despite the early date for spring-powered clockwork. They are high value masterpieces created to affirm their global dominance in the making of fine mechanism at this time.

London

From 1750 to 1850 the centres of mechanical automata production had shifted to London and Geneva. During this period in Switzerland the father and son makers Pierre and Henri Jaquet-Droz were producing incredibly complex animated figure automata. The most famous of these are the three 'androids' – the Writer, the Draughtsman, and the Musician – all made around 1770. These three automata are nearly life size and are on display today

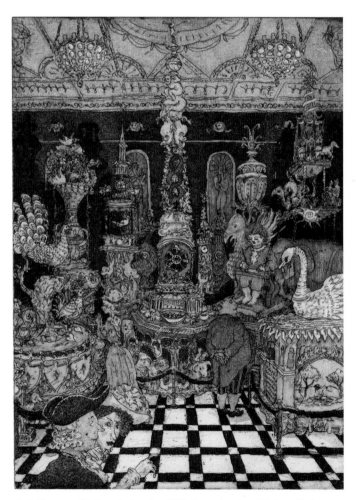

Cox's Museum of Automata, London 1772. A spectacular gilded confection of bejewelled automata and mechanical singing birds. Descriptions of the museum abound but not a single drawing exists. This engraving, commissioned from Robert Powell, captures the intensity of the exhibition where the Chronoscope, Peacock Clock, Silver Swan and The Writer all jostle together amongst the velvet curtains and lustrous chandeliers.

in the Museum of Art and History in Neuchâtel. The Jaquet-Droz opened a branch in London in 1783 managed by another great maker, Henri Maillardet, who is known for his bejewelled spider and an enamelled gold crawling caterpillar as well as the Writer automaton that inspired the automaton in the film 'Hugo'. It is through this London branch that the Jaquet-Droz supplied automata, watches and clocks to James Cox for sale onward to the important Far Eastern markets. Cox had access to the Chinese market through his own branch office in Canton. Although many automata and clocks are signed by Cox it is doubtful that James Cox actually made them himself. It seems more likely he commissioned them from talented craftsmen who designed and made them for his workshop. He was certainly an entrepreneur and with the rapidly expanding British Empire new trade routes opened and 'jewellers and clockmakers' like James Cox found ready markets for extravagant and expensive diplomatic gifts. So Cox's workshop produced spectacular gilded automata encrusted with jewels and destined for export around the world. Cox 'made' the fabulous Peacock Clock now in Russia but his biggest market was China where his expensive automata were known as 'sing songs'. As well as mechanical singing birds, Cox produced complex astronomical clocks as gifts for the Emperor, one with an automated telescopic pagoda set in a fantasy-filled garden diorama. Cox's workshop also made the life-sized Silver Swan that swam in a lake of glass from which it plucked and ate little silver fish; this is still on display at the Bowes Museum in the UK.

By 1772 the international trade had waned, resulting in growing debt and surplus stock. Cox's solution was to open a spectacular exhibition of automata in Spring Gardens, London, the huge entry fee being equivalent to a week's wages. Visited by the social elite and the great writers of the day, James Boswell and Dr Johnson, the exhibition was the talk of London for three years. Financial problems beset Cox and the museum from the start and although there were several attempts to raise money by raffling off the exhibits by lottery, the museum finally closed around 1777.

The automata and clocks may have appeared all frippery and show, supported by a gilded menagerie of exotic creatures, but behind the actual movements was a high level of technical innovation. Cox's workforce included some brilliant minds: his 'chief mechanik' was John Joseph Merlin, inventor of roller skates and a perpetual clock that never needs winding. The clock still exists in London's Science Museum and is actually powered by the natural changes of air pressure.

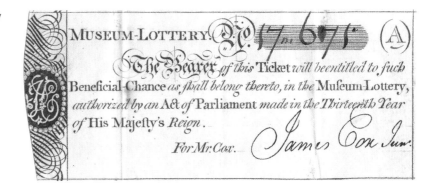

A ticket from Cox's Museum Lottery issued in 1773. The ticket originally cost one guinea. The prizes were the precious objects and automata in the museum up to the value of £5,000. I don't know if this is a winning ticket or not, but I would like to think it might represent an entitlement to one of his fantastic automata.

There are only a few remaining automata from the Cox workshop today, but we do have descriptions from an auction catalogue of 1772 describing twenty-three of the larger automata being offered for sale. This is one of the more brief and restrained entries in the catalogue describing 'Lot 4':

A richly caparisoned Elephant, on a magnificent Pedestal, which supports two beautiful Galleries. On the first is a sumptuous Chariot of gold covered with flowers, fruit, leaves, and ornaments of jewellery, upon which are two Figures of gold: it is drawn by a Dragon. On the upper Gallery another Chariot drawn by Horses round a rock, upon which is raised a Gothick Temple of agate, ornamented with jewellery, on the summit of which is placed an irradiating Star. This piece is twelve feet in height, and displays (besides the progress of the chariot) the fall of Cascades round and within the recesses of the Temple, and terminates with a spiral ornament.

By the 1820s automata were capturing imaginations across Europe, in exhibitions, on stage and in popular culture. The publication of Shelley's *Frankenstein* and E.T.A. Hoffman's *The Sandman* (later the ballet *Coppélia*) fuelled the fascination with artificial life both physical and mechanical; a passion for automata was spreading. Baron von Kempelen's famous chess-playing automaton was a good example of the wide appeal of the subject. It toured many countries until finally it was revealed as a fake automaton.

Complex automata – both real and 'fake' – still drew the crowds and inspired the media of the day, such as the enigmatic Psycho (1875), a life-sized turbaned figure sitting cross legged on top of a transparent glass pillar, who could apparently read a person's mind and perform magic. The mechanism inside the figure was controlled remotely by pulses of compressed air, invisible within the glass pillar.

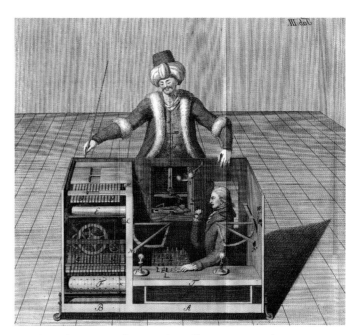

The Chess Player was made in 1772 by Wolfgang von Kempelen. It is an automaton chess opponent which played against Napoleon and Benjamin Franklin in a long career that saw it perform around the world until destroyed by fire in 1854. Known as a 'false automaton', the base was full of mechanism but a person was concealed inside, resulting in years of conjecture as to how it worked. (PICTURE: JOSEPH RACKNITZ)

This was an exciting time for automata, but Britain's turn as the centre of automaton production had passed. The Industrial Revolution had changed the customer base and by 1850 the clock industry in England had run into trouble. It had become uneconomic due to an addiction to high quality and over-engineering in the face of cheaper French and American imports. The French clock was also a high quality but a relatively cheap product due to the use of specialist division of labour within the environs of Paris. The American clock was even cheaper. By 1870 the French were able to combine their manufacturing expertise with the 'plastic' arts of sculpture and a natural flair for entertainment, to cater for a growing interest in clockwork automata.

Paris

The craftsmen of the Marais district of Paris rose to the task and realised that automata had a universal appeal, but most people could not afford them. Small companies formed, such as Roullet & Decamps, Vichy, Lambert, Phalibois, Renou and the singing bird specialist Bontems, each specialising in satisfying these new markets and competing for the biggest market share. Their subjects were street entertainers, animals, dancers, fantasy scenes of little people or celebrities from the music hall and circus, with the best acts in the world often performing within a few hundred metres of their workshops.

There were five World Trade Fairs held in Paris between 1855 and 1900. The last fair in 1900 attracted 50 million international visitors and 83,000 exhibitors. Many of the automata makers exhibited and orders came in from across the world. The race was on to impress the public with ranges of new and exciting automata.

This growth spawned rapid technological development of the mechanisms, and innovative new movements were designed, aimed at making the automaton more lifelike, impressive and entertaining. The automata makers included the funny quirks, winks and gestures, the accidents of life, into the actions of their machines. Their subjects were often distorted from reality into the surreal, with oversized heads or with the moon inset in a tree trunk; after all, this was the time and place for the birth of surrealism.

Parisian automata were made in much greater numbers than before, using batch production and division of labour to produce the quantity needed to meet demand. Although aimed at a large market they were still expensive machines – not toys, but high technology, like computers today. They often included automatic music boxes in an age that pre-dates recorded music of any other type. For a lot of owners they also hinted that the sublime mystery of life itself could be solved by the hand of man in the form of a marvellous machine, just about affordable, to take home.

The Far East

There is an almost parallel history of automata in the Far East, which I am not best placed to describe. But there are two automata I have restored that indicate the age and depth of the tradition in China and Japan.

The first is a small model of an ancient South-Pointing Chariot: this was a two-wheeled chariot upon which a life-sized statue of the Emperor stood with outstretched arm. The Emperor would always point south, no matter what twists and turns the chariot below him took. Chinese texts refer to these existing as long as 3,000 years ago and they apparently remained in use as a sort of mechanical compass until 1300. This model is a gilded brass miniature of the original and the gearing works very well to keep the Emperor pointing in the same direction that he started in. Even this small model is very enigmatic to see

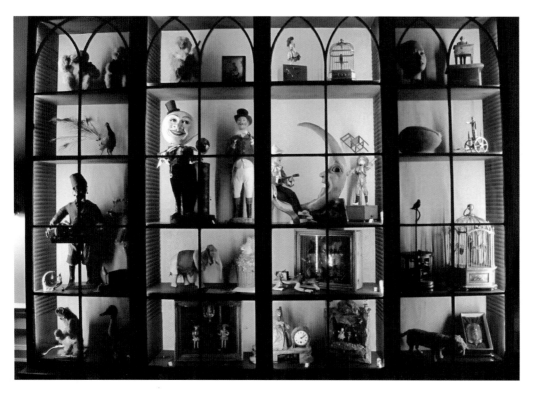

A cabinet of automata, containing mostly French automata featured in this book. The variety of subjects portrayed was as diverse as it is possible to imagine. Particularly popular were dioramas in box frames or shadow boxes animated with music. The mechanical singing bird was popular for its flowery decorative appeal, as even the most staid household considered them 'not creepy'.

demonstrated as it is pulled around a tabletop. A surprising amount of information on the South-Pointing Chariot is available online.

A rare appearance in the workshop recently was a 150-year-old Tea Serving Doll from the Japanese Karakuri tradition. It was clockwork and similar in design and materials to a modern craft automaton but lighter, extremely confidently made and remarkably did not use any metal parts: even the clockwork mainspring was made from a coil of thin whalebone. China and Japan have their own long and continuous tradition of automata, used primarily in theatre and ritual to the present day. I make only passing reference to them in this book as I have limited experience of them in the UK, but there is some excellent further reading suggested at the back of this book.

Wherever and whenever automata have been made the mechanisms are usually a mystifying secret. Whether incomprehensibly complex or deliberately hidden from sight, the illusion of life is key to inducing wonder and awe in the audience. This has been true until the last two decades, when exposed and beautifully made mechanisms have often been deliberately constructed to be on show. The cogs and levers now dance visibly, to animate the automaton. It seems that the ability to understand the vocabulary of pure mechanism is now a pleasure in itself. With this joy in mind, the following chapters will expose the mechanisms of past makers, explain how they work, and make it easier to develop and progress mechanical life, starting from the place the masters of automata left off.

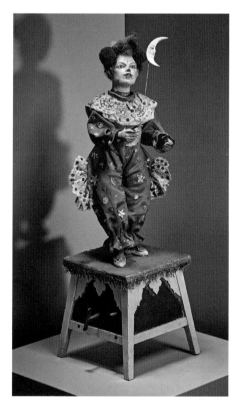

Clown Balancing the Moon on a Stick, Vichy, Paris, c.1880. Almost certainly a sculptural portrait of a circus performer attempting to throw the moon back up into the sky. Popular culture in Paris at this time was full of surreal imagery and a fascination with the moon. Automata subjects mirrored this fascination and the moon features in many automata.

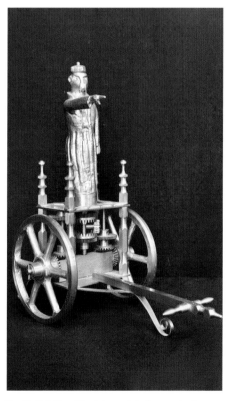

South-Pointing Chariot, model of an ancient design, China. Originally made life-sized, the emperor always points south as the chariot moves. This is achieved mechanically: the wheels are linked together using a form of differential gearing connecting the wheels to the emperor. His outstretched arm will stay pointing in whatever the direction set when the chariot starts moving.

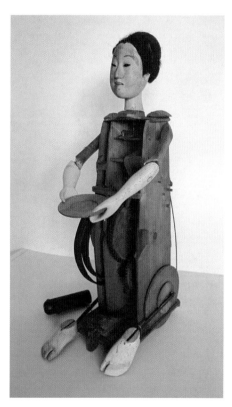

Chahakobi Ningyo (Tea-serving Doll), 1868–1911. Wood, papier-mâché, bone, gesso, ink, 19 inches tall. The doll is used to offer a cup of tea in a ritual tea ceremony. It walks to the guest, stops to allow the tea to be drunk, then turns and walks back when the teacup is replaced. (COURTESY OF THE KAMM COLLECTION 2016.143)

MECHANISMS

I hope this book will provide inspiration for the designer and maker of automata. To prevent repetition, each chapter restricts itself to explaining the mechanical principles of the particular motion of life and nature featured. Invariably automata share common mechanical methods for powering the automaton and storing information. This short section gives an overview of these common attributes as used in most of the automata featured in the forthcoming chapters.

If you are new to the subject or just fascinated by small mechanisms of the nineteenth century, then here we go.

Most automata mechanisms are comprised of three different sections each with a distinct purpose:

1. Drive unit
2. Cams and levers
3. Body mechanism

Some automata have these three separate units amalgamated in one complex mechanism, usually to fit inside the restricted space of the automaton's body. For most automata the drive unit and cams are housed in a spacious box base. The base mechanism transmits motion up into the automaton figure above by moving rods hidden in the legs.

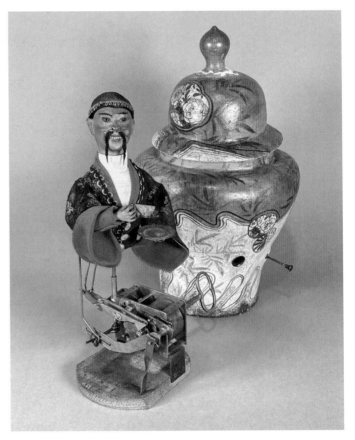

The Tea Drinker automaton, Vichy, Paris, *c*.1870. The lid of the vase opens slowly and the tea drinker rises up, turns and drinks tea before returning into the vase. The mechanism is constrained in layout by the small space inside the vase. The cams and levers are on the side of the mechanism. The outer lever opens the lid.

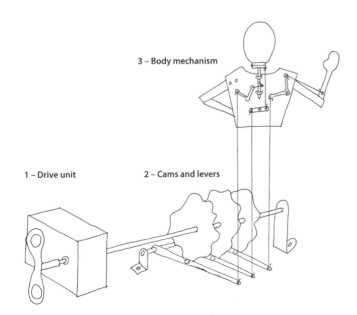

3 – Body mechanism

1 – Drive unit 2 – Cams and levers

A simple diagram of a clockwork automaton with three cams. The levers conduct movement up to the body plate. The figure has a head turn and nod with a waving arm. The drive unit and cams are usually enclosed within a base, the figure performing on the top. This is a common layout for many nineteenth-century automata.

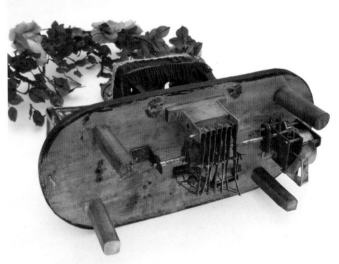

Monkey Magician, Phalibois, *c*.1890, viewed from underneath the base. The clockwork motor drives a steel shaft on which a wooden cam stack revolves. Half-way along each lever, the cam followers trace the undulating edge of their cams. The wire rods at the end of each lever rise up through a hole in the base to animate the figure above. (PRIVATE COLLECTION)

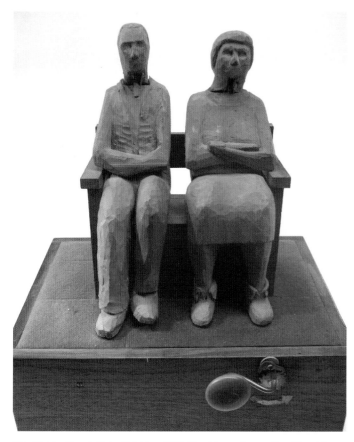

Couple on a Bench, Peter Robbins, 1987. Hand-turned operation. The old couple fall asleep, then the man wakes, sees something and kicks the woman twice to wake her, causing her to sit up. This narrative performance is achieved with a worm drive on the handle shaft which turns the camshaft by one revolution for thirty turns of the handle.

person turning the handle sees and feels what is required as they turn the handle and observe the result.

In its simplest form the handle may be a wooden dowel pressed into a short crank to be turned by the finger and thumb. Alternatively it could be a large, heavy wheel designed to impart speed and momentum to the automaton. Without the need for a train of gears or springs, the maker can devote more time and attention to complexity or artistry without issues of a lack of power or speed.

The advantages can bring their own problems, however: the automaton may need safety devices to prevent the human from exerting too much power or speed and damaging the automaton. A simple ratchet and click to prevent reverse turning works well. Power can be limited by shortening the turn handle. Further control can be designed in by limiting access to the lever with a shroud or recessing it. My experience of exhibiting automata tells me that an automaton placed in a dark corner without supervision will be subject to much bigger forces than one placed in a well-lit place with many people around.

Some of the earliest automata from the ancient world just used levers pressed down by hand. A row of levers protruding from the base of an automaton enables the person operating to co-ordinate and compound the movements. Using two fingers it is strangely satisfying to discover that turning a head and nodding it at the same time produces an uncannily lifelike motion.

There are many variations to the general schema of an automaton's mechanism, but the basic elements described below are common in automata throughout this book. Understanding them will provide a firm basis to understanding the 'secrets of automata' and the marvellous movements that result.

Drive units

The four popular ways to drive or power an automaton are:

1. Hand
2. Clockwork
3. Falling weight
4. Electric motor

Handles and levers

The simplest of these options is to use human power: a cranked handle or levers and buttons pushed or pulled. The advantages for a maker are huge: hand-powered automata do not need speed or power regulation as the

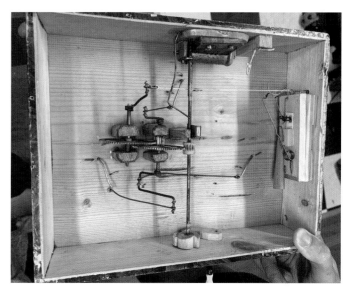

Cats' Tea Party, hand-turned mechanism, German, c.1890. Three cats are seated at a table, they turn to and fro making regular 'miaows' to each other as music plays. The central shaft is turned by the white porcelain handle just visible at the bottom. The crude wooden ratchet wheel is to prevent reverse winding. The paper bellows produce realistic miaows.

Clockwork drive

This is the most common method of powering the automata described in this book. Different parts of the clockwork motor revolve, rattle and whirr in ways that the automaton exploits to good effect. To describe this I have used terminology that is standard for clockwork mechanism and derived from horology. Therefore the term 'axle' in mechanics is in this book called an 'arbor'; a 'pinion' is a small solid cog; and a set of gear wheels is referred to as a 'train' of wheels. Described here are the basic parts and working method of a small standard automaton drive motor as used in nineteenth-century automata.

A clockwork drive motor uses the power in a coiled steel spring to turn a train of three wheels and pinions. You store power into the motor by winding it up until the spring is tightly coiled. The coiled spring uses a one-way ratchet and click system to hold back the considerable force involved. Once stored in the spring the power can only be released through the gear train. The power release is very measured and controlled, typically taking several minutes to exhaust itself.

The wheels and pinions of the gear train reduce in size successively to increase the speed and reduce the power. The final wheel turns a steel spiral called the 'worm' which is fitted with an air brake, in the form of a thin brass plate called the 'fly'. The fly spins so fast it is visible as a blur and due to its low power can be safely stopped with a fingertip or the point of a stop-start lever. This exchange of power for speed and vice versa is the principle behind all gear boxes and is very useful in a clockwork automaton drive motor as it offers opportunities to take drive off the motor at different rpm (revolutions per minute) along the train of wheels.

In practice, automaton drive motors usually have three possible locations where the power is taken from for driving different parts of an automaton:

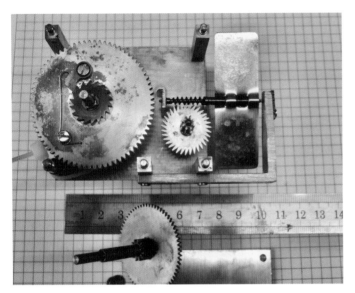

Clockwork drive motor. Front plate removed to show this high-quality (but quite grubby) three-gear mechanism. The powerful coiled spring is hidden behind the great wheel; the intermediate wheel has been removed to show the worm wheel engaging with the spiral worm. The fly spins silently in operation and is ideal for controlling the power of a clockwork mechanism.

1. Great wheel: used for slow walking actions and driving the music. The most power is available at this gear.
2. Intermediate wheel: this is the most commonly used working output for the automaton. It is used for arm lift, head turn and powering the bellows. The cams are most often mounted here.
3. Third wheel: peripheral features are driven from this fast-turning, low-powered wheel, such as eyelids fluttering and mouth chattering movements.
4. The worm wheel and fly: these are so fast and weak that they cannot usually drive parts of the automaton, but they are used for stopping and starting the mechanism and to produce whirring/purring sounds.

Weight drive

A weight-driven mechanism is inherently simple and easy to make. It is also one of the oldest methods of powering automata and has been in use since antiquity. A long cord is secured to a drum or cylinder, usually made of wood. The cord is wound around the drum and to the end is attached a weight of lead or stone. The weight hangs down,

Cams fitted to the drive motor of the Girl Holding a Marionette: a similar design to the mechanism shown earlier, viewed from the outside to show two cams. One is mounted on the great wheel, the other on the intermediate wheel which turns eight times faster. The girl nods her head and jerks the marionette up and down.

pulling the cord and causing the drum to turn until the cord is unwound. At one end of this drum is the 'great wheel' gear of the mechanism which can then power the intermediate gear in turn. The gear train is essentially the same as described for spring-driven clockwork but with weight drive there is no need to make a tempered steel spring, coil and restrain it.

The advantages are the simplicity of construction, the fact that the power delivery does not vary as the weight descends, and it is very easy to increase the power by adding to the weight. A disadvantage is the large space required for the fall of the weight and its lack of portability.

Electric motor

Clockwork was the dominant technology for automata during the nineteenth century but by the early twentieth century the advantages of the electric motor became impossible to ignore. An electric motor can run continuously and start and stop at the flick of a switch. These were ideal qualities for advertising and coin-operated automata in particular. Electric motors in automata usually need a gear box to reduce the high speed of the pulley down to suit the speed required for the cams.

In favour of clockwork, it must be said that the constant power and consistent speed of electric motors can dilute the character of an automaton's performance and the noise can also be intrusive. A little of the mystique is also lost by plugging in something to the wall that pretends to be self-contained.

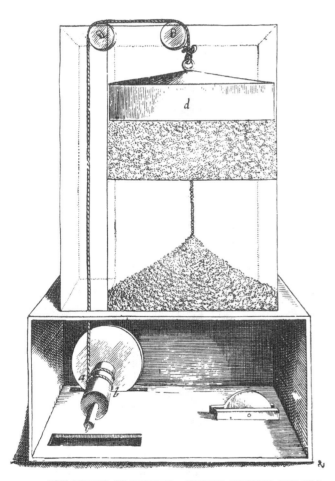

THE SHRINE OF BACCHUS. SECTION SHOWING THE PRO-PELLING MECHANISM.

Heron's Shrine of Bacchus was probably 3 metres tall and included many automated features. The main drive shown here is extraordinary in that the stone weight (d) sits on a bed of sand which gradually trickles away to lower the weight slowly under control. This propels the temple forward, presumably at a pace to suit the duration of a ceremony. (HOPKINS, A. MAGIC, STAGE ILLUSIONS AND SCIENTIFIC DIVERSIONS, 1897)

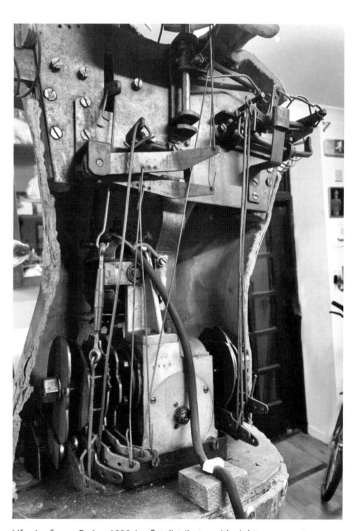

Life-size figure, Paris, c.1920. Leaflet distributor with eight movements powered by a small electric motor just visible by the green wire. The motor drives a large gear box with the cams mounted on output shafts either side. The figure uses a piston suction pump to lift leaflets off a stack via a sucker in the palm of his hand.

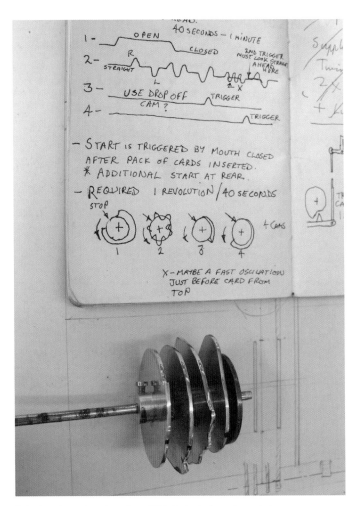

Cams and levers

Cams are specially shaped discs made of brass or wood, with edges profiled to specify an action or movement. The cam defines the size of the movement and the timing of it. A cam can be programmed with all the notes of a bird's song, dance moves or a magic trick. A good analogy is with a computer hard disk. In order to 'read' the information contained in the profiled contours of a cam, a 'cam follower' is used. The follower is mounted halfway along a lever and rides along the edge of the cam, moving the end of the lever up and down. The lever is pivoted at one end and because of its length it can magnify the movement traced by the cam follower. The mechanism is mounted so the ends of the levers are just below the hollow legs of the figure. The rise and fall movements of the levers are then easily transmitted by a stiff wire rod, up into the automaton figure via holes in the underside of the feet.

The cams must be locked together to turn as a group to make sure individual movements are coordinated; if not, you might get the teacup raised to the ear instead of the mouth. As the cam stack must turn as a complete unit, this has made possible some interesting variations in construction. There are economically made and reliable examples of complete stacks using wooden cylinders grooved for staples or carved with tracks of lobes in place of the individual cams.

Satyr head, magic automaton, 2009. A stack of newly made brass cams I made to be fitted in a life-sized satyr head that sleeps, wakes and spits playing cards out of the mouth. The notebook shows some of the cam profile development process which was first worked out linearly. The edges of the cams are burnished to reduce friction.

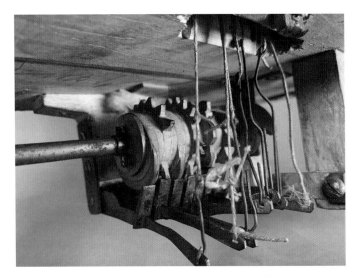

Monkey Dice Thrower, Phalibois, c.1875 with wooden cams. The seven cams are turned from a single cylinder of boxwood and then carefully carved with their lobes and undulations. The levers have wide followers soldered in position. The various breakages and bends in the control cords and wires are an indication that the automaton above is in original unopened condition.

Tightrope Dancers in a Tree, Paris, c.1880. The cams are formed from a grooved cylinder of wood fitted with wire loops and staples. You can see groups of three and four little kicks of the dancers' feet. A fourth 'cam' is formed by nails spaced around the end of the cylinder nearest to us. Note the lever return springs.

The body mechanism

The automaton figure is fitted with a body plate made of wood or metal in the shape of the torso. This plate is firmly fixed by wires or screws between the papier-mâché shells that form the back and the chest of the automaton. The body plate provides a mounting for the levers, cranks and brackets necessary to disperse and refine the movements of the rising and falling rods that come up from the base. The head and neck of the automaton are also mounted onto the body plate, the neck rod sliding into various brackets and hinged at the top to nod, while below a short lever extends from the rod and is pulled to turn the head. Small L-shaped cranks are positioned on the body plate with short linkages to change the ascending rods' direction of movement from vertical to horizontal. Both sides of the body plate are often used for mounting the sub-assemblies of cranks, return springs, and so on. The natural position for the breathing and head nod is at the front, and the arm and head turn mechanism at the back.

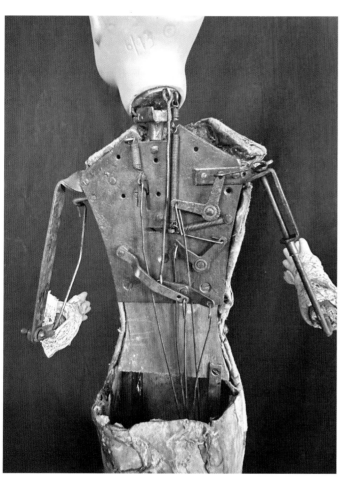

Figure with moving arms and head, France, *c.*1875, with movements of the head, turn, nod, both arms and eyes. The metal body plate is fixed to a wooden plate to make the body rigid. Five control rods come up from the mechanism via the hollow right leg. The movements are distributed by cranks and levers pulling against return springs.

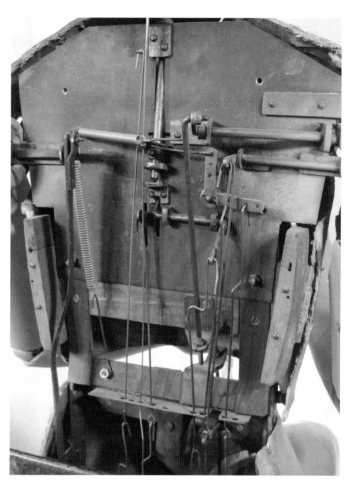

Life-sized automaton lady, Roullet & Decamps, *c.*1920. This automaton is robustly engineered for continuous operation by an electric motor positioned under her chair. The use of a holed spacer plate for the control rods prevents tangling. Despite the large size of the automaton, the papier-mâché and body plate design and materials used are exactly the same as those used in smaller automata.

Music

Sound has always been an important part of an automaton's performance. The chirping of birds, the melody of a pipe organ and the ringing of bells are some of the sounds that would accompany the movements of automata throughout history. The music is usually powered by the automaton drive motor via an additional gear wheel. In French nineteenth-century automata, music is produced by the pinned cylinder and steel comb of a small music box mechanism driven off the first or 'great wheel' of the clockwork motor. The musical mechanisms were always high quality and imported from nearby Switzerland. For reasons of space and layout the thin drive gears of the musical movements were often meshed at odd angles (up to 90°) with the drive gear of the clockwork motor. The meshing of the gears at an angle looks terribly inefficient from an engineering point of view, but due to the light loading, actually works very well in practice.

The volume of the music is affected by the size and resonance of the board on which it is mounted. So a musical movement fixed to the wooden base of an automaton can sound loud whereas a musical movement fixed to a small wooden body plate and covered in papier-mâché and layers of clothing can be barely audible.

The use of simpler noise-making devices, such as bellows (as in a cuckoo clock), or spring ratchets for a rasping noise is also common and is covered in the section on Sound in Chapter 4.

The many and various ingenious ways that movement is portrayed in this book are all powered by drives, cams, levers, rods and strings that share common features from one automaton to another. This section has explained the basics of these shared characteristics and has illustrated the mechanical foundations that power the various 'secrets of automata' that follow.

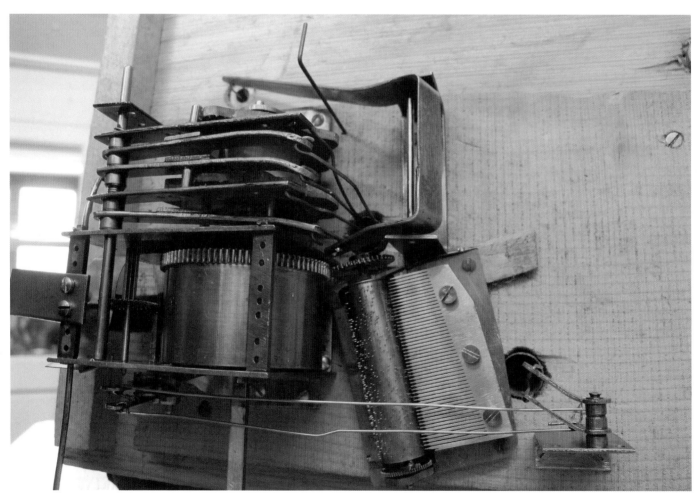

Cups and Balls Magician, c.1890, Paris. The mechanism powers seven cams and has a high-quality musical movement. The music is powered by a gear meshing at an angle with the great wheel of the drive motor. The space for the music is very limited, squeezed between the holes that mark the position of the feet of the magician.

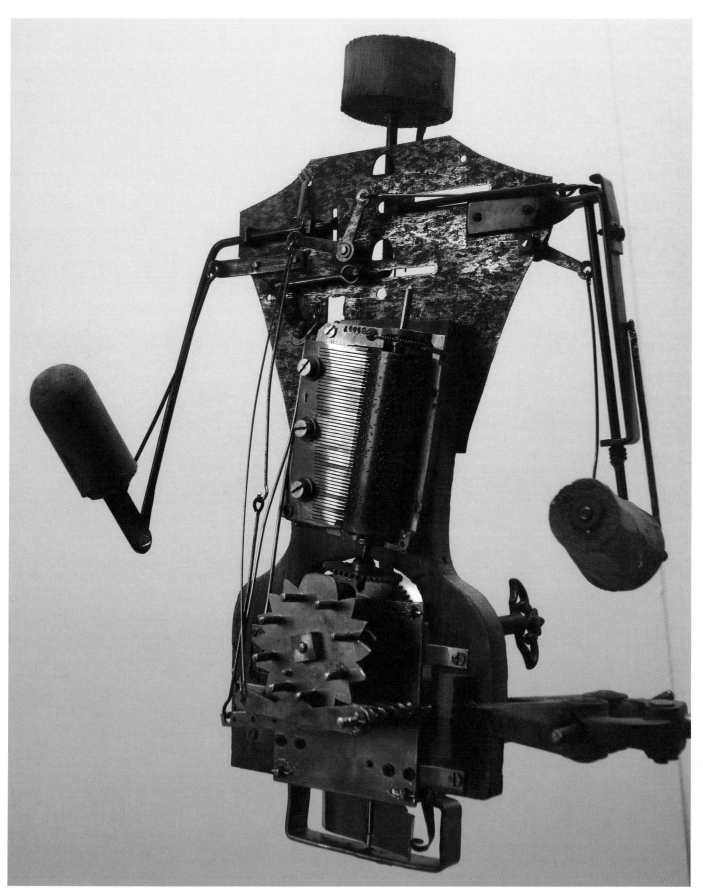

Banjo-Playing Minstrel, Vichy, Paris, c.1880. The mechanism is contained within the figure's body. Filling all the available space, the components are mounted on a wooden and steel body plate. The Swiss musical movement is powered by a gear meshing at 90° to the drive motor's great wheel. The photograph shows that the automaton has elbow and shoulder movements.

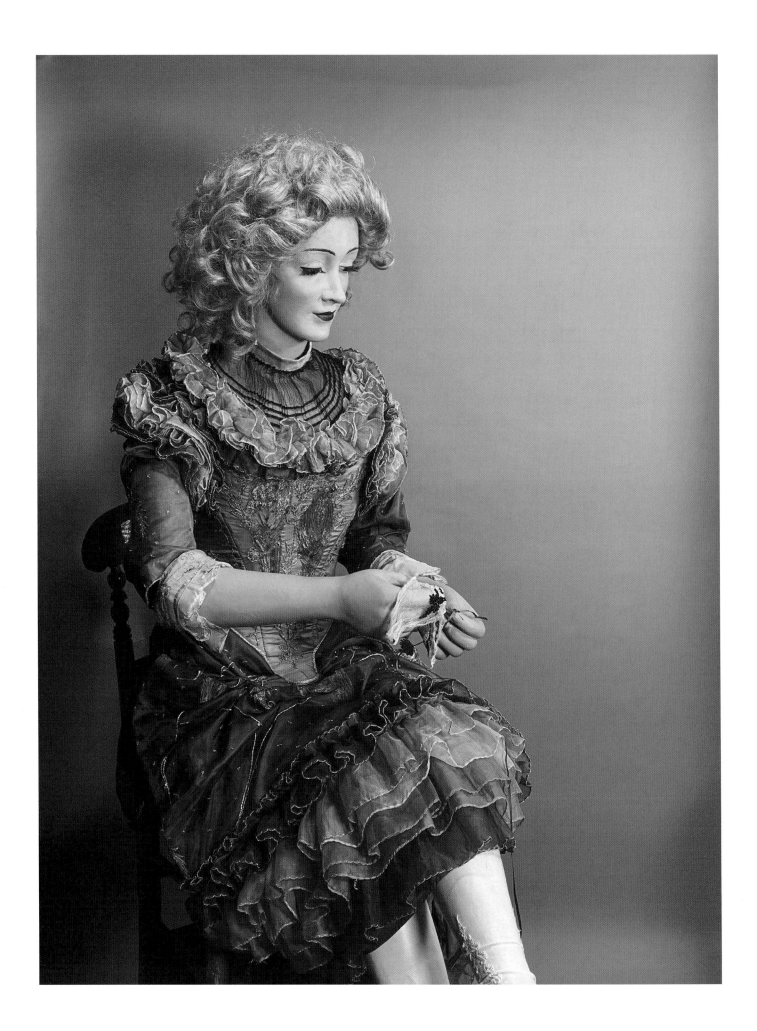

THE HUMAN BODY

The human body is the most popular subject for an automaton, ever, ranging from the plastic ballerina who spins away in a jewellery box to the Swiss androids who draw, write poetry or play music. The movements of the body are also some of the most complex to replicate with mechanism, walking being amongst the most challenging. Such is the fantastical nature of automata that two examples of human activity, smoking and drinking, are best demonstrated here by an anthropomorphic monkey and a bear, showing the inevitable crossover between chapters.

This chapter is not exhaustive but looks at seven different human actions, with a more comprehensive look at the multiple movements of a human face.

BREATHING

NANCY, A LIFE-SIZED LADY, PARIS, c.1910

Respiration is obviously unnecessary in a machine, but the presence of a rising and falling chest, a subtle movement, perceived by the viewer perhaps only subconsciously can make for an uncomfortable and desirable dissonance, because if the automaton breathes, is it alive? I once demonstrated the life-sized automaton Nancy to a visiting group of school children. The class stood in front of the inanimate seated figure and were

A mechanism for breathing, indicated by the rise and fall movement of the chest.

- Rising and falling chest
- Blowing out a candle

told she was listening out for the words 'a stitch in time saves nine' to be said in a London accent. The whole class repeated the magic phrase and Nancy came to life (her motor was on a remote control). Creaking and jerking she began looking right and left with her blue glass eyes, before crossing her legs, leaning forward and beginning to sew. A teacher at the back of the class stared at Nancy with wide eyes, turned pale and fled the room. Apparently it was the breathing action that had spooked the teacher. The children were amazed but unperturbed by Nancy's lifelike qualities.

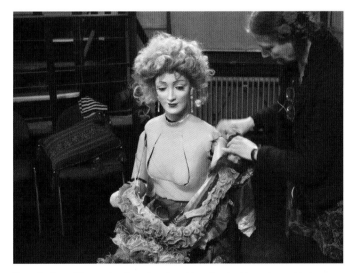

How the breathing action functions is evident by the hinged panel in her chest. It is spring-loaded to be in the raised position and pulled closed by a control rod. In this photo Nancy is preparing for a life modelling class in Edinburgh. Despite being a moving figure, she is also very good at staying still for long periods.

THE SECRET

The chest of the automaton rises and falls to simulate breathing. This is achieved by a movable cut-out panel hinged at the neck of the figure and extending over the breast. The panel is hidden by the clothes.

Nancy's life-sized body is made from very thick papier-mâché, a light, strong and easy to repair material. She has an unusual thigh joint that enables crossing of the legs and in operation is combined with a lean forward at the waist. The right forearm has linkages enabling a rolling up and down motion of the hand, for sewing.

The rising and falling chest

The movable chest panel radiates across the chest from the front of the neck, widening below the breasts. Nancy's body is made of thick cartonnage, a heavy-duty form of papier-mâché. The panel is hinged with pins into wire loops just below the neck. On the underside of the panel at the lower edge a pivoted bracket is attached. To this bracket is attached the rising and falling lever which is pushed and pulled by the mechanism. The raising of the panel's lower edge is approximately 5cm only, to make sure the action is appropriately subtle. The breathing rate and amount of lift should not be exaggerated to ensure it is as lifelike as possible.

Clothing

Nancy wears a dress with a low-cut décolletage (bare upper chest) with a ruched lace covering. The purpose of the black lace mesh panel is to catch the eye and empha-sise the rise and fall movement of the chest. The lace looks as if it is transparent but is opaque enough to hide the edges of the rising panel, making it difficult to see the joins. The fine mesh lace covering is only necessary with a low-cut dress, but is exactly what a real woman might have worn for modesty in the nineteenth century.

A smaller breathing automaton in our collection uses a white silk panel with a large pearl in a pendant necklace that sits in the cleavage. The pearl helps draw attention to the breathing action.

The mechanism

Nancy has six cams and levers for her movements; when these are combined, she can be very lifelike. Her individual movements are: leaning forward at the waist; crossing her legs; breathing; wrist for sewing; eyes left and right; head turn and head nod. She is electrically powered, which means she can be operated by a hidden remote control. The mechanics are of a robust construction, using mainly steel parts, intended for continuous performance in shop windows or over long periods.

The main driving pulley, stack of cams and levers are located upside down and underneath the seat of her chair, hidden by the folds of her dress. These can be driven by a belt from a motor positioned under the chair or even under the floor. The main wooden pulley drives a worm gear to reduce the speed and increase the power. It turns the stack of cams at a speed of about 1rpm. The six iron levers ride on these contoured cams and transmit movement via the connecting rods up into the body of the automaton. The rods in turn connect to various cranks and levers on an iron body plate in the chest and head to enable Nancy to perform her six movements in a rigidly choreographed routine.

Lady with a Fan, Phalibois, Paris, c.1890, 60cm high. This reclining lady lifts her veil and fans herself. She wears a dress designed to emphasise her continuously heaving chest. The chest has a large pearl sitting in the middle of it to draw attention. The breathing function is fairly subtle and in a smaller automaton benefits from something extra.

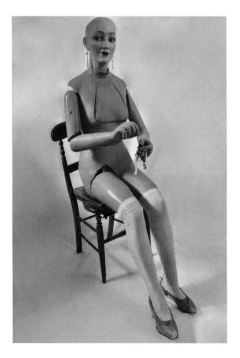

Nancy is definitely Parisian, c.1910. She came to us in 1998 from a lion tamer who worked in a private zoo supplying trained animals for films. It was in a barn at this zoo that Nancy had languished for many years with a broken ankle and damaged body, clad only in her silk stockings and original pink leather shoes.

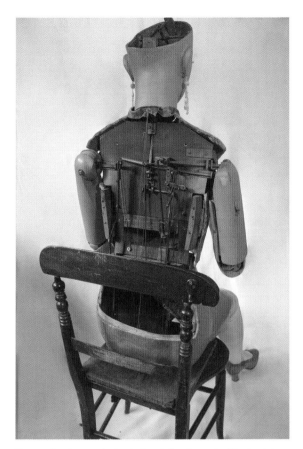

The mechanism on the backplate is fixed to a steel body plate. The control rods rising up from the levers under the chair are evident. The levers and spring that keep the chest raised are on the front of this body plate. A long rod controlled by its own lever and cam pulls the chest down against the spring pressure. The automaton is designed to perform effortlessly for long periods. As such, her mechanism is very robust and requires a relatively large electric motor.

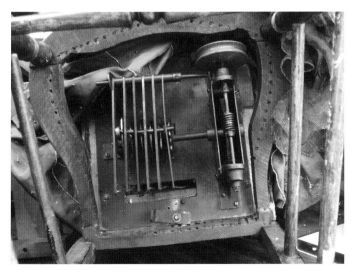

Under the chair is the cam stack, Nancy's 'brain' where the information for all her movements is coded. One of Nancy's more modern lifelike qualities is that she has her own Facebook profile (Nancy Animata) with a large international following of friends. They probably don't know that the high reduction worm gear obviates the need for a train of gears.

Nancy's human quality glass eyes, which scan about to make eye contact with her audience, and the complex range of movements give her a true 'Coppelia' quality. She is very definitely a life-sized living doll.

Other applications

The uncanny effect of a breathing mechanism has made it a popular feature in automata for centuries. The action instantly gives the impression of biological life. However, a rising and falling chest is not the only indicator of respiration that has been used. Some ventriloquist dolls and an interesting replica of Vaucanson's eighteenth-century duck use puffs of air from the mouth to suggest life. The puffs of air are produced from a rubber bulb or a mechanical bellows connected to a pipe in the mouth. Obviously a puff of air has the great disadvantage of being invisible so some means was always contrived to show the air. Usually a ventriloquist doll would blow bubbles or powder from a tube. The duck used a candle flame which it extinguished with one puff of air from its open beak.

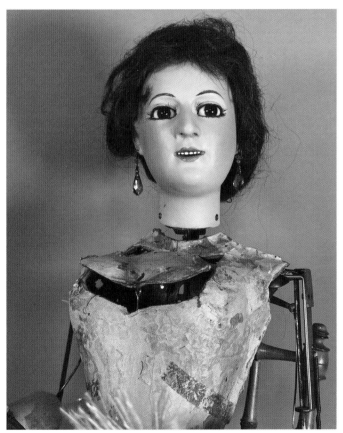

Another Lady with a Fan, Paris, c.1880. Height 50cm. This third example of a breathing automaton is by renowned maker Gustave Vichy. The chest follows the same mechanical design as Nancy's and the Phalibois Lady with pearl necklace. You can see the rod at the front of the chest. This pulls down the movable chest flap against spring pressure.

The automaton that actually eats is, of course, just an illusion. Digestion is the whole point of eating and this biochemical action is a rather impossible activity to represent with mechanism. The French inventor Jacques de Vaucanson claimed to have created an automaton with true digestion in the early eighteenth century. He made a life-sized automaton duck which ate cornmeal from a bowl, digested it, and to 'prove' the action was real, then expelled it in a changed form at the other end. The Digesting Duck went on to become famous all over Europe, until it was proven to be a trick. The digested corn or 'duck poo' that issued from the rear of the duck turned out to be 'pre-loaded' and not the same corn it had just eaten. Automata therefore restrict themselves solely to the physical movement of moving food from plate to mouth, sometimes with a chewing action too.

This is thought to be one of the last known photographs of Vaucanson's Duck before it was destroyed by fire in 1879. The Digesting Duck was made in 1739 and purported to eat, digest and then poo. Voltaire lamented that 'without the duck you would have nothing to remind you of the glory of France'. The digestion was a trick.

THE DUMPLING EATER, GERMANY, 1922

This automaton is carved from wood and originates from the Black Forest in Germany. Also known as the Knödelfresser, examples like this have been made since the early nineteenth century and are usually found eating dumplings on top of barrel organs, clocks or just kneeling by a tree, as here. The action is designed to be mesmerising and slightly comic; it has the air of something inspired by a fable or folk story. The figure kneels, balancing a very large bowl of dumplings which he looks down at, then takes a dumpling with his fork and carries it up towards his mouth. The mouth opens wide, revealing many teeth and a long tongue. The dumpling is deposited in the mouth where it is seen to disappear down the man's throat before the mouth closes and the eyes roll upwards. Still hungry, the man continues to eat dumpling after dumpling.

A traditional German automaton that portrays the act of eating dumplings with a fork, picked up from a huge bowl in front of him. Variations include eating potatoes and even rats!

- Arm lifts food into mouth
- Opening mouth
- Roll of the eyes

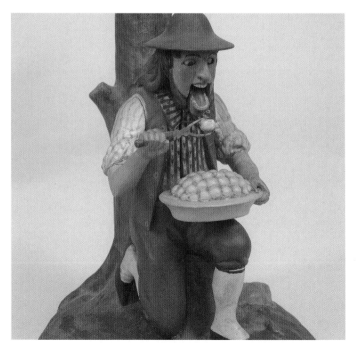

Dumpling Eater, height 26cm, dressed in Bavarian costume, wielding a fork in his right hand and resting on a tree stump. A pulley in the base causes him to lift a dumpling, his eyes to roll and jaw to drop, the dumpling moving continuously on a wire from the plate, through the mouth and the tree stump and back again.

This Dumpling Eater was illustrated in the classic automata book by Chapuis & Droz (1958), *Automata, A Historical and Technological Study*, and latterly was part of the Moe Goldy collection in the USA. It is an excellent example of an automaton still popular on Black Forest clocks today, capturing the stance and perfect whimsical movement of this character from folklore.

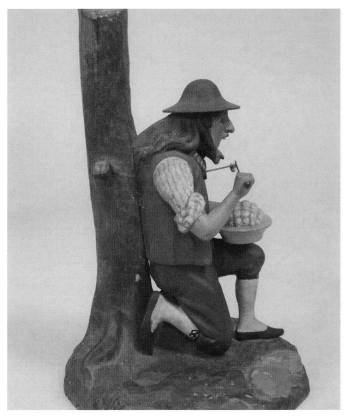

This side view of the Dumpling Eater shows that the tree serves two purposes in this automaton. It is necessary to provide space for revolution of the dumpling behind the figure. The tree also provides strength and stability to the figure. Later examples from the Black Forest dispense with the tree and the figures are sometimes simple and crude caricatures.

THE SECRET

- A rotating cylinder in the torso of the figure turns the dumpling on a long wire rod.
- The arm is lifted by the dumpling itself as it catches on the fork.
- A second wire rod from the same rotating cylinder opens the mouth before the dumpling arrives.

The mechanism

The clockwork drive mechanism in this automaton is missing and it is likely it was driven from a long-lost barrel organ or clock mechanism on which it sat. Dumpling eaters on top of clocks were driven from the strike train, resulting in them bursting into life every hour and eating as many dumplings as there were hours struck on the gong.

The mechanism for the dumpling eating action alone is complete and working within the figure, but the drive belt hangs down expectantly into the base for looping over its missing drive pulley. The belt ascends to just below shoulder level where it goes around a wooden pulley on a short wooden cylinder. This cylinder is on a stub arbor fixed at one side of the figure only. This one cylinder controls all the actions of the hungry man, a long rod extends out from it on the end of which the only edible dumpling is mounted. Also on the cylinder at a position a third of the circumference in front of the dumpling rod is another shorter rod whose purpose is to open the mouth prior to the arrival of the dumpling.

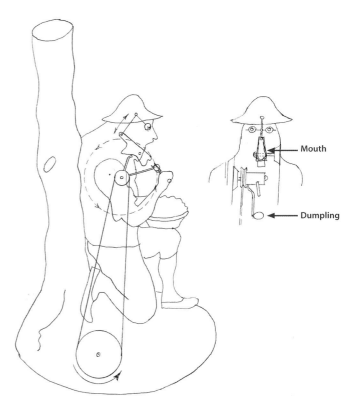

The wooden cylinder with dumpling on a wire rod controls the whole action. A clockwork mechanism, below the figure, rotates a pulley connected by a cord to the dumpling cylinder. The dumpling rotates anticlockwise. An additional wire on the same cylinder precedes the dumpling wire. Its purpose is to open the mouth just in time for the dumpling to enter.

Attached to the mouth extension inside the head is a wire linkage to swivel the pivoted eyeballs downwards as the mouth opens, so the man can look at the dumpling approaching his mouth.

The mouth is pivoted on another stub arbor mounted on the opposite side of the figure. The use of stub arbors, mounted on one end only, is essential to allow the free passage of the long dumpling arm into the mouth and past the mouth arbor.

The eating action

The pulley rotates the rod with a dumpling on it, in a wide circle anticlockwise. The dumpling exits behind the bowl and its rod proceeds up a long slit in the front of the body of the man. As it emerges it contacts a tine of the large fork held in the dumpling eater's hand. The dumpling raises the fork and thereby lifts the arm: it looks as if the man has forked up a dumpling whereas in reality the dumpling has picked up a fork!

The pulley cylinder's short rod has now contacted the mouth lower extension and has pushed the mouth wide open. In doing so it lowers the eyes. The dumpling approaches the open mouth and appears to be deposited on the tongue with the fork; the arm then descends. What is actually happening is that due to the differing circular radii of the fork (pivoted at the shoulder) and the dumpling (pivoted just in front of the shoulder), the fork (remember it is pushed up by the dumpling) falls off the dumpling and the whole arm descends under its own weight at the very moment the dumpling enters the mouth. The dumpling is seen passing along the tongue and disappearing down the throat of the figure. There is a long slit for the dumpling rod to move in that connects the exit hole behind the bowl to the entry hole, the mouth.

Some versions of the Dumpling Eater are fitted with two or three extra pins on the revolving cylinder. These pins follow the mouth opening rod and as the mouth starts to close they prod it open repeatedly to indicate a chewing action. The mouth, eyes and arm are all counterweighted to fall by gravity alone to their 'at rest' positions.

The arm raise and lower. The fork is a simple rustic two-pronged implement angled so the approaching dumpling catches it, lifting the fork by the upper prong or tine. The shoulder is pivoted a small distance behind the pivot point for the rotating dumpling, causing it to fall off the fork at the mouth, allowing the arm to descend.

Underneath the Dumpling Eater. An interesting view showing that the construction of the tree is in papier-mâché. The figures were mainly carved wood with some papier-mâché parts formed in moulds and the parts assembled. The mechanism is mounted on wooden blocks inside the figure. Intriguingly it is signed 'a Pau', a town in France, which explains the origin of the papier-mâché.

VARIATIONS

One of the most amusing and effective variations involves just one food, spaghetti. This long springy coiled food is represented in some automata by white string or, as in this case, wool.

THE SPAGHETTI CHEF, ENGLAND, *c.1970*

This advertising automaton was made by the prolific maker J.H. Animations. Powered by an internal mains voltage electric motor it was designed to run all day, enticing people into the shop. The company made many variations on this automaton for all the different trades, the most famous being the Cobbler for a shoe mender's shop. The heads and hands are made of rubber and the movements are simple in that the head nods forward and back whilst the right arm moves up and down, pulled by a crank on the motor spindle.

This J.H. Animations automaton is a repetitive simple electric automaton, but the principle has also been used to more amusing effect by modern maker, Paul Spooner. Spooner's Spaghetti Eater does the same action of raising

a forkful of string 'spaghetti' but instead of a plate he is sitting in a bath full of spaghetti. Introducing this absurd dimension elevates the composition from mildly interesting to a wonderfully funny automaton. Interestingly the arm is pushed up to the mouth with a wire hidden in the spaghetti falling from the fork, a similar action reversal to the dumpling eater.

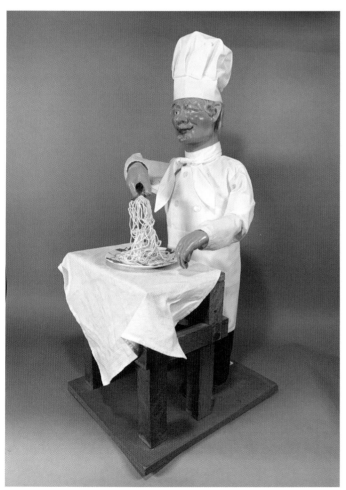

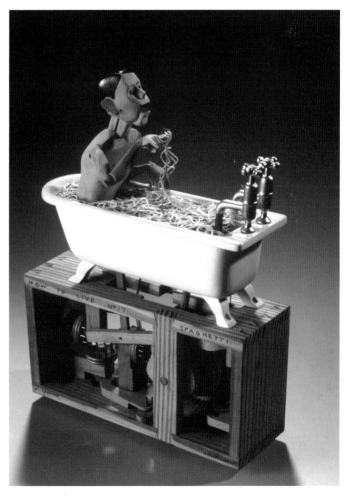

Advertising automata have always been popular attention grabbers in shop windows and displays. J.H. Animations, an English maker, supplied thousands of electric automata in the twentieth century all doing the same basic arm lift and head turn or nod action. The motors were fitted on an iron frame clad in plaster and later plastic bodies with composition or rubber heads.

How to Live No 17: Spaghetti by Paul Spooner, *c.1980*. The automaton is turned by hand and made of wood with many complex moving features. There are moving flows of spaghetti and tomato sauce from each of the taps respectively and a great chewing action. This automaton is part of the splendid Cabaret Mechanical Theatre collection. (PHOTO: HEINI SCHNEEBELI)

DRINKING BEARS, ROULLET & DECAMPS, PARIS

Human activities carried out by animals have always been entertaining and creatures such as ducks, pigs, monkeys and bears were often anthropomorphised by automata makers, sometimes even with human hands and feet. It is no accident that 'drinking bears' feature here in the chapter about the human body, because they are extremely human drinkers, using bottles and cups which demonstrate the principle of a drinking automaton very clearly.

A mechanism for drinking automata that uses real water poured from a height. The 'magic' bottle never runs out of the liquid.

- Pouring a real liquid
- Lifting cup to drink
- A bottle that never runs dry

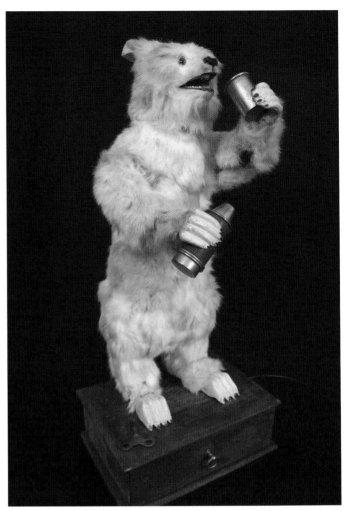

A Drinking Polar Bear, c.1890, Paris. The full cup is raised up to the mouth and the same lever that raises the arm has a rod to push up the head and tilt it back causing the mouth to open. The standing versions of these bears were produced in an age when bears were familiar street entertainment in cities.

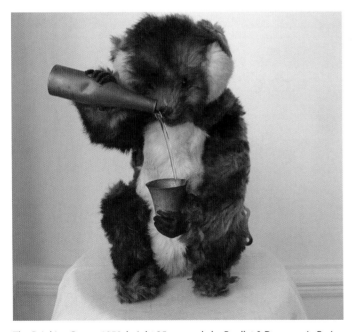

The Drinking Bear, c.1950, height 35cm, made by Roullet & Decamps in Paris. One of the most popular automata by this prolific maker. A stream of liquid issues from the bottle and pours down into the cup until it's empty. The cup is raised to his mouth and then lowered for the process to begin again. The bottle magically refills.

The clockwork bears examined here either stand up straight like a person or sit. Both versions use the same technique and mechanism, but the standing versions are older, made from around 1880 to 1910. The routine is great fun and runs like this: holding a small bottle in one hand and a cup in the other, the bear raises his arm and tips the bottle from a height above the cup. Water pours from the bottle and falls in a continuous stream into the cup. When the bottle is empty the cup is full. The bear lowers the bottle and raises the full cup to his mouth. With head tipped back and mouth open you can hear the liquid gurgling down his throat. The empty cup is lowered and the bear, still thirsty, pours another cup full from the bottle and drinks again. The bear fills his cup from the small bottle and drinks again and again. A good audience will gasp, twice! The first gasp when they see that real water pours from the bottle. The second gasp follows when they realise that the bottle never runs out.

The cup and the bottle are connected by a rubber tube. The tube is hidden inside the arms and across the back of the bear. The arms are lifted and lowered alternately causing the water to flow in a circuit using a combination of gravity and the siphon effect.

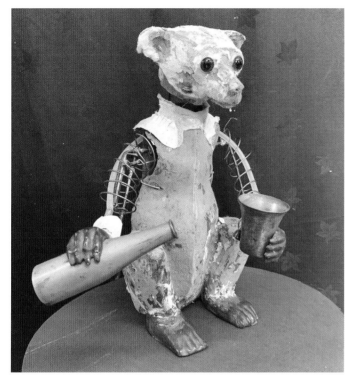

Without fur the drinking bear reveals the secret of the everlasting bottle. The arms lift and lower alternately. The bottle is tilted to pour by a long stirrup link in the upper arm which is swivelled down a few degrees as the arm reaches its high point. The spring-wound arms provide protection and space for the tubes and mechanism.

Bottle and cup

The bottle and the cup are made of metal, usually copper or brass. Just above the base, on the side of both receptacles a 5mm hole is pierced and a short length of brass tubing, about 50mm long, is soldered in place. The metal tube projects from the side of the cup and bottle near the base. The metal tubes enter unseen holes drilled in the palms of each hand and exit at the top of the wrists. The wooden hands are mounted onto the metal framework of the fur-covered arms. The flexible rubber tube is connected to the metal tubes where they exit at the top of the wrists.

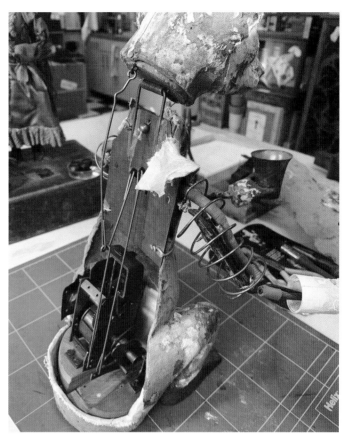

The clockwork drive motor and cams are visible at the bottom of the body cavity. The left wire rod which raises the cup splits in two halfway up to tilt the head back. The cord restraint that opens the hinged jaw is also visible at the top of the body plate. This bear's tube has perished away. The new tube will be routed from hand to hand across the back at shoulder height.

The tubing

A flexible rubber or silicone tube of approximately 5mm bore is used to drain the water from the cup when the arm is raised. The rubber tube runs unseen from the cup's metal exit tube along the arm to the shoulder, across the back and down the other arm of metal tube in its base. Care must be taken in selecting a tubing that is not too stiff. The tube must twist as well as bend, and soft tubing must not be so soft that it is easily compressed, therefore stopping the flow.

Flow

The small bore of the tubing can cause problems with the water failing to exit the cup. Check the height difference is sufficient for flow. The addition of a tiny amount of soap into the water can break the surface tension at the exit hole in the base of the cup. Some later models of drinking bear have a notch in the arm lift cam for the cup arm. This notch causes the arm to jerk at the top of its raise and this stimulates the cup to empty. Once the flow begins, a siphon effect helps to drain the cup often with a satisfying gurgling sound.

The pour from bottle to cup is an impressively long drop of about 8 centimetres but usually a few drops miss the cup, especially if the bottle is overfilled initially. Audiences seem to enjoy spillages but having a cloth to hand to mop up is a good idea.

The mechanism

The Bear uses a standard clockwork power unit positioned upright within the body. The drinking action is achieved by a revolving crank extending from the mechanism on both sides. The cranks are offset by 180° so the right arm is up when the left arm is lowered, and vice versa. A lever connects each crank to a short arm extension within the body. The right arm with the bottle has a special stirrup frame linkage from shoulder to elbow, which allows the forearm and bottle to be pulled around by a short extension rod connected by a wire link to the mechanism. This causes the bottle to tip when the arm is raised. The left arm crank is connected to the back of the head with a cord so that as the cup is lifted the head tilts backwards. This same tilt action opens the jaw which is restrained by another short cord to the front of the neck. The jaw is normally closed by a spring inside the head.

Variations

The drinking mechanism is very eye-catching and memorable so is occasionally used in advertising automata to promote the sale of beer and tea. The short run time of clockwork was a limiting factor so Roullet & Decamps produced an electric version which could run continuously.

THE ELECTRIC DRINKING BEAR

In the 1960s Roullet & Decamps produced an electric version of the drinking bear. It was mains powered and could run indefinitely until the water evaporated. I occasionally get this model to repair and, as always, the tubing has perished and needs replacing. The tubing has a life of no more than twenty years and then leaks straight onto the electric motor. In clockwork mechanisms the result is often rust but in the mains electric version the risk of fire or electric shock is significant. When restoring these bears, I always replace the electric motor with a modern 12-volt version to anticipate the next tube failure and protect my customer.

In automata the appearance of something as unexpected as a real liquid or smoke adds an element of surprise. Machines do not need to drink and seeing it apparently consume refreshment adds a fleeting suspicion that there might be life in the machine.

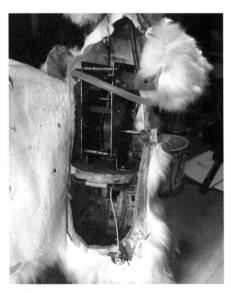

The standing polar bear mechanism from 1880 is configured very differently and has a musical movement attached under the wooden mounting. The tube for the liquid has been replaced and some German papier-mâché is evident. Possibly a copy of the French original varied to avoid a patent or perhaps a different source was used to supply the papier-mâché bodies.

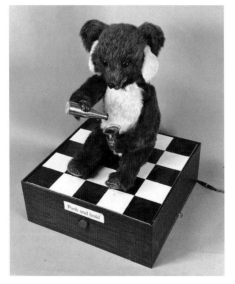

Electric Drinking Bear, c.1960, Paris. Originally produced with a 220-volt electric motor, the inevitable leaks from the rubber tubing made it dangerous. This bear has been mounted on a push button base and the motor has been changed to 12 volts. Ideal for exhibition use, the bear can drink all day as the water travels in a circuit.

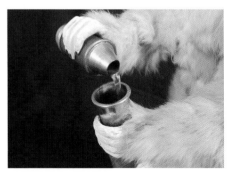

The pour is a magic moment, when the audience realises it's a real liquid. The polar bear pours quite close to the cup, although a higher pour would be more visible and impressive, like a cocktail waiter showing off. The small size of the cup is probably the reason for the close pour, as it is quite difficult to avoid spillages, no matter how smooth the clockwork.

SMOKING

SMOKING MONKEY, ROULLET & DECAMPS, PARIS, c.1900

Just about everybody smoked in the nineteenth and twentieth centuries. It is hard to imagine today, but smoking tobacco was as natural a human activity as eating or drinking. It follows that smoking would be an uncanny activity for a clockwork automaton. The Parisian makers rose to the challenge with an effective mechanism for automata to enjoy a smoke as well.

A mechanism for automata that 'smoke' either cigarettes or pipes.

- Exhaling puffs of smoke
- Arm lift

I have seen examples of modern smoking automata which attempt to achieve a lip seal around the cigarette end and the bellows without any crossover valve, the result being leaks of smoke and smoke issuing everywhere in an uncontrolled manner. I am old enough to remember smoking and the activity was strongly associated with confidence and relaxation, the exhaled smoke purring from the lips in a satisfying stream. The sliding crossover valve achieves this control and the automata makers found they had a very popular subject, especially as most automata in the nineteenth century were demonstrated as part of an after-dinner entertainment. It was a time when 'gentlemen' would smoke and 'ladies' would sing or play the piano.

Most smoking automata were portrayals of people – Turks, huntsmen, dandies, etc. – which is why smoking is included in this chapter. But our main subject here is an excellent smoker who happens to be an anthropomorphic monkey. He not only smokes: he does so with the most enigmatic glazed green eyes, the pupils dilated with pleasure. Obviously he has a very good tobacco.

THE SECRET

The cigarette is smoked by a clockwork-driven bellows within the monkey's body. A hidden tube leads down the arm holding the cigarette and connects to a metal pipe sticking out of the side of the holder and hidden by the hand. A second tube leads up to the mouth. Both tubes enter the bellows. To inhale and exhale discretely an automatic sliding valve within the bellows opens and shuts the two tubes alternately. The valve therefore ensures a glowing tip to the cigarette followed by a long plume of smoke exhaled from the mouth.

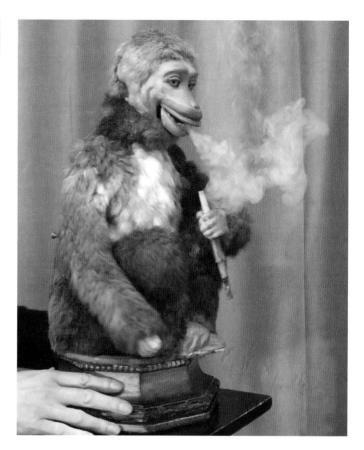

Smoking Monkey, Roullet & Decamps, Paris. Height 40cm, c.1900. Fur-covered papier-mâché body, powered by key-wound clockwork motor. The movements are as follows: raising of the arm holding the cigarette, head tilt downwards, eyelids close, upper and lower jaw open and a glowing tip to the cigarette followed by eyes open, and a plume of smoke exhaled from the mouth.

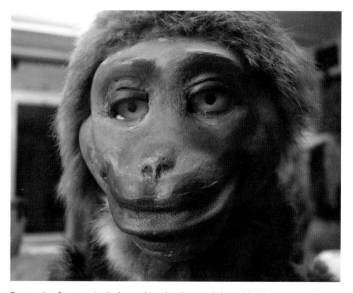

Expressive features include working leather eyelids and both upper and lower leather jaws. The fine leather is skived thin at the edges before gluing on to the head, then gessoed and painted. The lips hide two rows of white teeth. The striking use of high-quality green glass eyes adds considerable interest, despite being a very rare feature in monkeys.

The mechanism

The cigarette fits neatly into a short tubular holder permanently fitted in the hand. It cannot be removed because it has a short brass tube soldered or glued like a T piece halfway down the holder. This tube disappears into the palm of the hand and emerges halfway up the forearm. A pliable rubber tube is pushed onto it. The tube is hidden by the loose fur of the monkey's arm. The other end of the tube is pushed onto one of two pipes that exit the bellows, the inlet pipe. The other pipe on the bellows has the tube that ascends through the body and into the head where it is pushed onto a short brass pipe that exits just above the tongue and will eject smoke out of the mouth.

The bellows and valve

The single-chambered bellows is constructed from two wooden plates and an airtight leather covering creased to fold neatly inwards. The upper wooden plate is static and firmly attached to the frame of the mechanism. The other wooden plate is movable, hinged at one end and moved up and down by a simple crank driven lever from the clockwork mechanism.

Construction of the valve relies on careful geometry. The inlet and exit pipes should enter the bellows side by side with a gap between equal to their width. Inside the bellows they present as two holes to be covered and uncovered in turn by a rectangular length of sprung brass. This sprung brass turns through approximately 15° to and fro inside the smoke-filled bellows. It is riveted to a short circular stud protruding from a tight-fitting hole that leads to the outside of the bellows. On top the stud has a brass lever riveted on tight. This lever on top is moved to and fro by the crank on the end of the bellows. The valve crank is pulled and pushed by a special sliding wire link as the bellows opens and closes.

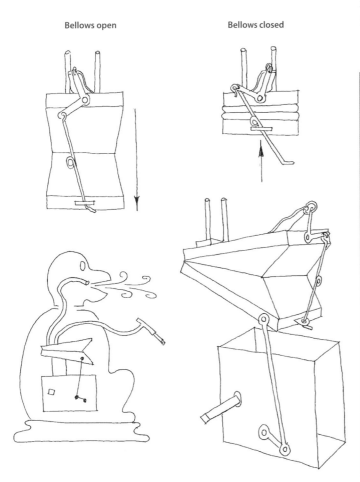

Bellows open **Bellows closed**

The leather 'lungs' of this smoking figure are bellows driven by a revolving crank from the clockwork mechanism. The bellows open and suck smoke from the left pipe. As it closes it forces the smoke out of the right pipe. Each pipe is opened and closed automatically using a crank-operated swing valve by the movement of the bellows itself.

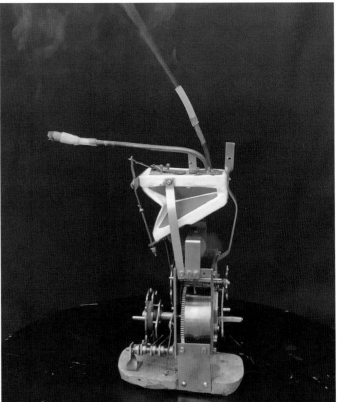

Smoking mechanism under test with real cigar prior to re-fitting in a Gentleman dandy automaton, similar to the monkey. The bellows has been re-covered and sucks well enough to cause a strong glow at the cigar tip. When exhaling, the inhalation tube is closed by the sway valve, so smoke is not pushed back out of the cigar.

The wire link

As the bellows opens and shuts, the wire link attached to the valve crank runs through an eyelet on the bottom plate. It is only pushed or pulled at the very top and bottom of the bellows stroke due to two protrusions in the wire. The lower end of the wire is bent at right angles and a loop is formed halfway along the wire. This arrangement means the valve is stationary for 90% of the opening or closing of the bellows. This ensures a full draw of smoke and a complete exhale as the valve 'snaps' over at the moment 'suck changes to blow' and vice versa, the resulting action simulates smoking perfectly.

The Smoking Monkey by Roullet & Decamps is a rare life-sized automaton. We once lent one to an art student who used it as the subject for an anti-smoking poster for the World Health Organization. He had just returned from Thailand where he hoped to photograph a well-known real smoking monkey. On his arrival he found it had died. The automaton smoking monkey now belongs to him, and the picture still features on the website of this now famous British artist.

Other applications

The smoking action is still regarded with fascination even amongst a largely non-smoking public. While most makers are content to feature straightforward smoking, variations on the smoker have been made.

DAVID SECRETT'S EROTIC SMOKER

I will keep the description sparse as the automaton is very explicit. A woman is about to sit down on a smoking man's lap. The man relaxes, sits back and inhales on his cigarette. The smoke then issues from an unlikely part of the man's anatomy that has slowly come up into view. The woman then leaps into the air, lowering her skirts, and turns around to face him. This is a hand turned automaton of considerable complexity. It features ten separate movements and an animated figure on a turntable as well as the smoking action.

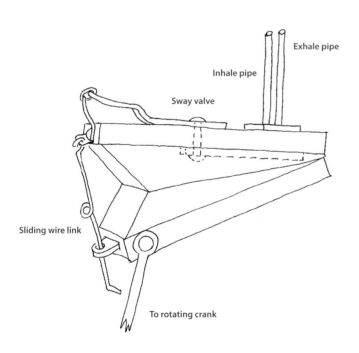

The bellows valve is key to a successful 'suck and blow' out of alternate pipes. Pivoted in the middle, it moves from one pipe opening to the other automatically using a sliding wire link. The two halves of the valve are riveted tight together at the pivot, which passes through a hole in the wooden top plate of the bellows.

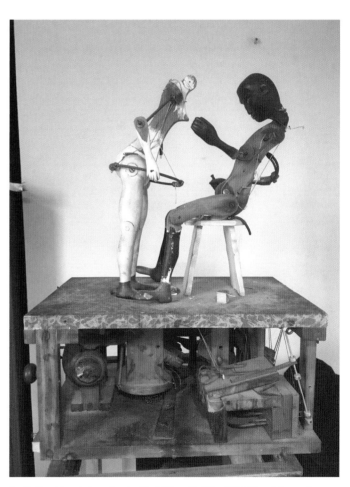

Erotic Smoking Automaton by David Secrett. UK, c.1980. The distressed condition of this automaton, now missing the head and clothes, is a long story. The ingenious mechanism features a turntable for the lady and smoking pipework that goes up the hollow chair back and into the man's appendage, thankfully out of sight behind his thigh in this picture.

MAN AND EXHALING DOG

The other surprising and humorous variation is a rare automaton from Roullet & Decamps in which a man inhales a cigarette whilst standing next to a table on which sits a poodle dog. The poodle then turns to look at him and the dog exhales the plume of smoke instead of the man. This is achieved by hiding the exhalation tubing in the man's arm, the hand of which is on the back of the dog, as if patting.

Finally, as this section 'draws' to a close, it seems fitting to end on a long exhale with this fabulous automaton Marquis Smoker dating from around 1880.

USING E-CIGARETTES FOR DEMONSTRATION PURPOSES

E-cigarettes seem like a possible solution for demonstrating these automata in a healthier way, and we have experimented with a large gentleman smoking automaton. After a few trials, however, we found the water vapour in the e-cigarettes caused two problems: firstly, steel parts in the internal valve became rusty and seized up; secondly the leather suffered with the dampness. To succeed, the automaton would have to be made using waterproof materials specifically to cope with the humidity of e-cigarettes.

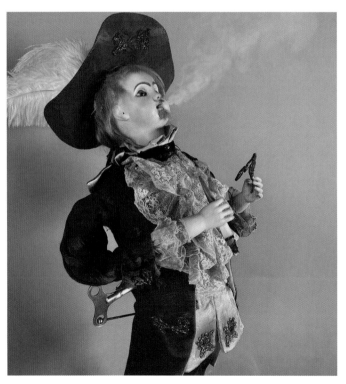

The Marquis Smoker, Paris. Height 60cm, c.1880. A fine silk-clad figure with bisque china head by Jumeau. The mechanism has been smoking away for nearly 150 years and in that time I have been privileged to restore him twice in the last thirty years for his owner. I believe he has a small cigar every day after dinner. PRIVATE COLLECTION

WRITING AND DRAWING

THE ANDROIDS OF JAQUET-DROZ, SWITZERLAND, 1768–1774

The automata are part of a set of three (the third is the Musician) known as the Jaquet-Droz Androids; they were made between 1768 and 1774 in Switzerland by Pierre Jaquet-Droz, his son Henri-Louis, and Jean-Frédéric Leschot. The automata are now located in Neuchâtel, Switzerland where they are on public display. They are extremely complex machines designed to show off a complete mastery of the automaton-maker's craft. The mechanisms are composed of thousands of different precision components operating together with the accuracy of a watch. However, the basic mechanical principles on which these complex mechanisms operate are relatively simple and straightforward.

Two clockwork automaton figures made in the eighteenth century: the Draughtsman, who draws a variety of pictures, and the Writer, who writes lines of verse.

- The Draughtsman draws four different pictures
- The Writer uses a pen to write lines of text

The mechanisms

The Jaquet-Droz mechanisms are able to write or draw a variety of different texts and pictures. The Writer is programmable; he can write any sentence using up to forty letters over three lines. This makes the writing automaton extremely complex, with just under 6,000 parts required. Watching either of the mechanisms in action is a wonderful mixture of sight and sound, a blend of clicks, ticking and whirring like a mechanical symphony. The complexities for both automata can be broken down into a set of simple blocks: drive motors, cam stacks, cam selection, lever and chain transmissions, arm pivots, head movements, and so on. The different blocks are all connected and mounted in a brass framework fitted into the confined space within the body of the automaton. The mechanism is housed like this, inside the automaton, in imitation of the internal anatomy of a living being.

I shall explain the main elements behind the Writer automaton whose mechanical features are more complex than those of the Draughtsman. The Writer's production of individual letters allows for a natural segmentation of

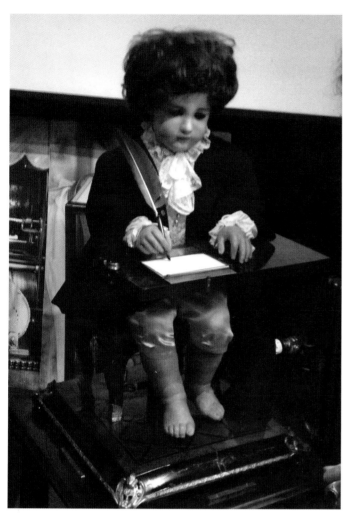

The Writer. Exhibited almost continuously for over 250 years, this clockwork automaton performs the now arcane task of writing a pre-programmed set of words with a quill pen to suit the occasion. The figure of a chubby child is the original choice of the makers, but he has been restored, re-dressed, and has even changed sex in his long life.

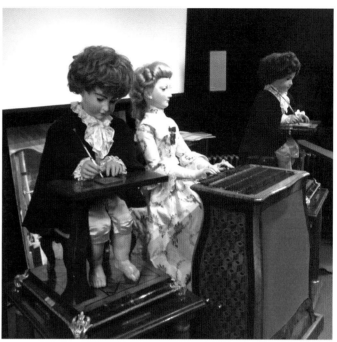

The 'androids' of Jaquet-Droz are rare survivors of eighteenth-century automata: two life-sized children who write and draw respectively and the beautiful lady musician who plays an organ and 'breathes'. These clockwork figures are Swiss national treasures and demonstrate a complexity and longevity that is matched by few other automata. The firm of Jaquet-Droz still exists today. The automata are on display at the Musée d'Art et d'Histoire de Neuchâtel in Switzerland.

THE SECRET

The pen's motion for either automaton is dictated by two shaped cams: one cam for vertical lines (the × axis) and the other cam for horizontal lines (y axis). Curves result from both cams acting together on the hinged and pivoted arm. These x and y axes are joined by a third axis (z) whose cam acts to lift and lower the pen on to the paper.

Examples produced in 2014 of the automata's handiwork. The Writer is obviously struggling with spacing. I noticed this was due to the human operator running the machine without the outer spacing disc in place; he actually gave the pad of paper a little physical push at the end of each letter to compensate. Both automata are over 250 years old.

the mechanical action and as the text written is programmable this adds considerably to the interest. The automaton is probably the prime example of complexity, durability and ambition in a machine that still enthrals today as much as it did in the eighteenth century.

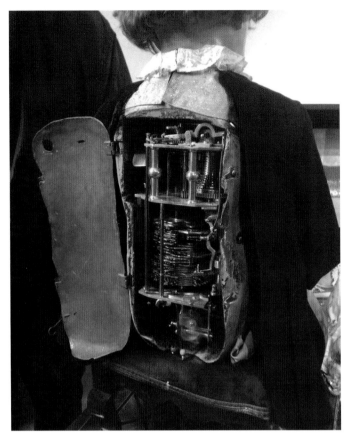

The Draughtsman's mechanism is simple compared to that of the Writer. At the top, behind the two knopped pillars, is the cone-shaped fusee of the clockwork motor. Below the motor is the cam stack comprising of the thirty-five shaped discs necessary for making four drawings, along with additional actions such as blowing away the dust from the pencil lead.

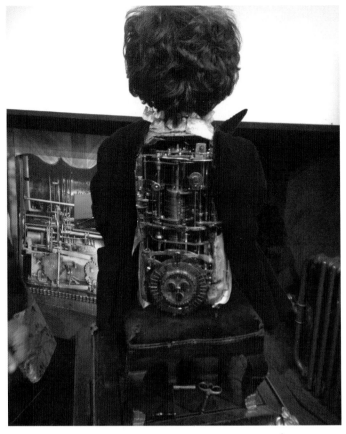

The Writer automaton with the back door removed to access the mechanism. The wig and clothes will have been changed many times over the centuries since he was made, but the papier-mâché body and most of the mechanism will be exactly as Jaquet-Droz made them. The reason for the choice of a rather chubby child is unknown.

The cams

Cams are circular brass discs with specially shaped edges. The edges are profiled to translate into specific movements of the boy writer's arm. A set of three cams working together via jointed levers can move the boy's hand forwards, backwards and side to side, the third cam lifting and lowering the pen. Each set of three cams provides movement that corresponds to a letter of the alphabet. In total 78 (26 × 3) cams are needed to provide the ability to write the components of the whole alphabet, although only three will be in use for any one letter. An additional 42 cams are required for other movements of the automaton such as the head, eyes, ink pot and left arm. The cams are therefore arranged in a vertical stack and revolve in unison.

The cam stack consists of 120 cams stacked together on a steel shaft; they revolve and slide up and down the shaft fixed together as one unit. The cams are in three sets of 40 cams, and these three sets primarily correspond to movements of the right hand of the automaton: forward and back (40); right and left (40); and up and down (40). For one complete revolution of the cam stack a letter will be drawn using three cams simultaneously, one from each set. The edges of the three cams are 'read' by three fixed levers. Each lever is pivoted to ride up and down on the edge of the cam translating the movement to the arm.

Between revolutions the followers lift clear and the whole cam stack slides up or down rapidly, stopping suddenly when the correct cams for a particular letter or movement are aligned precisely under the appropriate followers. The cams are just 0.7mm thick with a 0.7mm space between them; the speed with which the heavy cam stack rises and falls requires a counterbalancing force. This counterbalance is a coiled spring connected by chain to the stack, working in the same manner as a retractable steel rule. To position the cam stack with precision a second major component is needed: the selector disc.

The selector disc

An indexing disc, fitted with 40 adjustable pegs around its periphery, is responsible for selecting the correct three cams from the cam stack to write each letter. When the cam stack completes one full rotation and stops, the selector disc then indexes around anticlockwise by one fortieth of a turn. On top of the selector disc rides the hardwearing ruby tip of a steel sensing lever which is lifted or lowered by the letter pegs fitted around the whole circumference of the disc. The height of each peg is very accurately determined and varies by 40 tiny increments, each 0.25mm of the potential 10mm rise and fall of the sensing lever. The peg height corresponds to the desired cam set in the stack.

The movement of the lever is amplified and transmitted by fine steel chains which pull and push the cam stack up and down. The pegs are wedge shaped to facilitate lifting the lever and they are clamped in place by the set screws seen below each peg.

The second disc

The mechanism of the writer is also fitted with a second programmable disc which overlays and moves with the pegged selector disc described above. This disc is fitted with forty pairs of adjustable lobes. The purpose of this disc is to specify letter and word spacing by moving the writing pad on the tabletop. The left hand is attached to

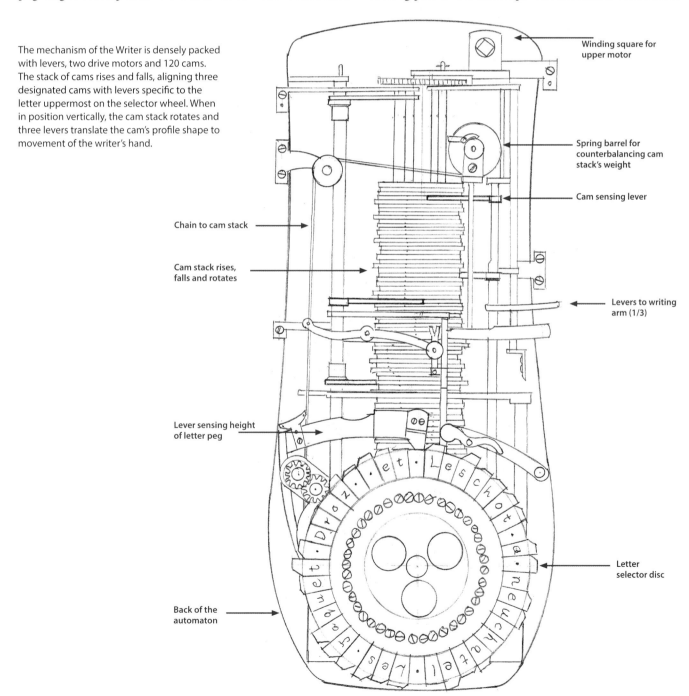

The mechanism of the Writer is densely packed with levers, two drive motors and 120 cams. The stack of cams rises and falls, aligning three designated cams with levers specific to the letter uppermost on the selector wheel. When in position vertically, the cam stack rotates and three levers translate the cam's profile shape to movement of the writer's hand.

Winding square for upper motor

Spring barrel for counterbalancing cam stack's weight

Cam sensing lever

Chain to cam stack

Cam stack rises, falls and rotates

Levers to writing arm (1/3)

Lever sensing height of letter peg

Letter selector disc

Back of the automaton

the writing pad and moves with it. The pad actually pulls and pushes the left arm which appears as if it is the motive force for the writing pad and not the other way round, so the action appears relatively natural.

The disc also controls movement of the ink well by the side of the table. When the writing pad is moved to start a new line the pad 'shoots' across the table with considerable speed and would strike the ink well if it had not mysteriously moved out of the way just before impact on an extendable bracket. The Jaquet-Droz would perhaps have wrangled with this obvious design flaw. Should they have reduced the number of letters in each line to match the limited arc of the arm over to dip the pen? In the end the mysterious moving ink well is a humorous mechanical feature that goes unnoticed until pointed out.

The power units

The clockwork motors that power the Writer are another unusual feature of this automaton. It is powered by two separate fusee drive motors with powerful coiled steel springs – one positioned at the top of the mechanism and the other positioned below the mechanism. Each is wound separately and is responsible for powering separate sections of the action. The top motor raises and lowers the cam stack and powers the arm movements. The lower motor powers the selector disc and head movements. What is quite extraordinary is that the power units are interlocked so that when one operates the other must remain still. Movement of each power unit is initiated by the concluding movement of the other. In this way potential damage is avoided as the cam stack can only move when it is correctly aligned in the neutral space between letters or words.

Accuracy and precision

The height of each peg determines the three cams that correspond to a specific letter. The movement from selector peg to pen tip is amplified by the sensing lever and

then transmitted into linear and rotary motion via a long sequence of chains, cams and levers with many pivots and links. All the accumulated free play in this train of joints will result in errors at the point of pen to paper. The effect of wear is lessened by the use of jewelled bearings and a refined understanding of the composition of the steel and brass used, its hardening by heat and burnishing, and the way each interacts with the other. Wear and slack errors should also be the same for all letters written, meaning that they can be adjusted out if maintained properly.

The biggest errors would arise if the levers were to locate over the gap between cams instead of the cam itself. This would result in the automaton making spelling mistakes or scrawling incoherently.

This mechanical precision is impressive and is a product of the same Swiss precision needed for fine horology. In a watch or clock the errors in the timing of each tick of the balance wheel accumulate to time lost or gained at the end of the day. The use of sapphire and ruby for bearing surfaces in the Jaquet-Droz Writer shows its horological lineage and an intention to create a lasting legacy of precision.

The whole contrivance is built without compromise of function or quality and perhaps most impressively of all, it is built to fit into the small space of the automaton's papier-mâché body. The cavity measures just 110 × 130 × 260mm. The body must accommodate components such as the cam stack (168mm in height) which also needs additional space to slide up and down.

The cavity is closed by a thin metal door which covers the whole back and allows access for winding both motors and admiring the mechanism.

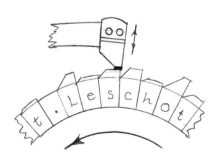

The pegs on the edge of the selector disc vary 10mm in height by 40 increments of 0.25mm. There must be no free play or wear in the long sequence of levers and chains that connect the sensing lever to the cam stack. The tip of the lever is jewelled with a small ruby to lessen friction and wear.

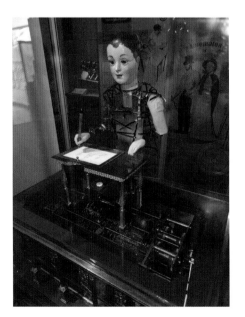

Maillardet's automaton can write three four-line poems and draw four different pictures. Housed in the Franklin Institute in Philadelphia since 1928, it arrived at the museum as a mysterious box of pieces, damaged by fire. When restored, the automaton revealed its maker by writing the words 'written by the automaton of Maillardet' at the end of the first poem.

Automata with the mechanism contained within the body are inherently more lifelike. Overcoming the problems of limited space, organic shape and stability mean they usually represent the finest iteration of the automata maker's craft. This is all the more impressive in Jaquet-Droz's case as the Writer automaton is infinitely programmable using the pegs on the disc.

Comparison can be made with the Draughtsman Writer built thirty years later in 1805 by Henri Maillardet, who worked in London, at the workshops of Jaquet-Droz. This automaton is sitting at a table in the same way as the Jaquet-Droz automata but its mechanism is housed under the table in the large box base and therefore built without size constraints or problems of fit and stability. Maillardet's automaton is impressive to watch but it is more akin to an animated mannequin sitting on top of a large machine when compared to the Jaquet-Droz Writer. The Maillardet Writer inspired the film 'Hugo' which features a writing automaton. Incidentally, I was the automaton consultant for the film and designed the automaton's mechanism to contain a mixture of elements from the Jaquet-Droz androids. The film portrays the 'Hugo' automaton as containing its mechanism in the body.

I was lucky enough to see the Jaquet-Droz Writer perform, close up. The single feature that impressed me far more than any other was the sound of the mechanism. It was a fantastic series of confident clicks, clunks and whirrs. The sounds were so precise and clearly defined with an unstoppable crisp momentum, it was a symphony of precision I did not expect.

VARIATIONS

THE CLOWN ARTIST

A variety of toys and models that write and draw have been made over the last two hundred years and many demonstrate the principles and methods for drawing automata quite well.

This late nineteenth-century tin toy is modelled as a brightly coloured clown artist. The clown draws a variety of pictures according to cams loaded into the base. The subjects are recognisable images from the time, such as a portrait of Queen Victoria or Gladstone. The cams are riveted together in pairs to act as one unit: one cam moves the pencil horizontally; the other cam moves the pencil vertically. The cam followers are simple pegs riding the edges of each cam, dictating a precise picture drawn on the paper via a parallelogram of two long jointed levers

encircling the cams. The common pivot point for both levers is near the peg followers which read upper and lower cams separately. The opposite joint to the fixed one is a floating joint that can move in all directions. The motion is transmitted from the floating joint of the parallelogram up via a tilting tube that terminates with the clown's head. The gimbal joint for the tube is positioned at shoulder height. The arm projects at right angles from

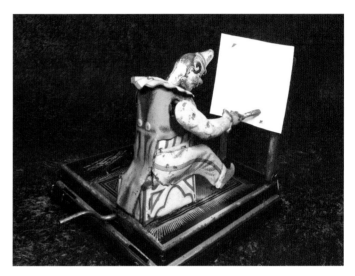

The Clown Artist dates from *c.*1895. It is a hand operated, German tin toy by Philip Vielmetter. The clown's easel is spring loaded to maintain pressure between the paper and the pencil tip. The cams are riveted together in pairs which describe vertical and horizontal movements of the pencil. Each set of cams represents a different picture drawn on the easel. (PHOTO: GFU COLLECTIBLE)

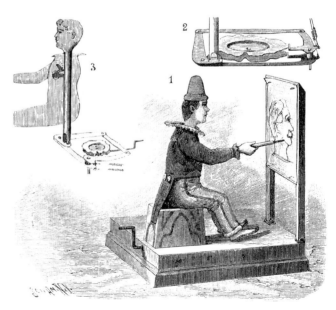

THE TOY ARTIST.

The mechanically produced drawings on the clown's easel are made using the simplest pressed tin mechanism. The pairs of cams fitted into the base are interchangeable, enabling a large variety of different pictures to be drawn. Most of the images are of well-known figures of the nineteenth century: portraits of Gladstone or royalty like Queen Victoria. (PICTURE: HOPKINS, A. MAGIC, STAGE ILLUSIONS AND SCIENTIFIC DIVERSIONS, 1897)

This writing machine has two cams, one for each axis, × and y. The levers are joined together at the top pivot and move the pencil to accurately write a short word. Produced as a laser-cut kit and a pdf plan it was designed by Shasa Bolton in Tasmania who produces several different interesting writing machines in kit form.

the tube at this shoulder joint for some distance, which amplifies the motion at the pencil tip. The clown's head follows the pencil tip at all times, as if watching it carefully, a result of it being attached to the same tube as the arm.

DOODLER

The way the cams and levers work in the Clown Artist is very similar to that employed in this modern simplified writing machine that uses the same parallelogram lever principle. Designed for simple hand operation by turning the cams directly, the pencil will write a word on the paper below (in the Clown Artist a tube replaces this pencil to transmit the motion up to the arm). The three bolts seen at the top of the photograph are the lever pivot point with the two cam followers below. Gravity serves to keep the followers in contact with the cam edges.

AUTOPERIPATETIKOS, USA, c.1860

This clockwork doll is an excellent walker. She steadily tramps forward with confidence and a perfect balance. Each foot lifts in turn and is placed down in front of the other. So sure-footed is this automaton that in addition to the tough plaster-headed version a deluxe one was produced

A method of simulating sure-footed walking on two legs in an automaton figure (for four legs, *see* Chapter 3).

- Forward movement by lifting each leg off the ground in turn
- Moving the raised leg forward each time

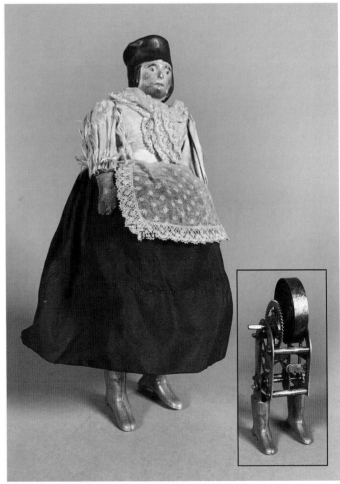

The Autoperipatetikos ('the automatic walking one') was patented in the USA by Enoch Rice Morrison in 1862. Standing 27cm tall, she was made by a variety of manufacturers including Martin & Runyon and Joseph Lyon & Co. of New York. The mechanism is an interesting and early example of a figure which could take steps forward, rather than rolling the feet along.

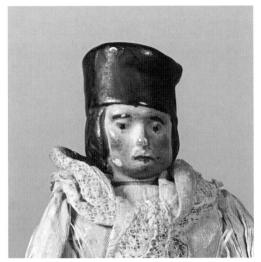

THE SECRET

As each foot is lifted off the ground a small unseen rod extends from under the hollow shoe. The curved end of the rod holds the doll upright and rolls slightly on the floor as the foot is moved forward around the hidden rod. The rod retracts as soon as the foot is lowered. The automaton effectively maintains both feet on the ground at all times whilst appearing to lift each foot clear.

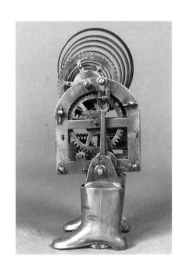

The walking mechanism. The arched shape of the pierced brass plates and the developing open coils of the steel spring make for one of the most visually aesthetic clockwork mechanisms ever made. In motion the levers and their movements are beautifully coordinated. The body is usually easy to lift off so the mechanism and legs can be observed walking.

with a fragile porcelain head; the makers were completely confident that she would not fall over. The simple walking action described is actually very difficult to achieve in an automaton or robot. When one foot is lifted, the machine's tendency is to fall over. The solution usually results in big feet and an inherent instability that is anything but confident. The latest robotic solutions are jittery creatures requiring huge processing power to simulate nature's perpetual striving for balance, something that the human brain takes in its (literal) stride. In this automaton a clever solution has been devised. The walking action is simple and effective, but not quite what it seems at first sight.

Walking motion

The clockwork mechanism is contained within the skirts of the automaton. The weight of the mechanism keeps the centre of gravity low. Extending below the mechanism are a pair of short legs. The legs are barely longer than the brass boots she wears, but each leg has two levers that extend right up to the top of the mechanism. The pair of levers have a circular yoke at the mid-point which acts as the revolving fulcrum for the leg. The top of each lever ends in a U-shaped yoke restraining the movement to an up and down action. This combination of revolve and

oscillate in the same lever provides the necessary ambulatory 'lift, forward and lower' at the 'boot' end of the lever.

What is so clever is that the hollow brass boot to which a lever is riveted hides another identical lever with a small skid fitted at the bottom, within the sole of the boot. Now take a deep breath as I explain how it works: The boot lever hides a skid lever. Both levers are long, reaching up to the top of the mechanism. The 'skid lever' lies exactly next to and against the boot lever, sliding against it. Both levers are moved to and fro and up and down by a pair of circular cams revolving in a large hole in the centre of the levers. These two circular revolving cams are riveted together on a rotating shaft; their centre holes are offset by 3mm, so not concentric. The two revolving cams are riveted at 180° to each other so when one lever is moved up the other is down. The top U-shape yoke of the skid lever slides up and down on the same fixed pin as the boot's U-shaped yoke ensuring the top goes up and down. At the same time cams, midway down, move the lower ends in an arc, rolling slightly at each step and taking turns to contact

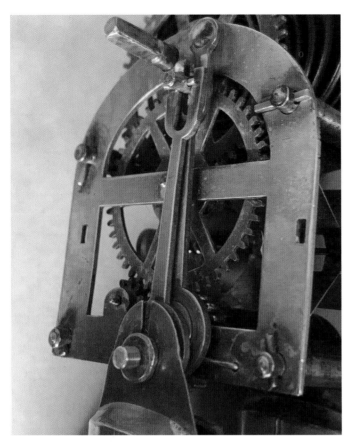

Pivoting around the offset circular cranks are the leg levers. There are two levers for each leg, the outer one attached to the boot and the inner one attached to the secret skid lever. When one goes up the other comes down, and vice versa. Each lever has a forked top constrained to ensure a circular motion at the bottom boot end.

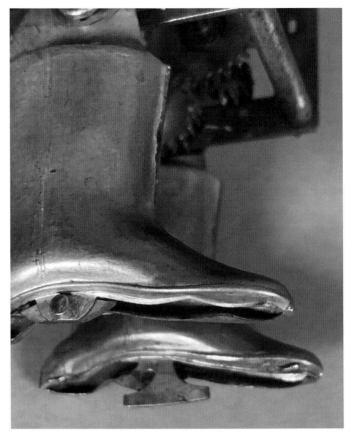

The lever is visible here extending from the underside of the left boot, while the right boot nearest to us shows that the lever has retracted up on its orbit and is now out of sight. The pressed brass boots are curved up in the centre to ensure the heel and toe contact the ground, improving stability fore and aft.

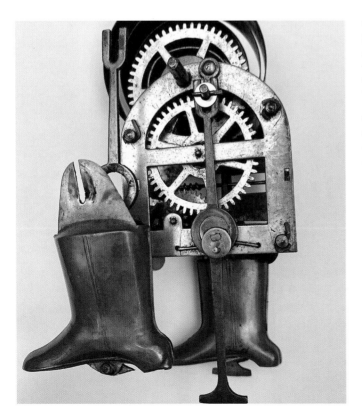

The mechanism here has the right leg removed and shows the unusual shape of the pair of long brass levers that animate each leg. The circular cut-out in the middle is fitted over the appropriate offset circular cam riveted at 180° to its partner. The whole machine is constructed of pressed and stamped brass components, showing its American heritage.

the ground. The two pairs of circular cams for right and left leg must themselves be 180° offset to each other otherwise the careful steady walking action will be replaced by a strange hopping action. A secondary small and almost imperceptible movement is the boot tipping the toe up as it lifts and tipping the toe down as it descends. This is caused by the boot being riveted to the lever right down at its sole level, so the top edge is effectively moved back and forth by the circular mid-point cam.

The Autoperipatetikos mechanism may appear at first sight to be a cheat because the lifted foot does not leave contact with the ground completely. The mechanism is still correctly described as a true walker, albeit a four-legged one, with effectively a second pair of legs hidden within the boots of the first pair.

Other applications

The distinctive hidden lever principle is not to my knowledge used in other automata, which possibly makes the Autoperipatetikos method of walking unique. The other methods used can be summarised as:

Sliding feet

Most other walkers use sliding feet in permanent contact with the ground. In order to ensure forward motion a ratchet and click is used in the form of serrated wheels under the foot and a small gravity click preventing backward rotation. This gives the distinctive robotic 'slide' of each foot in turn but has the disadvantage of requiring an absolutely smooth surface and very large feet.

Three points of contact

Many bipedal 'walkers' instead use a third point of contact for balance. The third point usually takes the form of a wheel and can be a visible trailing wheel or hidden in front such as a figure pushing a wheelbarrow. The surest way to achieve balance is to require the human operator to hold the hand of the automaton, for example the Roullet & Decamps clockwork walking doll, which must be taken by the hand and have the arm raised for the clockwork legs to walk.

THE WALKING VENTRILOQUIST DOLL

We once owned a life-sized walking ventriloquist figure made nearly a hundred years ago by Arthur Quisto. The doll used solid rubber tubes as 'muscles' stretched taut over wooden pulleys in the hips and knees. When you took the hand of the seated boy, and lifted the arm, so taking some of the weight, the doll's legs straightened as the rubber contracted a little and he stood up. By twisting the hand slightly to lessen the weight on each foot he took faltering steps forward, the rubber muscles pushing the leg forward when the foot left the ground. With practice, the walking action looked terrifyingly realistic. By force on the hand, he could be pushed back down again to the sitting position. Despite the 'friendly' and youthful face, this dummy was the most unnerving of ventriloquist dolls to own; entering the room he was always catching my eye. Eventually we sold him to a famous TV ventriloquist who performed with him on stage. I like to know where he is located and last heard that he was in a small UK puppet museum sitting in a glass case.

Quisto Walking Figure, c.1936. This lifelike walking ventriloquist doll features tubular rubber 'muscles' in his legs, and was created by Arthur Quisto (1882–1960), a prolific maker of ventriloquist dolls and Punch and Judy figures. His work featured many innovative features such as remote operation with pneumatic control and electromagnetic actuators. He died aged 82 falling from his roof in a thunderstorm.

FACIAL FEATURES

Each moving facial feature in an automaton has its own distinct mechanism. Animating them can crowd the space in a small head. Of the ten* possible features I have seen, it is the eyes and mouth that are the most often animated. This section examines the mechanisms for eye, eyebrow and mouth movement in three different automata.

Animating the face.

- Eyes moving side to side
- Eyebrows raise and lower
- Mouth opening and closing

THE WINDOW TAPPER, GERMANY, c.1900

A small man with wild hair, measuring just 50cm tall, he is looking straight at you. This rather alarming happy character demands your attention with an expression of humour tinged with threat. The raised stick strikes the inside of the shop window to get your attention, his eyebrows raise and his eyes scan quickly right and left, all the while chattering, the mouth opening to show flashes of white teeth. The figure wears white gloves and his left hand jabs repeatedly with pointed finger at something in front of him, an advertisement or a product of the shop's choice. The Window Tapper was a marketing phenomenon that was common in shop windows in the nineteenth and early twentieth centuries.

The most engaging automata are characters with expressive faces. Moving facial features are a useful tool in bringing them to life as individuals. Blinking, chattering, winking, raising eyebrows and even a sneer were common features. Sophisticated and expensive, most nineteenth-century automata would, at the very least, include eye movement and mouth opening. Many characters unexpectedly stick out a long red tongue as part of the action and I can only think it was thought of as more amusing then than it is now. Other moving features, such as flapping ears, upper lip sneer, winking and hair lifting, are sometimes found but more commonly on ventriloquist doll heads, where a multitude of movements is considered a benefit.

The human face of the Window Tapper. An effective automaton head needs to be well sculpted. Even if the sculpt is economical on detail it can still come alive with well-placed and interestingly proportioned features like the nose and hair on this face. The large glass eyes are very lifelike and move together with the mouth and eyebrows to animate this unsettling character.

The confines of the human head have rendered the mechanisms of all the above movements fairly standard in design, with similar cross bar, crank and return springs layouts, all crammed into the ovoid cavity. What does vary between makers and styles is the quality of the construction. Some heads have highly engineered components whilst a great many others are made of bent wire and string. What is peculiar, in my experience, is that the crude bent wire versions are often livelier in action, and just as reliable as the heads built with mechanisms engineered like watches. A common feature is the use of return springs to hold facial features in an 'at rest' position, i.e. mouth closed or eyebrows down. This device means that mechanism is only required to pull in one direction to achieve the motion required, as the spring provides the return.

* The ten different moving features I have seen are: hair lifting, brow wrinkle, eyebrows, eyelids, eyes, ear flap, nose extend, upper lip, tongue, mouth open.

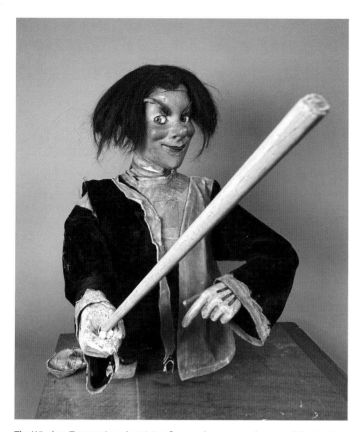

The Window Tapper. An advertising figure who vigorously tapped the inside of a shop window glass with his stick and then pointed at a product. Made in Germany 120 years ago, he is missing the base containing the drive motor. The mechanism is still present inside the body and head. The face has movement of the eyebrows, eyes and mouth.

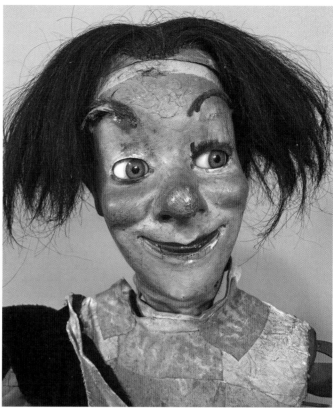

His eyes are the most important facial feature in this automaton. Deep in the base, the eye cam has pulled down a lever and pushed the eyes over to his left. The Window Tapper has large spherical blown glass that attract attention. Originally fitted with fine eyelashes in addition to his furry eyebrows. The eyebrow position is shown raised.

The Window Tapper featured here is a good example of a refined machine approach to facial animation: not over-engineered but simple, rugged, and designed to chatter and look around continuously whilst advertising a product in a shop window.

The mechanisms

Eye movement

I will describe the mechanism of the Window Tapper's uncanny movement of the eyes to left and right. The description and drawing are of this particular automaton's eye mechanism, which uses a right-angled crank separated into two short levers on the same tube. In other automata this is simplified to a single L-shaped crank; *see* 'Variations' section below.

The eyes are linked together and pivot in wire loops fixed into the plaster inside the head. This method of embedding shafts and mountings using plaster is common in nineteenth-century automata. A cam attached to the

drive motor in the base of the automaton is responsible for moving the eyes via a lever which pulls down a long wire rod. The rod ascends into the torso and up into the head. Links and cords can accommodate flexible joints like the neck. Movement sideways across the body plate is achieved using L-shaped cranks. The eyes are spheres of glass with a thin brass rod extending from the top and bottom of each sphere – this is the axis about which they rotate left and right.

As the eyeball is thin blown glass it cannot easily be drilled to accept the rod like a wooden eyeball might, so the wire rod does not pass through the eye. Instead, it is wrapped around the back of the sphere and has a sharp vertical turn up and down at the upper and lower poles of the sphere. To keep this wire 'stirrup' in place, the rear of the eyeball is heavily coated in a glue and plaster putty (or epoxy clay today). This coating also fixes to the back of each eyeball a horizontal brass lever protruding backwards; with these levers the eyes will be linked together and turned. The eyeballs' upper and lower axis rods pivot inside wire loops whose ends are themselves securely embedded in plaster inside the head. The stem of the wire loops can be bent to allow for a very important adjustment: the fit of the eyeball tight forward into the socket. The human eye is gripped by its socket and has no gaps around the edges. The best automata, like this one,

have similarly close-fitting eyeballs, the ball being rubbed in to the plaster coating inside the eye socket. Eyes fitted too far back with gaps around the socket are generally not realistic to look at.

Mouth movement

Automata have a lot to talk about and without a 'voice' they must make do with an active 'chatter' action to simulate speech (or eating and smoking). A thin brass strip forms the lower lip. One side of this semicircle extends back into the head and forms the actuating lever for opening the mouth. The curved brass strip is pierced with pivot holes at the corners of the mouth by which the lip rotates down to open the mouth. The extension into the head is pierced to fit a return spring (keeping the mouth closed) and the pull up link (to open). The metal wire axle for the lower lip is embedded in the head material either side of the mouth. A rocking lever, fixed to a small wooden block inside the head, is used to pull up the link and open the mouth. The mouth cam in the base of the automaton pushes down its lever and so pulls down on the rod which extends up into the head. The rocking bar opens the mouth. So far I have described the lower lip only as a curved brass strip but it is transformed into a realistic opening mouth by a thin leather covering. The leather extends down to the lower chin and is fitted before the papier-mâché head is coated in gesso plaster. The top edge

The back of the head opens to access the mechanism. The papier-mâché is made with German newspaper covered in gesso on the outside. The axles and wood blocks are plastered and glued into position. All the main levers are visible, at least in part. By referring to the drawings below it should be possible to identify the different components.

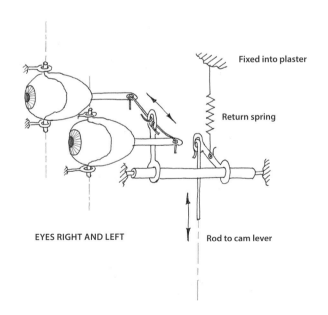

Fixed into plaster

Return spring

EYES RIGHT AND LEFT

Rod to cam lever

The eyes are linked together to work in unison. A spring pulls a lever up to push the eyes over to the right. The rod ascending from the base pulls down on the lever to move the eyes over to the left. With the cam profiled with smooth curves the eyes will scan to and fro, searching out the audience.

of the leather is glued onto and over the top of the lip and has enough flexibility to be stretched sideways to match the curve and be glued to the head on the other three sides. The Window Tapper automaton has a relatively small mouth opening used to simulate chatter. Other automata, using this same hoop and leather technique, can achieve a wider gape if necessary. A row of cardboard or wooden teeth is fitted to the lower jaw which flash white as the mouth opens; this helps to draw attention to this feature.

Eyebrow raising

To give the automaton the ability of expression or surprise a pair of thin, hairy eyebrows curve down the temples to the inner eyes. Each eyebrow lifts dramatically, pivoting on its outer extremity. This movement mimics human eyebrows lifted by the muscles of the brow. Both eyebrows are carefully shaped from the ends of a long brass rod that passes right through the temples of the head and form a kind of horizontal 'C' shape as the ends are bent together in front of the brow. Small lengths of brass tube are inset into the plaster of the head where the wire passes through the sides; these are bearings for the brass rod to turn in. The protruding ends are bent round to the front and

carefully formed into the eyebrows' curving arc. The wire ends are flattened by filing or hammering to improve the adhesion of the thin strips of animal fur, trimmed short. The fur is glued onto the wire arcs to finish the eyebrows.

In order to raise the eyebrows, a long lever is soldered to the brass bar at the mid-point inside the head. It extends backwards to the rear of the head cavity and forwards into the small gap in front of the bar. The front extension has the return spring which is attached to the wooden neck core and is used to keep the eyebrows normally down. The rear extension of the lever is attached to the long wire that extends down to the mechanism in the base and pulls the lever down to raise the eyebrows. The cam in the base is profiled for sparse intermittent raising of the eyebrows. A continuous flapping up and down would be silly.

This Window Tapper has been finely modelled as a wise magician, with features not quite as exaggerated as a caricature. The likeness is one of a mythical or folklore character, and it is this initial confident modelling that contributes most to its success. Each of the movements incorporated into the head re-enforces the initial impression of life and fantasy in this very strange little man.

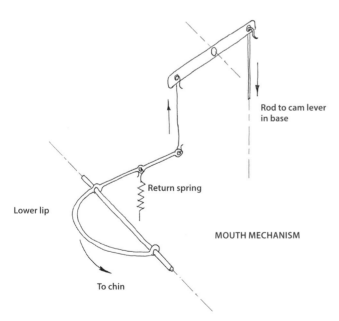

Rod to cam lever in base

Return spring

Lower lip

MOUTH MECHANISM

To chin

The hoop is the lower lip. The axle is inset into the corners of the mouth allowing the hoop to rotate down when its internal lever is pulled up. Thin leather is glued to the lip and provides a flexible cover of the gap underneath. The principle of this hoop mechanism is also used in other automata for closing eyelids.

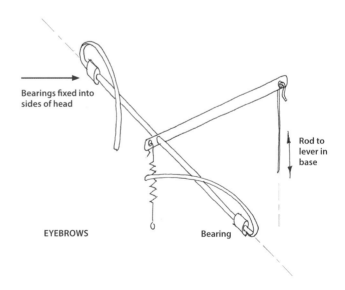

Bearings fixed into sides of head

Rod to lever in base

EYEBROWS

Bearing

Simple and effective: the eyebrows are two ends of an internal bar crossing behind the brow. The bar exits each side through a brass bearing under the hairline. The bar is revolved through a small arc by its lever to produce a large sweeping arc of the eyebrows. The return spring holds the eyebrows down; the rod pulls to raise.

NANCY

This imposing automaton is slightly larger than life and has prosthetic-quality blue glass eyes. The eyes turn to look from side to side and rotate downwards (a rare function) to look at her hands as she sews. The leather eyelids partially close as the eyes lower.

There are a number of interesting features demonstrated by the mechanism inside Nancy's head. The fragile glass eyes have been successfully drilled for the stub axles about which they rotate to look from side to side. The eyes also lower to look downwards by being mounted in a linked together gimbal, or 'C' shaped frame. This rotates them both down in unison, together with the side-to-side

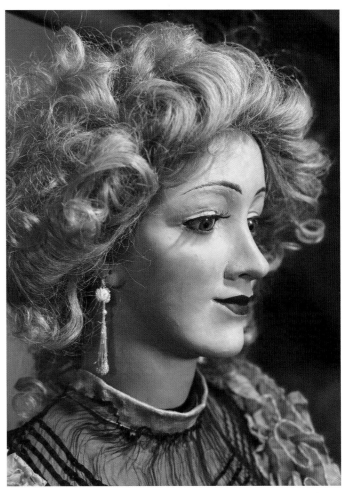

Nancy has a substantial mechanism designed for continuous operation by an external electric motor. Six steel cams are fitted to a large pulley and worm gear under her chair with rods ascending up into the body to animate the legs, arms, chest and head. The automaton is traditionally made of papier-mâché with an iron body plate on which is mounted the mechanism.

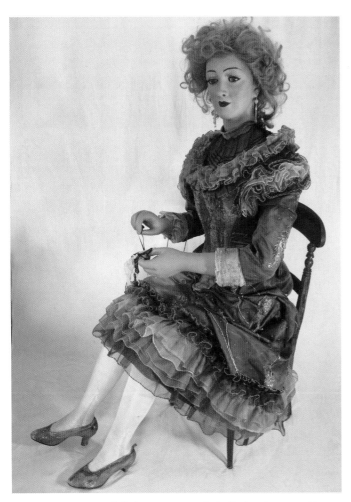

Life-sized automaton of a lady sewing, 1910, Paris. Made to impress with a complex mechanism including eye movement in all directions, eyelids, head turn and nod, breathing chest, bending at the waist, crossing the legs, arm raise and sewing action. The eyes are prosthetic quality blown glass and are intentionally adjusted to meet the gaze of onlookers directly.

Nancy's eyelids are made of thin leather painted to match the skin. The lids close only halfway when she is looking down. The leather is fitted to a movable brass bar at the lower edge and merged into the gesso above and around the eye. Nancy's lashes are full size; smaller automata use fine strips of mohair for lashes.

mechanism in the same unit. The second interesting feature is necessary to accommodate the extra up-and-down motion of the eyeball. It is the open loop 'stirrup', a long oval shape formed in wire by which the eyes are moved left and right. The end of the eye moving lever moves in an arc within the stirrup. A simple and effective solution to connect elements that have compound movements. For more information on Nancy *see* 'Breathing' in Chapter 2.

Ventriloquist doll heads

The ventriloquist uses an animated mechanical figure through which they speak as a double act. Traditionally the performer has their hand in a hole in the back of the dummy's body gripping a pole that supports the head. The pole is furnished with levers for the various movements of the head operated by the fingers and thumb of the performer. There can be up to seven functions of the head although the usual is two or three: eyes to the left (figures usually sit on the performer's right knee); the essential mouth movement; and an additional function selected from sneer, wink, blink, eyebrow, hair lifting, ear wagging, smoking or drinking. What is pertinent to our examination of head movements is the simplicity and apparent crudity of the materials and methods used in ventriloquist figure construction.

Let's look at 'Wobert' made by Geoff Felix in 2002. Mr Felix's figures are made in the traditional English style popularised by Leonard Insull (senior and junior) who made most of the twentieth century's most iconic ventriloquist figures. Wobert has a life-sized papier-mâché head and traditional three-lever control on his support stick. Inside his head is a classic mechanism of bent wire and soldered joints. The same three movements are present as in the Window Tapper: eyes, mouth and eyebrows.

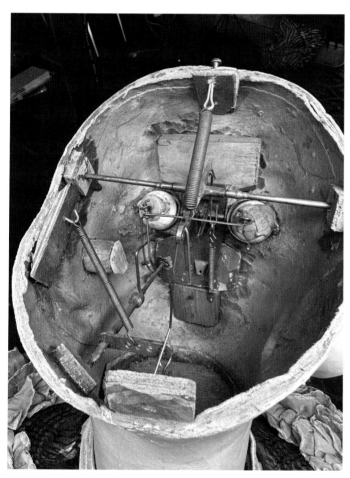

Inside Nancy's head are fixed two cross bars, one from front to back to mount the mechanism for the sideways eye movements and a second across the temples whose levers and links perform the lowering of the eyes and, simultaneously, a half closure of the eyelids. Only two rods are required to enter the papier-mâché head from the mechanism underneath.

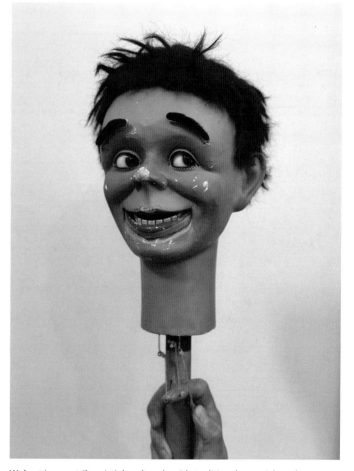

Wobert is a ventriloquist's head made with traditional materials and techniques in 2002 by Geoff Felix. The stick below has three levers which are pulled down to operate the mouth, eyes and eyebrows. The leather lower jaw will accommodate a wide smile. The eyes look forward and move to the figure's left, because he sits on the performer's right knee.

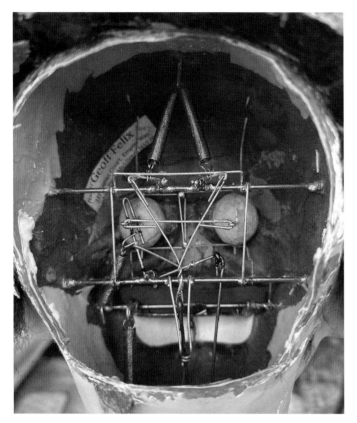

The simple wire and solder mechanism is traditional. It looks crude at first sight but is precisely proportioned and effective in use. All the same elements are there as in the engineered Window Tapper featured in the text. Note the cement coating the back of the eyes which holds the wire pivots and levers, and red felt lining the mouth.

This allows for an interesting comparison of the different styles of mechanism used for identical functions. The same use of brass cross bars embedded in the papier-mâché is used to support the frame for the eyes and the levers, but here the similarity ends. The cranks and levers themselves are bent from brass rod and connected by galvanised garden wire twisted and soldered at appropriate places. There is no use of brass or steel plate at all; even the base of the mouth and teeth are made of cheap tin sheet, which incidentally gives him quite a bite.

The major difference in the principle of the mechanism is for the eyebrows, whose radial operating wires allow a turning angle more suitable for the flat brow of Wobert's face. The support frame for the eyes is made with long pieces of wire suitably bent to allow for adjustment of pupil height and a good tight fit into the eye sockets. The simple connecting link between the eyeballs is also used to adjust for pupil separation. This frame design makes cross or wonky eyes easy to prevent. Also visible is the red felt lining the mouth and, below it, the white leather used for the jaw gusset of the opening mouth.

The technique of using a flexible leather covering for eyelids and mouth is shown in the restoration of a 1960s ventriloquist doll head, Tiffany (below). She has a leather opening mouth (lower jaw) but also a raising of the upper lip in a sneer. The process is the same for eyelids, upper or lower lip, vent doll or automaton, it just varies in scale.

Tiffany, a ventriloquist's doll by Insull, c.1960, with talking, winking, eyebrow and sneer functions. The three views show stages in the replacement of the leather on her top lip. The first picture shows the brass hoop that forms the movable part of the upper lip. The soft leather is glued on and then blended into the face before painting.

Blink and wink

Moving the eyeballs from side to side is natural and lifelike but a common mistake is to rotate the eyeballs up and down in an attempt to simulate blinking and winking without using eyelids. This is still quite complex mechanically and never looks right. I recommend that effective eyelids be made with the hoop and leather method (described for the mouth above). Having separate eyelid mechanisms for both eyes also gives the opportunity for alternately winking eyes. This entertaining feature is always fun to see in the automaton or clever human, especially when done to music.

Eye gaps

The close fit of the moving eye in the socket is very important in bringing the face to life. I recommend spending as much time as necessary shaping the inside of the socket and adjusting the eye setting as tight forward as possible until the eyeball fits without gaps.

Compound movement

Moving the head side to side and up and down at the same time gives a sweeping arc to the head which is the opposite of expectations of machine movement. It instantly gives a natural lifelike look to the movement of the automaton.

Size

The head should not be small in relation to the body. In nature, head proportion is very consistent in never appearing too small. This makes small heads on automata look very wrong. Perversely, a large head can look very good on an automaton, in the same manner as a caricature or cartoon, the head of an automaton can be made very large to good effect.

Little Tich, c.1906. A portrait head with alternately 'dancing' eyelids made of thin leather. This clockwork automaton is of the English music hall performer Harry Relph (1867–1928) whose leaning 'big boot' performances were regarded with acclaim as sublime physical theatre in France and great comedy in England. His small stature gave the English language the word 'tichy'.

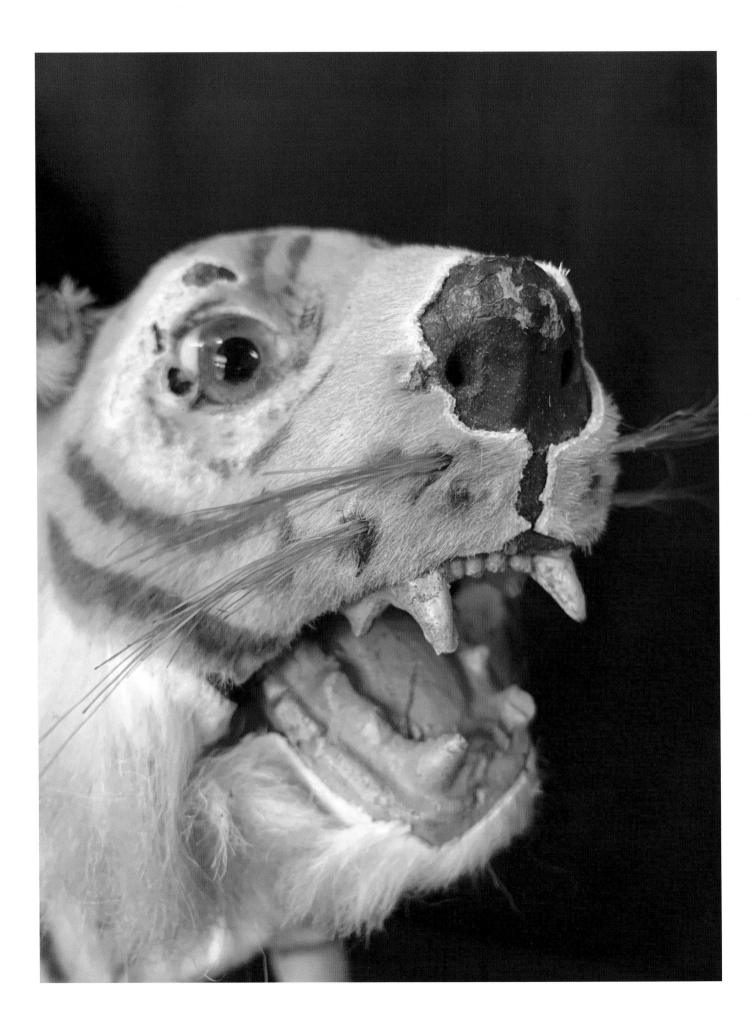

BIRDS AND ANIMALS

Animals and birds are some of the most enjoyable and beautiful automata to watch. The challenge for makers has been achieving realism. Most creatures have some intrinsic quality of movement or life that belongs particularly to that species – the pendulous rock of a walking tortoise, the gravitas of a stalking cat, or the deep, deep growl of a lion. Good observation was a quality the best makers began their journey with, and identifying that single element was often the key to success. Birdsong is explained in the last section and is such a refined and complex subject it could have filled a whole book by itself, but here I have stuck to explaining the principles behind producing the main movements and sounds.

My wife loves to demonstrate this automaton to groups of children. She claims it is a blinking and winking tiger, and if you get up close and look into its eyes it will blink and sometimes even wink. Of course they trust her and move in very close. They stare straight into the tiger's green glass eyes. The tiger leaps suddenly, the children shriek loudly and jump nearly as high as the tiger. I think this borders on child cruelty, but the general laughter when it leaps at them does cloud the issue. Anyway, it is a wicked delight to demonstrate.

The tiger is notable for its short legs, giving it a stunted look. It is believed that Gaston Decamps, the talented artist of the family, was looking for a real tiger to model, but the Paris zoo had only a very old and overfed tiger who rarely stood up but stayed slumped against the bars of its cage. Gaston drew it carefully, but not being able to make it stand up, he had to guess the length of its legs.

LEAPING

THE LEAPING TIGER, ROULLET & DECAMPS, PARIS, c.1880

No other automaton has such an air of growling menace as this tiger, yet he actually retreats back as his growl becomes deeper and louder, he crouches, the tension grows, the sound of powerful springs creaking and groaning joins the deep resonant roar … the roar stops and … BANG! The tiger leaps forward, up to a metre, through the air.

A tiger growls menacingly and sinks back onto its haunches before launching into the air with a sudden leap forward.

- Growl and roar
- Leap into the air
- Jaws open and close

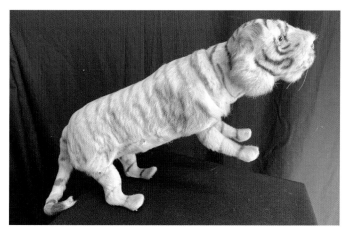

The tiger, at the instant of leaping. The clockwork tiger is relatively heavy. In order to jump into the air a powerful mainspring in the motor is needed, this is used to tension a long coil spring hidden in the length of the tiger's body. The power in this long spring is released when fully stretched, by an automatic trigger, catapulting the tiger up and forwards.

The Leaping Tiger, c.1880, 48cm long. Clockwork automaton made by Roullet & Decamps in Paris. A very popular automaton that cleverly uses the animal's fierce reputation to induce a sense of trepidation in the viewer. When wound, the tiger makes a deep growling sound and slowly crouches back before suddenly springing into the air with a terrifying leap forward.

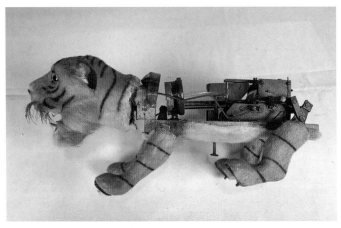

The body of the tiger has been removed and here he is in a half-crouch a few seconds away from leaping. The heavy mechanism is placed over the hind legs where grip is needed to propel him forwards. The long, bent rod disappearing into the head at one end, and attached to a small crank on the mechanism, moves the jaw open and shut.

The rear paws of the tiger are equipped with a single 'claw' to provide grip at the moment of leaping. The weight distribution favours the rear of the tiger and the front paws are covered in felt, with the result that the rear digs in while the front legs slide and lift up before the whole beast leaves the ground.

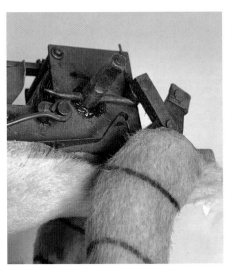

The most powerful part of a clockwork motor is the mainspring arbor, shown here with the key winding square on the end. The 'drop-off bar' is fixed through a hole in this arbor and is shown just before the moment when the 'leg lever' is about to drop off, straightening the legs in an instant for the sudden jump.

THE SECRET

Three features make the tiger leap:

- A long, powerful coil spring, which is stretched by the crouch action.
- A steep drop-off cam to suddenly release the pent-up power.
- Short spikes in the rear paws to provide grip for the leap.

The Leaping Tiger is made of thick papier-mâché covered in a fine goat fur, carefully painted with stripes. The body is mounted on a wooden platform to which the legs, head and heavy mechanism are securely fixed, for the whole animal is subject to sudden strong shocks at every leap.

The mechanism

The leap spring
The long powerful 'leap' spring is strong for an automaton of the tiger's size, in fact it looks as big as a bed spring. It is so strong that, at the neck end, the brass securing bracket it is attached to is reinforced with a crossover strap like a metal sticking plaster holding it down to the wooden chassis. The top of the bracket also has a twisted steel gantry wire fastened down like a guy rope in order to hold it upright against the pull of the spring.

The other end of the spring hooks into a hole on the rear right leg extended lever. All the tiger's legs are joined together by strong rods and tie bars to move in unison. The axles are embedded in slots across the wooden chassis. When he jumps, he pushes off with all four legs together. The rear wooden paws are each fitted with a spike to aid grip and ensure a 'jump' forward rather than an explosive 'slide'. In order to prevent the spikes hammering themselves flat into the paw with each leap, the maker did not use nails but thin steel screws with the heads nipped off. Details like this are important to the function of the tiger, but not so good for the polished surfaces of your furniture!

The drop-off bar
The leap spring is gradually stretched and tensioned by a slowly rotating steel bar fixed in a hole through the mainspring winding shaft. This steel bar, which functions

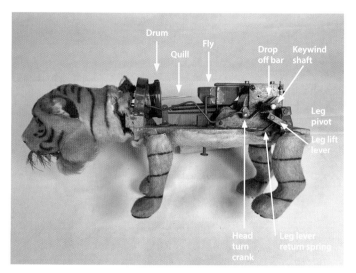

The 'drop-off bar' rotates slowly and powerfully anticlockwise, until it contacts the 'leg lift lever' which bends the legs forward. All four legs are rigidly connected by a bar across the back and along the far side, so they crouch in unison. In the background you can see the long 'jump' spring which is tensioned by the crouch of the legs.

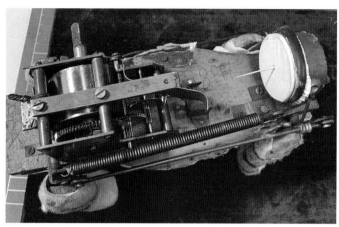

Looking down on to the mechanism shows clearly the long 'jump' spring. This spring is very strong and stretches the length of the body, tensioning as the tiger crouches. Also note the vellum-covered growl drum and its quill. The drum is attached to the leg linkage rod, causing it to move closer and become louder just before the leap.

much like a drop-off cam, rotates slowly and as it does so it lifts the left leg lever, causing all four legs to fold forward at the hip. The tiger appears to crouch right down on to the ground. The action is slow and forceful as the winding shaft rotates with maximum available torque; it is the slowest moving part of the mechanism. When the tiger is fully down in crouch position the bar tip slips off the leg lever. At that moment the tiger leaps forward as the spring contracts explosively and all four legs straighten in an instant.

A problem for the drop-off bar is its location, in a hole pierced through the slow-moving winding shaft. This shaft's primary purpose is to accept the key to wind the mainspring. The key will turn the winding shaft in the wrong direction when winding up the mainspring. The drop-off bar would then turn and lock the wrong way against the top of the leg lever and the mechanism cannot be wound up. The tiger resolves this problem by the use of a hinged leg lever. The drop-off bar simply pushes it down and it hinges out of the way at each turn to allow winding. A simple hinge would leave the leg lever dangling down, unable to pick up the drop-off bar. The solution is that a leaf spring attached to the wooden chassis keeps it up at right angles to the leg, ready to receive the drop-off bar as the clockwork motor powers it slowly round.

The tiger has an interesting safety function. He will often run out of wind at the moment when the 'leap' spring is exerting most force and the legs are folded almost flat to the body. There is a danger that picking him up and winding will cause the tiger to leap unexpectedly in the hands of the unsuspecting keeper. The mechanism is designed so that as soon as the key begins to turn, the drop-off bar rotates as well (it is on the winding shaft) and lets down the leap spring as well as straightening the legs – a perfect reset.

The jaw-opening (or head-turning) action

The tiger needs lots of power to leap into the air so this action is, unusually, powered from the mainspring winding shaft itself. The clockwork motor's intermediate wheel is the normal place to power an automaton and in the tiger this is used to power the opening and closing of the jaws. (In other models with a fixed jaw, it powers a turning of the head from side to side using the same method.) The arbor extends out just beyond the plate and is fitted with a short crank. This revolves and moves a long wire rod that extends all the way forward and into the head of the tiger. This long rod moves the hinged jaw open and shut or turns the head if the neck is pivoted.

The roar

The sound the tiger makes contributes greatly to the tension prior to the leap. As its realistic production is so effective and applicable to other automata you will find it fully described in the 'Sound' section of Chapter 4, The Natural World.

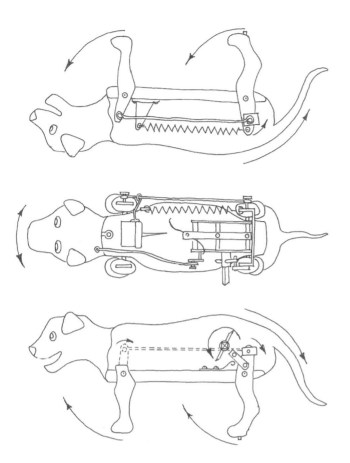

The jump, jaw and growl mechanism. The legs are linked both by a tie rod down the right side and a bar across the rear ensuring they all move together. The rotating S-shaped fly contacts the drum quill producing the growl; the drum is mounted on the leg tie rod, moving closer as the tiger crouches and deepening the growl.

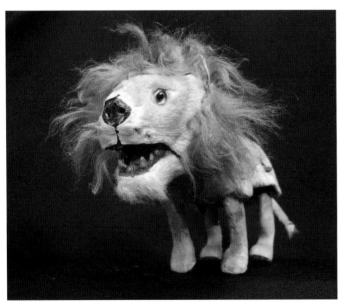

The Lion. With the identical mechanism and the same actions as the tiger, the Roullet & Decamps lion was nevertheless not as popular as the tiger. The dramatic mane of fur does not seem to make up for the ominous green penetrating eyes that the tiger has. The automaton was also made with the choice of head sway or mouth opening.

The Leaping Tiger is unusual for a clockwork automaton in that power is taken directly from the spring winding shaft where most torque resides. Power is then transferred and stored in a stretched coil spring until suddenly released. The shock stresses the gear train and in some cases we have found sections of gear teeth flattened by the force. This has required a new wheel or some clever dentistry to solder in new teeth. Despite this, the tiger treads a mostly successful line in balancing strength with lightness. Hence the variations are cosmetic or small details. The main variation is the lion which uses exactly the same mechanism and body. Both tiger and lion are found with either a shaking head (side to side) or an opening and shutting mouth, never both.

WALKING AND RUNNING

Walking on four legs

This section begins with a look at the most common four-leg walking mechanism, a simple straight-legged walk. The main part of this section will then explain and illustrate an ingenious walking dog mechanism that bends at the knee, moving with a very realistic walking performance. Finally, we shall look at two different variations: a slow tortoise, and a monkey that runs across the ground.

There are two styles of gait that four-legged automata do: the walk and the run. In life these movements are so complex that mechanical representations are always going to be approximations of the flesh and blood versions, a compromise between the stability required for balance and a lifelike movement. With four-legged animals the first two mechanical challenges that present themselves are:

1. Moving the legs in a diagonal sequence for balance.
2. Ensuring the motion is forward and not oscillating on the spot.

In real living animals it must also be said that the diagonal sequence is not quite as straightforward as implied above: the sequence does vary, depending on species and its speed.

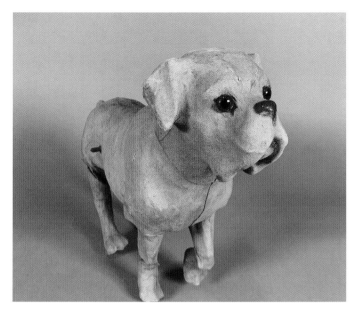

Clockwork Dog, made of papier-mâché by Roullet & Decamps c.1890. The body is covered in close-fitting leather. The walking action features fully animated knee joints in the front legs which pull the dog along, the rear legs sliding forward on hidden rollers, giving a very lifelike movement. Bending at the knee is unusual in automata of any period.

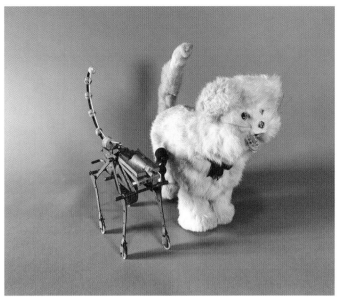

Walking Cat, Roullet & Decamps c.1910. Shown with the mechanism that animates it removed. The mechanism is primarily designed to provide the sliding leg action for the cat's forward motion. On top of the mechanism are the ancillary mechanisms: the bellows with horn for the miaow sound and the ingenious tail flick, described on page 74.

WALKING CAT, PARIS, c.1910

The Walking Cat (its curling tail action is described on page 74 is a good example of a simple walker. The walking action is straight legged and any shortcomings in realism are more than made up for by the accompanying miaow sound and realistic tail flick. The movement of the legs in a diagonal manner – front right, back left, followed by front left, back right – is achieved by using two levers, connected to the legs, and a crank on each side of the mechanism. Each leg is connected by the lever to the central crank. The central crank is mounted on a shaft that extends each side of the mechanism, where an identical crank is set at 180° to the first. The crank shaft is usually the first gear in the train after the mainspring gear so has plenty of power. As the crankshaft turns, the legs move in a perfect diagonal action with balanced smoothness.

The Walking Cat has a stiff, straight-legged motion. The feet or paws of the cat remain in contact with the ground at all times. The feet do not slide along the ground, they roll, and to facilitate this each paw is fitted with a small wheel with a hard rubber tyre hidden within the paw. There is a ratchet click above each wheel. The point of the ratchet click falls by gravity onto the wheel's edge. The ratchet action means the wheels can only be rolled forward, as rearward rotation causes the angled point of the click to dig into the wheel. This ensures the wheel

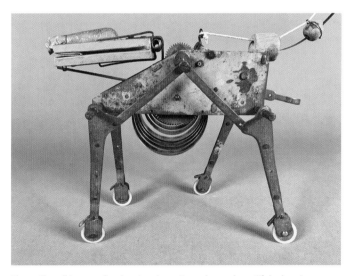

The cat's walking mechanism is enigmatic and even beautiful when in motion. The legs are an assembly of pivoted levers powered by a rotating shaft with a crank each side. The disc crank is visible at the central apex of the levers. To achieve diagonal leg movement, the crank on the opposite side is offset at 180° to the near one.

locks when attempting to roll backwards so the leg can only push the animal forward. Without the ratchet 'one way' wheel the legs would oscillate on the spot. Different designs of ratchet have been used over the years, including sprung ratchets and toothed metal wheels. All designs are prone to failure by clogging with dust and fur. This simple gravity click is probably an attempt to make it more reliable as it has only two parts: the wheel and the click.

The ratchet click is raised to show its tooth shape, but the normal position is down with the tooth riding on the edge of the composition wheel. The angled tooth allows forward movement but in reverse the point digs into the wheel and the longer gravity arm is pulled hard onto the circumference of the wheel, acting as a brake.

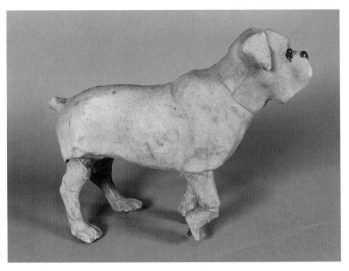

The knee bend is rarely seen in automata and is considered a very complex attribute in robotic engineering. Perhaps this is why it is strangely enthralling to watch this 130-year-old dog manage to do it with such style. After the leg straightens and reaches forward to gain ground the foreleg accelerates back with a graceful and realistic flick.

THE BOXER DOG, PARIS, c.1890

A well modelled boxer dog measuring 30cm in length, this automaton has one of the most satisfying walking actions I have seen. The key-wound dog is driven

- Bending at the knees to lift and place the feet
- Forward motion on four legs

by clockwork which is enclosed by a papier-mâché body covered in a leather skin. The four legs move in the usual diagonal motion driven by a central offset crankshaft as described for the cat above. What is most unusual and rarely found in an automaton is that the front legs are articulated at the knee joint. The back legs slide along as usual, stiff legged (as in life) with small wheels free running and enclosed in the paws. The front leg action is completely different to that of the cat: each leg is lifted in turn and its foot is placed forward and down before bending at the knee to pull the dog forward. The front paws have a hidden metal 'paw' which grips the surface and pulls the rear legs' wheels along, resulting in realistic forward motion.

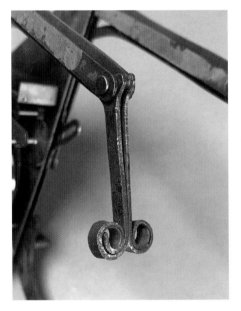

Excellent grip is achieved with the double coil paw of the front legs. Above the paw the foreleg is shaped like an elongated 'T', which allows the push and pull levers to be attached at the knee. The finished automaton has the legs clad in papier-mâché tube which is then itself leather covered, a challenge to maintain its flexibility.

THE SECRET

- A slot cam on the crank.
- A complex arrangement of eight levers in each of the front legs.

The mechanism

Powering all four legs is a single central gear-driven shaft. The shaft extends each side of the mechanism and terminates in a small crank at either end. One crank is for the right legs and the other the left. The two cranks are set at 180° to each other to ensure the movement is a

walk using diagonal legs in unison rather than a hop like a rabbit. The crank pins move two long right-angled levers up and down by rotating within a long slot in each lever. The levers extend forward and back and turn down where they are pivoted at each corner, to form the legs. The rear leg levers comprise of just two levers soldered together

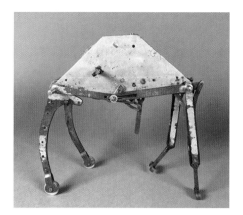

The mechanism is made of brass gears with steel pinions and arbors. The side plates and various levers are plated iron. The long right-angled levers of the legs are soldered together for economy. Note that the shape of the rear leg is similar to that of the cat mechanism suggesting a limited number of these 'knee benders' were made.

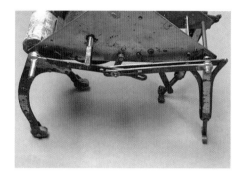

Looked at in conjunction with the drawing above it should become clear how the front legs have double levers that stay concentric until the crank pin enters the angled part of the foreleg slot and pulls the foreleg backward. The cylindrical lead weight shown between the back legs is necessary to balance the head of the dog and prevent falling forward.

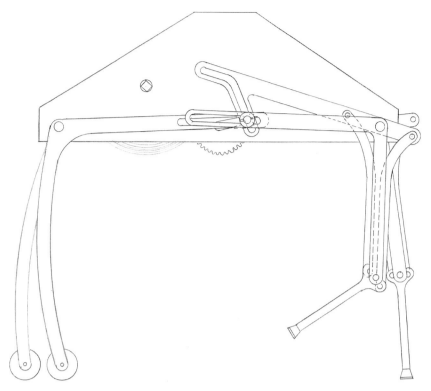

The heart of the mechanism is the central rotating crank. The crank is concentric with the gear teeth shown. The crank's pin rotates in three separate slotted levers. The inner slot lever moves the back legs forward and back. The middle slot lever is directly under the outer for most of its oscillation. The outer slot moves the front thigh.

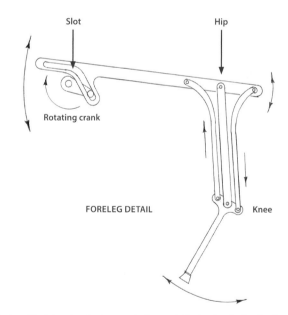

A simplified drawing to show only the parts that animate the foreleg. The foreleg has two symmetrically placed curved levers, whose purpose is to push and pull the small horizontal bar on top of the foreleg. The push/pull levers are designed with curves at the top to narrow the width of the thigh for the papier-mâché and leather covering.

at right angles where the hip joint comes through, they have a metal wheel fitted at the back paws. The rear legs are straight without a knee joint and roll along pulled by the front legs. The front legs are more complex and are each comprised of an assembly of eight levers. The extra complication is necessary to achieve the impressive and functional foreleg articulation.

Starting at the central crank, two slotted right-angled levers extend forwards, one in front of the other. The outer lever controls the thigh movement, the rotary crank working its slot up and down and causing the whole leg to move forward and back in the same movement as the back legs. The inner lever independently controls the foreleg. The same rotary crank pin rotates in both of the slots. The outer lever has a straight line slot for the crank pin (which

is required to convert rotary to reciprocating motion) but the inner lever has a similar straight slot that halfway changes direction and angles downwards sharply to cause the lever to accelerate and increase its range of movement. This angled slot 'cam' in the foreleg lever has the result

of moving the thigh and foreleg together for half of the movement until flicking the foreleg back with a graceful bend of the knee at each step.

At the other end of the long slotted lever is the hip joint for the front legs. The hip pivots on a shaft and continues forward beyond the hip for a short distance. This enables the hip joint to be straddled by the two curved levers that extend down either side of the thigh lever and attach to the knuckle or 'T' at the knee. It is the small movement up and down of these two levers that pushes and pulls the foreleg forward and back. The curved levers are positioned close to the thigh lever which, for strength and stability, is actually two identical levers one in front of the other with a small gap between. This gap gives lateral stability to

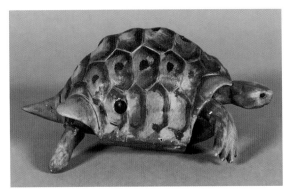

The Tortoise automaton cleverly uses a particular characteristic of the clockwork motor to achieve a relaxed but determined movement. The slowly developing coil spring turns a large gear wheel with the slowest motion but the highest torque of the whole gear train. The drive to the leg axles is taken directly from this gear via a pair of synchronised pinions.

the thigh 'bone' and also provides a space for the curved foreleg levers to partially enter, enabling them to be tight against the thigh so the leg can be thin. The simplified drawing overleaf shows the principle behind this complex and precisely made assembly.

VARIATIONS

SLOW-WALKING TORTOISE

This small automaton was made around 1890 by Roullet & Decamps and is very realistic. A variation on the drive method for diagonal leg movement is found in the uncannily lifelike walk. The papier-mâché and wood body is quite small (15cm long) and accurately moulded and painted. The legs are made of wood, and the slow, methodical gait of the tortoise throws the body side to side. The tilt of the body at each step also causes a pronounced lazy swing of the head which replicates the action of the reptile precisely.

The mechanism differs from the cat and the dog, which use one central crank on each side and long levers linked to the legs. The tortoise has a separate crank for each leg. The legs extend upward above the crank to be restrained in a sliding fork; this changes the rotary motion to linear below the crank at the foot. The front and back leg arbors have the cranks on either end set at 180° to each other. Each leg arbor has its own pinion gear meshed directly to the 'great' wheel. (The 'great' wheel is the clock makers' term for the biggest and slowest wheel in the train; it is also the wheel with the most torque.) The front and rear

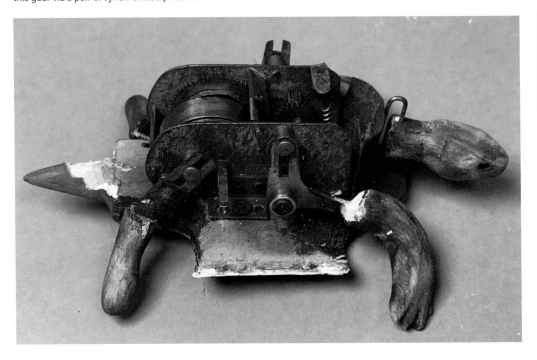

THE SECRET

High torque and direct drive to the front and back legs.

The tortoise's head is suspended on a rigid wire loop, so that just a slight tilt of the body turns the head from side to side in a lolloping action caused by gravity alone. The screw heads indicate the positions of the end of the rotating cranks for the leg axles; above them, the leg extension slots slide in the fixed pins.

leg pinions have to be synchronised when initially meshed with the great wheel. This is important to preserve the diagonal leg sequencing.

The high torque and direct drive make this design the ideal mechanical choice for powering the legs of a determined and powerful tortoise.

The run

Most four-legged animals change gait when moving into a run or gallop. The diagonal leg movement transforms into a movement of both front legs stretching forward, moving in unison, while the back legs contact the ground to push the animal forward. Hence the horse gallops in roughly the same way as the rabbit hops, back legs and front legs stretched back and forward at the same time and brought together into the centre of the animal, only for the rear legs to power the animal forward as the front legs reach out again in front.

RUNNING MONKEY

This Roullet & Decamps fur-covered monkey from *c.*1950 has a fast-running clockwork motor with no speed governor. The mechanism has the same drive motor and chassis layout as the cat and the dog described above. The important difference is the sequence in which the legs move. They are united in pairs. As both front legs stretch forward simultaneously both of the back legs stretch backwards, followed by all four legs coming into the middle together. This action happens rapidly as the clockwork gear train is unrestrained by any fly or governor to control the speed it runs down. Effectively it is the work done by the legs themselves that is the only constraint on the power released after winding up the animal. It is fast.

The front paws have rollers fitted to enable them to slide forward without friction, while the rear paws are large and plain for maximum grip. The rear legs power the automaton forward in just the same way as nature designed it. The sprightly run of the monkey across the floor can be unnerving as it gives the impression of being a little out of control.

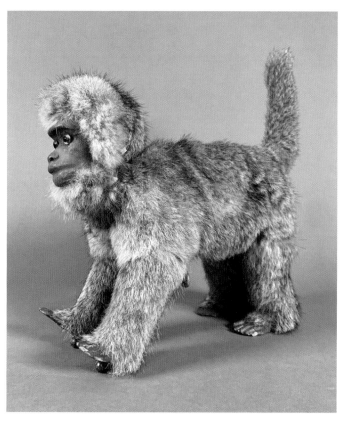

Running Monkey, *c.*1950. The automaton is one of the later models produced by the firm of Roullet & Decamps. Although traditional clockwork, the motor has no worm and fly mechanism to regulate the speed and runs down freely with plenty of power to propel the monkey in a frantic run. The monkey throws its front legs forward almost explosively.

The small balls that roll along under the heels of the monkey's two front paws are essential to the running action. The front legs can then move forward without friction while the rear paws are large, ensuring good surface friction. The rapid stretching and contraction of the legs to propel the monkey forward is an alarming but realistic animal motion.

THE SECRET

The crank pins on the central drive shaft are NOT offset by 180° but move in unison either side of the chassis to cause a rapid stretch and pinch of the legs together.

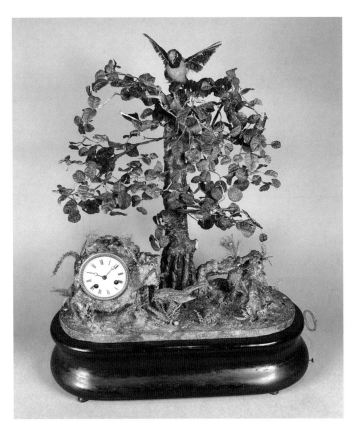

Musical diorama of a tree with birds, clock and waterfall, made in France, c.1880. This realistic scene features a large bird which flaps its wings and a bird drinking at a small waterfall. What is not evident until the automaton is set in motion is the appearance of two 'flitting' birds which move rapidly from branch to branch in the tree. (PRIVATE COLLECTION)

BIRD BOCAGE CLOCK, PARIS, *c.1880*

This clockwork automaton is 60cm tall and has four moving birds in a tree. A pendulum clock is set into the rocky base below. When started by pulling out a button on the side, a raucous twittering sound begins. The large bird at the top of the tree flaps its wings and the foliage below stirs as two iridescent hummingbirds appear in different parts of the tree and flit from branch to branch. Next to the clock is a moving glass rod waterfall and a small pool at which a green bird bobs up and down drinking. The whole scene is preserved under a large glass dome. The clock runs for a week, striking the hours on a hidden bell.

Birds flying quickly from branch to branch, a twittering pause then flying on again amongst the thick foliage of a leafy tree.

- Birds flying from branch to branch
- Twittering sound of birdsong

A brightly coloured taxidermied bird surmounts the tree and has been automated to flap its wings. Beneath it a hummingbird prepares to 'fly' from a branch. The bird is mounted on a fine hinged bracket on which he 'twiddles' at the end of each flit of his wire supports.

THE SECRET

Realistic flitting is accomplished by speed of movement and a turn of the bird's body on landing to face forwards. To achieve this the following techniques are used:

- Two offset hinged parallel rods keep the birds facing forwards.
- The trunk of the tree hides the long rods and levers.
- The flitting is so fast that the black rods moving the birds are not visible.

The two wire rods that connect the bird to the tree are hinged at a short distance from each other in the tree's trunk. The bird is mounted on a small platform at the end of the rods. The geometry of this arrangement means the bird automatically turns to face forwards as the rods swing it across between the branches. DRAWING BY A.J.L. WRIGHT

The mechanism

The tall glass dome keeps dust and curious fingers away from the fragile diorama and sits in a groove around the top of the moulded wooden base. This base hides the mechanism, which is not fixed to the base but screwed to the underside of the wooden floor of the diorama. When lifting out the diorama from the base the whole mechanism comes with it and can be stood on four wooden 'service' legs provided for this purpose. The clockwork drive motor is of high quality and probably supplied to Phalibois from a specialist maker of clockwork. In nineteenth-century Paris this sort of division of labour was common and is one of the reasons the British clockmaking industry collapsed as it could not compete with imported French and American clocks on quality and price. The powerful drive motor has a long output shaft which turns the stack of seven cams with unfaltering speed over a long duration.

The cam and lever mechanism might appear crudely made but are in fact a remarkable example of confident and refined automata mechanism made with a particularly economical use of resources. Visible in the photo below of cams and levers are at least four different varieties of wood, each selected for specific qualities that suit its use for the base, pulleys, cams or bellows. The cams are formed from a single cylinder of wood. The wood is turned to round on a lathe and the seven cam divisions are cut individually along the cylinder by clearing deep grooves between them. The levers are formed from lengths of wire with flattened and pierced ends. The centre of each of the wire levers has been coiled around a shaft to form an economical version of a collet, and just before the lever's hinged end a soldered metal flap acts as a follower to trail along the bumps and contours of the cam. The active ends of the levers are pierced for the wire rods that transmit the up and down motions up into the recess at the back of the tree.

The hollow tree hides the cranks, return springs and supports that disperse the motion out to two flitting birds and one flapping bird at the top. The flitting birds can be of two types: the first uses just one cam to flit and turn its body automatically to face forwards, jumping from one branch to another. The second type uses two cams: one to jump from branch to branch and the second to cause the bird to wiggle, turning to and fro on each branch it lands on.

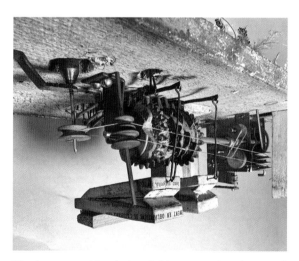

Wooden cams and the clockwork drive motor, viewed mounted upside down underneath the base. The thin cord is mounted on a fast-turning motor output for the twisted glass rod 'fountain' which sits in the brass ferrule. The two paper bellows are spring loaded to close quickly, which produces the rapid tweeting noise of a tree full of twittering birds.

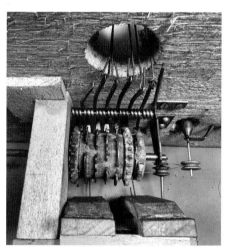

The one-piece wooden cam 'stack' is remarkable in its effectiveness and durability. Despite more than a century of use the wooden lobes are intact. This is due to the trailing followers being lightly loaded and the use of suitable lubrication. The green residue on the cams is old animal fat grease. The bellows blow whistles for the bird song.

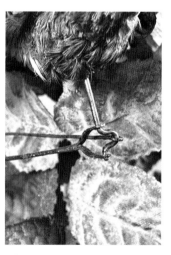

A fine wire gantry just 7mm tall supporting a tiny taxidermied hummingbird. The cranked support with its own wire 'puller' can turn the bird rapidly from side to side while the main support wire transports the bird from branch to branch. The extra level of continuous movement helps to keep the bird visible despite being cloaked within dense artificial foliage.

The drawings below explain pictorially the actual mechanism of both types of flitting bird. The drawings are by the late A.J.L. Wright and are reproduced from a 1998 edition of *The Musical Box Society Journal*. I much admire A.J.L. Wright's explanatory drawings of automata, as they always succeed in picturing the most complex mechanism in simple terms.

For the movement to be convincing it is important that the levers pause, then move very quickly when the bird 'flits'. To achieve this, springs are fitted to project the bird at speed once the cam has initiated the 'flit'.

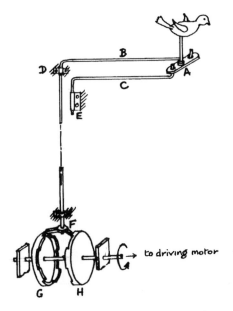

Two different types of flitting bird mechanism found in nineteenth-century automata. The first drawing shows the bird flitting and facing forward automatically at the end of each swing. The second drawing shows a separate cam and stirrup mounting for the bird which allows it to wiggle independently each time it lands.
(DRAWINGS BY A.J.L. WRIGHT)

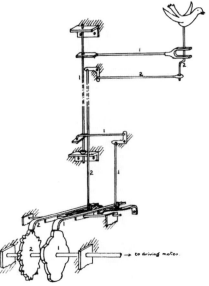

The bellows

The chaotic tweeting sound of the two bellows-driven whistles accompanying the sudden movement of birds in the foliage is very realistic when in good working order. The bellows on our singing bird bocage are covered in French newspaper and look to be the original coverings. Now split and leaking air, it is a mistake to think this is a failure of the material which is now 140 years old. I suspect the newspaper may well have lasted for the first eighty years before failing which matches the performance of most other materials. We replaced it with thin brown paper to keep the snappy, light action which is so important to the sound.

The whistles themselves are made of two square plates of tin for each whistle, with a small central hole. The plates are fixed either side of a hole in the lower wooden plate of each bellows, so giving a 5mm gap between them. The bellows have one pair of holes slightly smaller than the other, giving two tones to the 'tweets'. Surprisingly the whistles could not be made to 'sound' when trying to check their performance out of the bellows. The 'tweet' magically appeared only when re-covered with paper and supplied with exactly the right flow and pressure.

The action of this automaton might be thought of as quite a specialist one with limited appeal, but in practice automata makers found it to be a very popular subject. They produced many variations of the 'flitting bird bocage' in large numbers throughout the nineteenth century.

The bellows have been re-covered with new paper coverings and the whistles are 'peep peeping' with a surprisingly good volume when both opening and closing. The sound is generated by air flowing through two perforated metal plates mounted opposite each other on the bellows' bottom wood. Note that the upper perforated plate is not visible as it's inside the bellows.

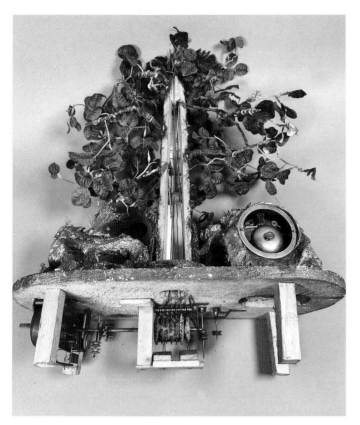

The mechanism is wonderfully organic in the way its control wires process up the trunk of the tree, dispersing movement to the flapping bird on the very top. The clock movement, visible on the right, strikes on a delicate silver bell and is completely independent from the automaton birds which are operated at will by a pull of a button.

The automaton described earlier is for a simple diorama with just two flitting birds, but the principle can be expanded for grander automata. This distressed example of a remarkable strap work bronze vase with clock and bocage of flowers was made by the master singing bird maker Bontems of Paris in the late nineteenth century. It promises to be buzzing with about a dozen animated birds, flitting, turning and dipping. When restored, the mechanism will activate on the hour with loud twittering from the whistles and bellows in the base; the birds nestled amongst the silk flowers on the top will spring to life in a display lasting for up to a minute. The birds are taxidermied hummingbirds with iridescent feathers that will catch the light as they pirouette and flit.

The drive motor for the bird automata is very large and is probably designed to provide hourly displays for the duration of the eight-day clock with automatic silence at night. The nineteen cams are stacked centrally under the mechanism and their corresponding control rods pass up behind the clock mechanism like a forest of steel tendrils, a demonstration of the lengths to which the principle can be taken if you have a big enough mantelpiece.

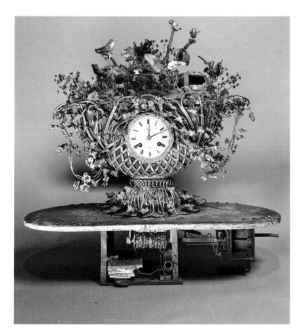

Awaiting restoration is this complex singing bird bocage sitting in a bronze strapwork vase. The height is 70cm and a dozen small birds are mechanised to flit about and move in the fine silk flowers that once adorned the top. The showy nature of this automaton is part of a long tradition of impressive mechanical singing birds that stretch back centuries.

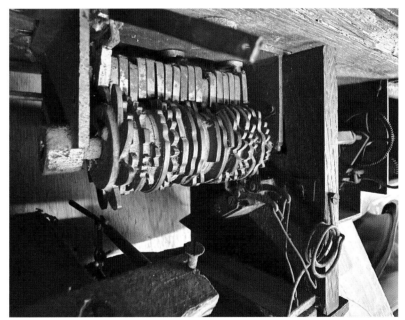

The large mechanism of the vase bocage is capable of powering the bird song and movement for short performances at hourly intervals over a whole week. This photo shows the impressive stack of nineteen individual cams and levers that animate the birds above. The far end has two rods descending to the bellows to pump air for the bird.

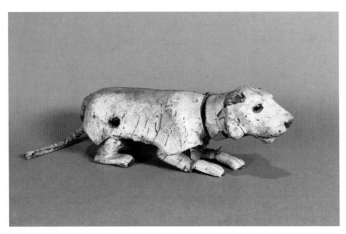

The Leopard, clockwork automaton by Roullet & Decamps, c.1880. A well-worn stalking leopard with papier-mâché body and big glass eyes. The leopard emits a low growl as he creeps along, hugging the ground and swaying his head from side to side. Using several imaginative features and a chain drive, this mechanism achieves an almost perfect feline stalking movement.

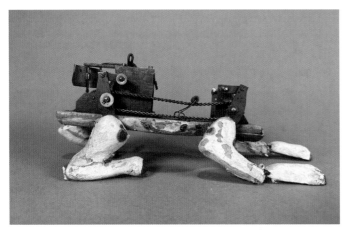

The mechanism mounted on a wooden base plate on which the legs are mounted. This mechanism is one of the highlights of my collection. I always demonstrate it with the body removed as it is so beautiful to watch. The purring of the fly whizzing and the simplicity of the chain drive linking the moving parts is mesmerising to watch.

THE LEOPARD, ROULLET & DECAMPS, PARIS, *c.*1890

True to the rather threatening title of this section the automaton described here moves with determined precision. The Leopard automaton's stalking action is perfectly described in motion by a sequence of mechanical linkages. The links are joined by a chain and feature the brazen use of an engineering taboo (described below) to bring it to life. It is wound by a key inserted into the side of the papier-mâché body. The clockwork movement is started by pulling out a button on the side of the Leopard. The button is on one end of a slim rod that slides out to release the fast-spinning air brake called the 'fly'. Immediately an intense purring noise begins as the fly reverberates within the fur-covered body and a determined movement of all four legs encourages you to place the automaton down quickly. The movement is strong and slow, rather tank-like in its forward progress. The correct sequence of alternate forward and back leg movement is accompanied by a rocking of the body from side to side. The creature hugs the ground as low as possible whilst lifting its legs in a relentless stalking motion.

Crawling and creeping: a mechanism for stalking cats that uses increased friction for gravitas and tension.

- Stalking forward
- Purring sound
- Head turning side to side

Forward motion

The Leopard uses a standard clockwork power unit positioned between the back legs. The rolling gait is achieved by a very short revolving crank extending from the mechanism at the animal's thigh. The cranks are offset by 180° so the left leg is forward when the right leg is back,

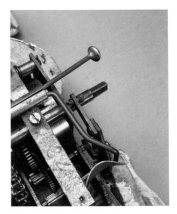

Detail of the leg mechanism. The short throw crank is just visible in this photo outside the upper plate of the mechanism and just inside the leg. It turns slowly with lots of torque. The circular motion of this crank lifts and lowers the leg. The fixed constraint at the top ensures the leg is moved forward at each circuit.

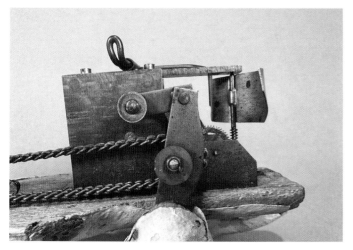

The spinning fly is attached to the steel spiral worm which is turned by the worm wheel whose pointed teeth are shown in this picture. The upper two links of the leg are simple pivots for the rotating crank (hidden) which is turning a sprocket within the loop of the chain. The chain is driving the front legs in unison.

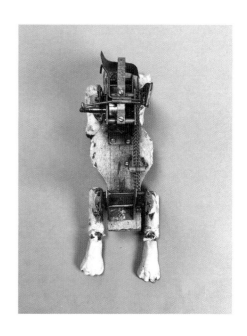

The ladder chain has been in use for more than 150 years and is an excellent way to transmit drive to all four paws with the minimum of friction. The noise of it running over the sprockets contributes to the sensation of growing tension. The layout shows the position of the mechanism as far back as possible to balance the head.

The chain tensioner ensures the front and back legs stay synchronised by preventing the chain jumping a tooth of the sprockets. The simple pierced wooden dowel rolls well, and its spring wire is coiled each side to increase its effective length for a constant pressure over tight and slack sections of the chain. It is a simple and cheap solution.

and vice versa. A double pivoted lever extends down into the leg and is constrained by the fixed lever pivot above. The rotary motion of the crank causes the vertical lever of the Leopard's thigh to rise and fall while the short lever pushes and pulls the leg forward and back, so the back legs crawl. For grip, two small nails protrude from each of the hind paw pads. The nails dig into the surface to push the Leopard forward. The rear paws push and lift alternately, providing all the forward propulsion for the automaton.

Front legs – chain and tensioner

Another maker might have used long levers to connect the rear legs to the front legs, but Roullet & Decamps had observed carefully how important it was that each of the legs lifted an even amount to give a realistic crawling motion. The front legs must also have the same rotary cranks to rise and fall, so an axle is mounted in a frame between the front legs with the required offset cranks.

To link the back and front legs a ladder link chain is used. The chain is stretched around two small sprockets just inboard of the front and rear leg cranks. This chain transmits the power from the rear legs (attached to the clockwork drive motor) to the front legs. The chain is set up on the sprockets so when the rear left leg is back the front left leg is forward and vice versa. It is important that the chain must not jump a sprocket tooth or the legs will get out of synch and the movement will look comically wrong. In order to ensure this does not happen the chain could be fitted tightly, but this would sap power. Instead Roullet & Decamps have used a loose chain and fitted a chain tensioner on the slack upper run of the chain.

The chain tensioner looks crude but is very effective. The tension is applied by a roller made from a pierced wooden dowel. The roller turns on a length of spring wire bent around the top run of the chain and is sufficient to maintain tension without stretching the chain. The spring wire is looped each side of the wooden roller to increase the effective length of the spring wire.

Front paws

As this Leopard moves forward, the viewer is disconcerted, not by something being wrong with the movement but something uncannily right. In nature, stalking movements are fascinating – the animal's riveted attention is focused on its prey and we can't help but watch. The automaton Leopard is the same, and this is largely to do

The springs in the wrist joints show signs of age. It is an unusual joint, allowing tremulous flexibility coupled with the rigid limitation of the internal cord within each spring. The wooden paws are bored out, creating a shallow hole into which molten lead is poured. It is then covered in leather, hiding the reason for its unnaturally heavy weight.

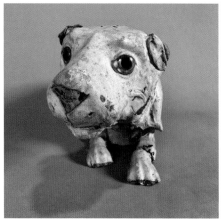

The head is turned in a very controlled way by being pushed and pulled by the rigid wire rod attached to the front right leg and the side of the wooden neck core. As the leg moves forward it pushes the head to one side and vice versa. The realistic glass eyes would have accompanied a black leather nose.

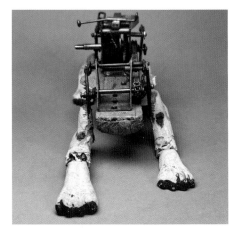

I was given this mechanism thirty years ago to break for parts as it was missing the body. It worked perfectly so I have used it in demonstrations ever since. It is incredibly popular. The head is also missing, and I had to add a piece of lead to the front to prevent him rearing up on his back legs.

with the unusual front paw movement. The wooden front legs have a special flexible joint at the first joint or wrist. The wooden forepaws are hollowed out and filled with lead. As the leg is lifted, the front edge of the weighted paw stays in contact with the ground and is pushed forward by the leg. This is a movement that is rare and mechanically 'taboo' for forward motion, engaging friction. Engaging friction is usually thought of as a brake or stop, like trying to push an umbrella along the ground point first. The leopard has plenty of power to sustain this motion which is kept on track by a relatively complex elbow joint. The elbow of the lead-weighted forepaws might be assumed to be a floppy loose joint at first sight, but is in fact a pair of brass springs inset into the wooden joint side by side. Each spring has a thin cord or string running inside it, which is secured into the wood at each end. They act as compact muscles and tendons, imparting a reactive liveliness to the forward progress.

I have repaired several examples of these joints in automata where the front paws are missing. The simple part is drilling and filling the forepaws with lead. This contrasts with the care and precision needed to make the double spring and string elbow joint. It is very important to the action to include the string within each spring and ensure correct lengths of both. The whole of the papier-mâché body and wooden limbs are covered in a thin leather with short fur pile, adding to the realism.

The head turn

As the body rocks from side to side at each step, the head moves right and left to counterbalance the Leopard. This is achieved by a wire rod connected to one side of the wooden neck core. At the rear, the wire is attached just forward of the hip joint on the right front leg. As the leg moves forward the head is pushed to the left and drawn back again as it moves back. The linkage is all hidden within the papier-mâché body, and overlapping fur covers the gap at the neck joint.

Other applications

This specialised mechanism portrays feline stalking behaviour and achieves its lifelike quality by adding mass in the form of lead-filled cavities to the front paws. The principle is useful in automata that drag or push limbs or objects. Adding weight is also useful in finger tapping or foot stamping automata, the extra mass of the hidden lead replacing the muscular effort of the living example.

Perhaps the most valuable transferable lesson from this automaton is that of 'rule breaking'. As a horologist (clockmaker) I am acutely aware of friction. A large part of my formal training was concerned with reducing friction to allow clockwork to run for a week or more. The discovery that deliberately causing engaging friction in the front paws of this automaton produced such a lifelike movement was a surprise to me. The Roullet & Decamps Leopard demonstrates that designing a lifelike mechanical movement is not just about sound engineering but also imaginative 'rule breaking'.

CAT, ROULLET & DECAMPS, PARIS, c.1910

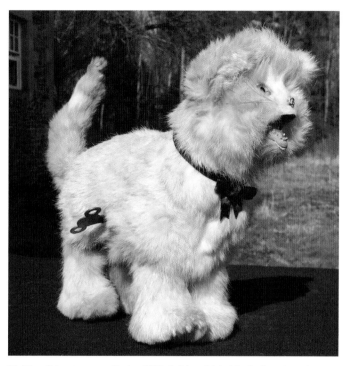

With a coat of soft white fur and green glass eyes, at first sight this automaton cat appeals on a sweet and cuddly level. Then the doubts creep in: 'Why the piercing stare, the white teeth?' and my favourite, 'Is it real cat fur?' The automaton is actually covered in rabbit fur, which is somehow thought to be ok. The satin ribbon and sometimes even a jingly bell serve to reassure the unnerved viewer that all's well … until it starts to move. The makers Roullet & Decamps are having a great game with us, but they are also showing off. The cat has one particularly outstanding movement and that is the curl and flick of its tail.

Wound by a key inserted into the side of the body, the movement is started by pressing down a lever protruding from the cat's bottom. Immediately the cat starts to purr as the mechanism whirrs inside the papier-mâché body and simultaneously the legs begin to move at pace. Once placed down on its feet it sets off on a stiff-legged walk. The tail then curls slowly over the top of the cat's back and suddenly flicks down straight again. Every few steps forward the flick of the tail is accompanied by a long, languorous 'Miaow'. There is something very realistic about the tail's action and that is due to the mechanism that curls it from its tip first, rather than its base.

A mechanism for the curl and flick of a cat's tail that can be adapted for the curl of the elephant's trunk or even the beckoning finger of the human hand.

- Tail curling from the tip
- Walking forward
- Mouth opening
- Miaow sound

Walking Cat automaton, Paris c.1910. At 30cm high this clockwork cat is nearly life size. It's great fun to watch walking, but its unique selling point is the movement of the tail. It is long and fur covered, and curls up slowly accompanied by the sound of a loud miaow before suddenly straightening with a flicking downwards motion.

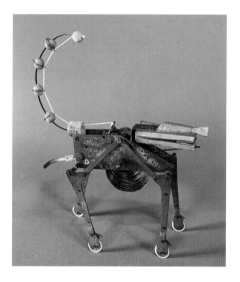

The cat mechanism will wind up and work without the body in place. It is a fascinating mixture of materials, shapes, movement and sound. As it walks along, the dramatic scorpion-like curve of the tale flies back like a whiplash, accompanied by the plaintive note of a long miaow. The paper-covered bellows and horn are original and still working.

The progressive muscle contraction in the tail is replicated using string, a gently tapering spring and a set of wooden balls.

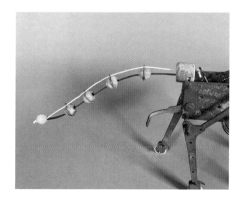

The string is tied to the pull lever at one end and to the last ball of the tail at the other. As the lever pulls, the curve begins at the tip of the tail and curls up over the back of the cat. The whole tail assembly is covered in a long sleeve of white fur, completely hiding the mechanism.

Tail: curl and flick

The tail is curled by a wire lever pulling a string that is attached to the tip of the tail. The string runs through a hoop on each of six wooden balls spaced equally inside the length of the tail. The string is fastened only to the final ball in the tip of the tail which therefore curls first. The balls are pierced with a 5mm hole, and a steel spring passes through the middle of each ball which is locked in place with two tapered wooden wedges. The tempered steel spring is gently tapered to the tip; this is important as it is the feature that ensures the tail curls from the tip first rather than the root of the tail. The string passes through the wire guide hoop on the top of each ball. The wooden balls are grooved for this wire hoop which is kinked to provide the hoop for the string to pass through. This sounds complex but in reality it is simple to make and reliable in operation. The balls can be grooved by hand file and the wire is shaped and then secured by a short twist underneath. The string enters the main hole in the final ball (tail tip) and is secured by the wedges fastening it to the spring end.

What pulls the string?

There is a vertical wire lever that pulls the string evenly and slowly before releasing it suddenly. Let's call it the 'curl lever'. This lever has its own arbor and a separate projecting rod acting on a drop-off cam. In a rather economical (and effective) fashion, the cam is simply a stubby pin projecting from the face of the largest gear wheel which pivots the lever backward to pull the lever. There are in fact two pins on this wheel at 180° to each other protruding from either side. The resting pin on the opposite side lifts and

drops a small sprung bellows which makes the 'miaow' sound. With perfect timing to attract attention the 'miaow' occurs fractionally ahead of the tail flick by virtue of its shorter lifting lever. (*See* the section on Sound with more information in Chapter 3.)

The movement of curl and flick is startlingly real and, coupled with the well-timed miaow, would instantly seduce the viewer who would forget the somewhat clumpy walk action. However, the ball and spring tail is fragile and will break when bent at 90°. The fur absorbs and holds moisture; eventually it rusts the steel spring to weaken it and the wooden balls can split. This is good for the repairer who has regular work to repair them but a lesson for the maker when mixing materials.

Other applications

Just as the cat captivates the viewer with the unexpected curl and flick of its long tail, the same enigmatic curling action can be used in other jointed members. In modern animatronics it is known as a type of 'cable mechanism' and can be used either side of a spring material to cause a tail to sway side to side. One of the most impressive variations of this mechanism dates from 1774, the life-sized Silver Swan currently on display in The Bowes Museum in the UK. The Swan neck curls downward, sways side to side, darts down to 'catch' a fish and lifts its head up high. The

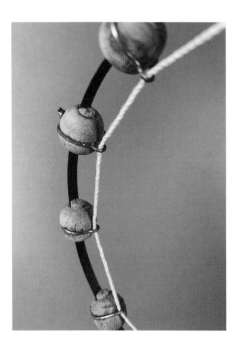

The balls are secured onto the tapered spring with wedges made from split dowel and pressed in above and below the flat spring. This is to keep the spring centred and flat. The spring is actually quite fragile and will break if bent at too sharp an angle. Note the rust induced by moisture wicked in by the fur covering.

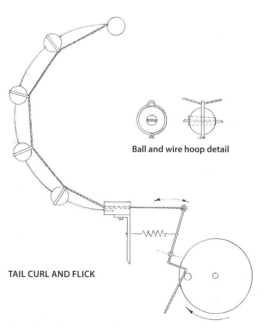

Ball and wire hoop detail

TAIL CURL AND FLICK

The tail mechanism is pulled by a very simple bent wire lever pivoted at its centre and fitted on an arbor between the main movement plates. The wheel peg that pushes the lever over contacts the slope of the lever and pushes it away before reaching the corner and dropping off. This causes the tail to immediately fall back down.

neck movement is achieved in the same way as the cat's tail but using five fine chains and brass pulleys instead of balls, and because of the weight of the heavy silver neck and head, sliding counterweights.

The following variations of much simpler automata show just how effective an imaginative application of the principle can be without resorting to the complexity of the Silver Swan.

Elephant's trunk

The Walking Elephant automaton by Roullet & Decamps uses an almost identical ball and string method to curl the elephant's trunk with one significant difference: the pulling lever rides down the slope of a cam rather than dropping off a pin. There is no need for a sudden flick. The gentle cam slope gives an even curl/uncurl action which is more in keeping with the correct movement for a trunk.

Finger

To beckon with a slow curl of a finger on the upturned hand, the internal string is attached to the fingertip which will curl first. The finger could use gravity instead of a spring when beckoning with finger upwards.

Sit-ups and press-ups

To conclude this section, mention must be made of a contemporary automaton that uses this principle in the most elegant way. Paul Spooner's Sleeping Musculature uses a captive string looped around an offset wheel to produce the pull and release. The fine cord goes up through the base and into the jointed figure at the hips and is only fixed at the front of the neck joint.

The first part of the pull lifts just the head, the second part raises the upper chest and arms, and the final part lifts the stomach. At each of the three stages friction and effort increase just like in a well observed real sit-up. As the figure lies down again the sequence is reversed, with the head the last part of the body to unfold as the internal string goes slack.

The foreground figure doing press-ups, Mens Sana in Corpore Sano, is again operated by a pull string in the base which pulls and releases smoothly a lever just visible between the feet and fixed at right angles to the legs. The hips, shoulders, elbows and wrists are all connected to the legs, which are the only parts directly lifted by the mechanism.

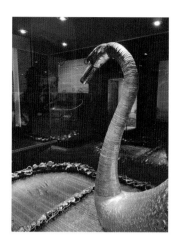

The Silver Swan in the Bowes Museum, England, is an eighteenth-century example of a sophisticated cable control mechanism using five fine chains. The neck can turn and bend in any direction using a similar principle to the cat's tail mechanism. The neck is covered in overlapping silver rings which allow complete flexibility for it to preen and catch fish.

Elephant automaton, Paris, c.1880. This clockwork walking elephant flaps his ears and gently curls and uncurls his trunk. The mechanism is similar to the cat's tail but uses a set of cardboard rings inside the leather trunk. The leather covering makes this automaton difficult to repair as it is nearly impossible to remove and replace the leather without damaging it.

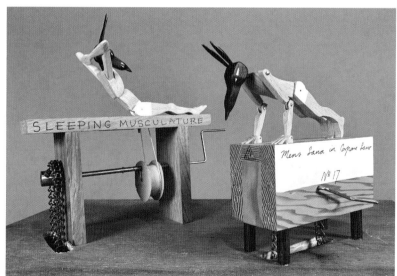

Sit-Up and Press-Up Anubis, 2002. Design by Paul Spooner, made by Matt Smith. This is at first sight a very simple automaton. The small details of the movement that are so human seem like mechanical accidents, but in fact are trains of movement resulting from the simple pull and release of a string when the handle is turned.

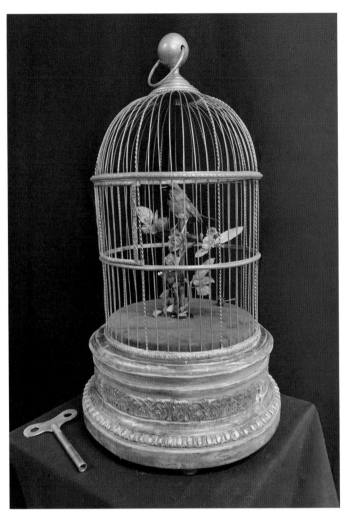

Singing Bird in a gilded cage. This mechanical bird sits on its flowery perch and sings, continuously powered by a clockwork mechanism hidden in the base. There were many variations, including two- and three-bird versions as well as birds positioned amongst the foliage on artificial pot plants or completely freestanding birds with the mechanism contained completely in the body.

Hero of Alexandria. A 2,000-year-old design for singing birds that sing in sequence, pneumatically powered by compressed air. Water fills the upper cistern of a stack of four, compressing the air above it and sounding the whistle before it empties by siphoning into the cistern below it, sounding the next bird in turn. Described in Hero's manuscript *Spiritalia*.

BIRDSONG

For over a thousand years, mechanical singing birds have been entertaining their audiences. In gilded cages or popping out of tiny boxes, they were favoured as an expensive gift for sultans, emperors and kings. In the eighteenth century the Chinese emperors and officials called the automata and clocks brought to them as diplomatic gifts 'singsongs', so popular was the singing bird. Early examples pre-date clockwork and were powered by weights or water wheels. A rising water level within a closed cylinder will compress the air trapped above. This air could escape out of a whistle at the top, producing a single note. Several whistles could produce a variety of notes. A rotating pinned cylinder could turn on and off the air flow to these whistles and so produce a melodic birdsong. Hero of Alexandria published designs for automata birds working on this principle nearly two thousand years ago.

Around 1785 the sliding piston whistle was adapted for use in singing birds. Its variable pitch enabled the use of a single whistle for all the notes; it also acquired the ability for the musical notes to slide into each other. This is a much more realistic way to portray the sound of birdsong. As well as dispensing with the need for multiple pipes it enabled miniaturisation in the form of the new 'snuffbox' birds.

The mechanism I will describe here is a good example of a refined design for birdsong developed by Blaise Bontems, who worked in Paris in the nineteenth century, perhaps the finest maker of mechanical singing birds. It is a relatively complex mechanism but the principles on which it operates are quite straightforward when taken individually.

SINGING BIRD IN A GILDED CAGE, BONTEMS, PARIS, c.1880

A brightly coloured bird sits on a perch amidst a bloom of silk flowers and leaves. His perch is in the centre of a beautiful golden cage with an ornate gilded wooden base. The key winds the clockwork mechanism and the life-sized feathered bird opens its beak and begins to sing. The bird turns to and fro whilst singing loudly, looking from side to side. Both the beak and the tail move as it sings.

Mechanism for the production of realistic birdsong.

- Birdsong
- Beak movement
- Tail movement

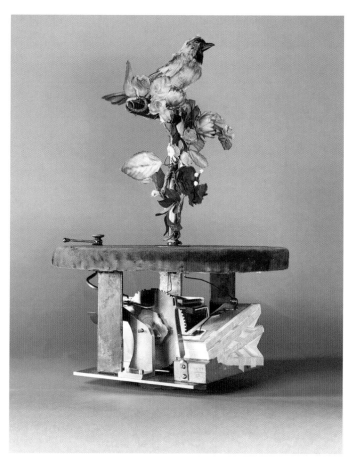

A perfect automaton? This 130-year-old bird is still full of life and singing beautifully amidst wax-coated silk flowers. With the cage and gilt wood base removed, the mechanism can be appreciated as one of the most compact and interesting applications of clockwork. The control systems are fully integrated into the drive motor, which also pumps the bellows.

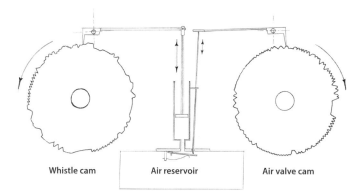

Whistle cam Air reservoir Air valve cam

Whistle and air valve cams are usually fixed together, side by side, but are shown here separated, opened like a butterfly's wings to illustrate their different functions more clearly. The lever followers have nibs of hardened steel that follow every contour, dip and hollow of the revolving cams. The air valve is shown pushed open, allowing air into the whistle.

THE SECRET

There are four ingredients necessary to get the bird to sing:

- A whistle with a sliding piston to vary the note.
- A valve to turn the air supply on and off (the beak is connected to this valve, so it opens whenever air flows).
- A three-chambered bellows to supply air at constant pressure.
- A clockwork motor to supply the power.

The mechanism

The sliding whistle

The air valve opens and air rushes into a small brass 'swanee' whistle, sounding a note. A piston in the whistle tube can slide up and down. This varies the tube's effective length and therefore the pitch of the note played. The piston's movement is controlled by a cam and lever which can move rapidly, stopping and starting the piston at any depth and sliding it between notes. The sound produced in this way can imitate the beautiful song of a nightingale perfectly. The air valve is at the bottom of the whistle assembly; it can be thought of as a tap, metering out the flow of air as well as shutting it off completely. The air valve has its own cam to control it, as shown in the drawing above. For birdsong the valve must open and close smartly when required, sealing perfectly when closed, if it leaks, then a continuous background drone can ruin the song. The flow of air is of course synchronised with the position of the piston (the notes).

Sliding whistle and its air valve. Shown removed from the bellows, my finger is pushing open the air valve to just lift it which would allow air to enter the whistle. Note the closure spring and the angled stop bar to prevent pushing it open too far. The slim piston is lightly barrelled to accommodate axial movement within the whistle.

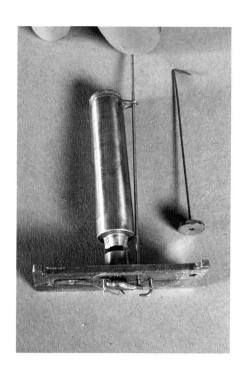

The bellows

For the whistle to sound correctly and clearly, the air supply has to be constant and supplied at an even pressure. This is achieved by a triple bellows assembly consisting of three separate air chambers, each one a miniature version of the traditional 'V' shape fire bellows. The three chambers are all joined together, back-to-back. Two chambers are 'pumpers' drawing in air and pushing it through to inflate the 'reservoir' chamber. A spring compresses the reservoir gently, ensuring air is available to the whistle at a steady pressure at all times. The two pumping chambers

ensure the reservoir does not run out of air when one is on the intake cycle. The three-chambered bellows design is very successful in delivering constant air pressure and has evolved little over the last 150 years – the main changes being the covering of the bellows which now use a rubberised cloth, and the use of plastic disc valves instead of paper flap valves (both of which are debatable as improvements). The mechanism described here is a traditional one dating from 1880 by Bontems of Paris. It uses a thin Zephyr skin (animal intestine) covered bellows with card stiffeners to prevent blow outs and internal paper flap valves.

The airways inside the bellows connect the pumping chambers to the reservoir chamber, which in turn feeds a steady supply of air to the whistle air valve. All these air passages and chambers have their own one-way flap valves. The valves are all made traditionally of paper, cut in the shape of a lollipop, fastened by gluing the stalk. The exception is the whistle's air valve, which is a flap valve made of thin brass. There are four paper air valves which must open and seal closed perfectly.

The covering for birdsong bellows is traditionally leather. This varies in thickness depending on the size of the bellows. The bellows shown below is stripped of its coverings and new Zephyr skin has been carefully marked out prior to cutting out and fitting.

The compact three-chambered bellows is built on a fine-grained wooden frame. The whistle and valve are mounted on the front above a shallow air chamber in the base. On top is the 'spill valve' whose job is to prevent over-inflation of the reservoir chamber by tipping up when its tail lifts too high, 'spilling' the air out.

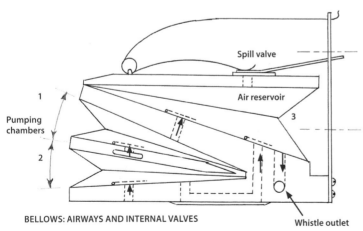

BELLOWS: AIRWAYS AND INTERNAL VALVES

The two pumping chambers have a reciprocating centre board which is lifted up and down by the clockwork mechanism. The pumpers (1 & 2) are connected by drilled airways to feed into the air reservoir (3). The airways are opened and closed by internal paper flap valves. The reservoir supplies air under pressure to the whistle which attaches over the outlet.

Small bellows are covered with Zephyr skin (made from animal intestine membrane) just 0.08mm thick. Larger bellows can use tanned leather up to 3mm thick. The stripped bellows in the background show, both pumping chambers' air intakes, a hole and a side slit, the cross restraint above the internal air valve, and the top hole for the spill valve.

Air valves

Paper flap valves shaped like a lollipop are used to permit air to enter the bellows. A tiny spot of glue on the stalk allows the disc of the 'lollipop' to float freely over the air entry hole. Under vacuum they open and under pressure they seal. The valves allow the air to be pumped to the whistle via the reservoir. The paper valves are restrained from being blown open too far by a loose cross of paper straps over the circular end; these also increase the surface area to aid closing as the bellows chamber evacuates into the reservoir. It seems extraordinary that such a low-tech simple paper valve can become airtight under low pressure but the finest makers in history used this method in their gold and bejewelled bird boxes. When carefully made, paper valves perform extremely well, working snappily and efficiently at low pressures.

There are six valves used in the triple bellows assembly, with only one – the spill valve – accessible on the top. As a restorer I have to be calm, relaxed and exact in replacing the internal paper valves; confidence is required to achieve the necessary free play and smooth seatings. When the bellows is finally finished and sealed, I can fit the whistle. If just one internal valve is leaking a tiny bit of air, then the whole bellows covering has to be removed to repair it.

Cams and levers

The contours on the edge of a singing bird whistle cam are visibly different to most automata cams. Rather than moving smoothly up and down, they jump up and down discrete steps corresponding to the notes of the bird's song. These steps are small, less than 1mm, so the lever and follower are slender and light which makes it possible to read the steps rapidly. The lever is also pivoted very close to the cam, enabling a large magnification of the movement at its opposite end, a 1mm step typically magnifying to 3mm at the piston. Therefore, if a jump of a whole octave is 7mm at the cam, this would cause the whistle piston to move by 21mm using these dimensions.

There are a total of three cams and three levers:

1. The whistle cam, which alters the piston position in the whistle (notes of the whistle).
2. The air valve, which opens and closes the supply to the whistle (also beak open/close).
3. Bird movement, turning to and fro.

The three cams are synchronised correctly and then fixed in position side by side. They combine song and movement perfectly as they revolve together. The rotation of the

Bellows air valves. Paper flap valves shaped liked lollipops and made of ordinary cartridge paper are shown here removed, and also fitted in position inside an air reservoir. A loose strap stops them opening too far and helps them seal. The brass disc valve is used in modern singing birds; it uses a captive floating disc to seal the hole.

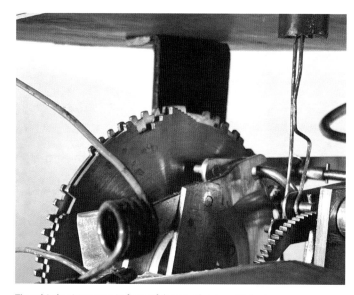

The whistle piston cam in front of the air valve cam. At the top you can see a set of eight rising steps corresponding to an ascending trill of birdsong. Behind the steps the air valve can be seen kept open for the trill and then closed and opened three times after the trill ends for three descending notes.

cams moves the piston inside the whistle, sliding it up and down for each note. The air valve cam opens and closes the air supply correspondingly or leaves it open between notes to give a sliding glissando. The air valve cam is also connected directly to the beak of the bird; in this way the beak opens and closes at the same time as the air valve, cleverly ensuring perfect coordination between the sound heard and the beak movement.

There is another superb function I have not space or remit to fully explain in this book but I can't resist mentioning it: intermittent birdsong. Most Bontems birds,

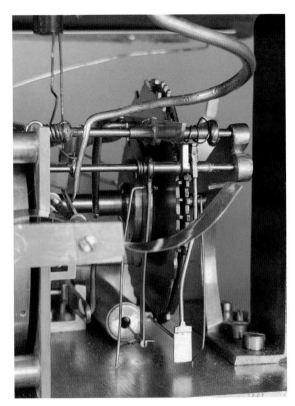

The levers and cams. The paddle at the bottom is attached to the lever whose 'nib' is reading the air cam above; the paddle taps the air valve rod to open and close it. The whistle piston rod lever is connected to its cam follower 'nib' by a short brass tube. Note the two wire return springs for both levers.

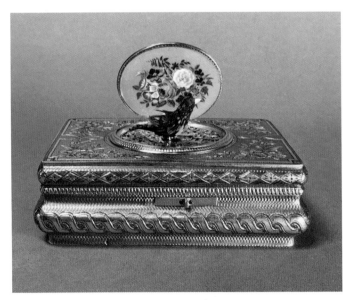

These expensive marvels are incredibly seductive gifts. They pop up and sing beautifully and often have a compartment in the back ostensibly for snuff, but when selling them I used to say, 'for a dedication to a lover'. Note the pierced grille to let the sound out and the bird-shaped trap door that allows the lid to slam shut.

including this one, are fitted with it. It allows the bird to sing a short phrase of birdsong then pause, motionless, for up to two minutes … before suddenly bursting into song again. This repeats, prolonging the whole performance to perhaps twenty minutes long on one wind. It achieves the pause by using a feedback mechanism that depends on the slow leakage of air from the inflated reservoir chamber. This collapsing bellows eventually trips a lever to restart the mechanism. It requires an additional notched cam and lever to select complete phrases of birdsong by dropping into the cam notch and stopping the mechanism at a point when the bellows is also full. The long pauses make the whole thing much more bearable to listen to.

The singing bird mechanism has been refined over 2,000 years and perfected in the last 250 years to that described above. The sound is far more vibrant and realistic than any electronic recording of birdsong. It is like sound from a live orchestra, just one small step away from the sound of the living bird itself. I restored a modest Bontems bird cage a few years ago and uploaded a video of the mechanism to the Internet. Thousands of people agreed that the sound fits the video's title: 'The Finest Bird Song of 1890'.

Other applications and variations

Singing bird boxes
The smallest form of mechanical singing bird produced in significant numbers is the Singing Bird Box, also known as a tabatière or Snuffbox bird. It is a small box measuring approximately 80 × 50 × 25mm that fits comfortably in the palm of the hand. These often precious metal boxes have a small oval lid in the centre of the top which flips back and a tiny (15mm in length) feathered bird pops up. The bird sings, flapping its wings and moving its tail and beak whilst turning to and fro rapidly. At the end of the song the bird quickly falls down into the box and the oval lid slams shut.

The secret as to how these birds are made is that the mechanism is wrapped around and over itself to fill every single space within the box; it is literally packed full of mechanism. The mechanism consists of the same elements of a full-sized singing bird in a cage. They are usually of precious metal adorned with enamel scenes or sometimes tortoiseshell with silver mounts.

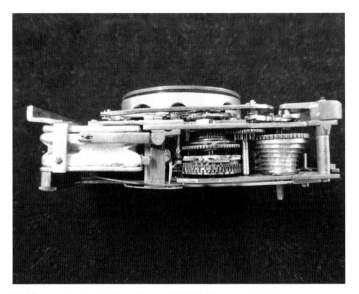

Bird box mechanism by Bruguier, c.1830. This fine example is far more complicated than the Bontems-style bird described above. It has a fusee to even out mainspring pressure and a cam stack that elevates to play a series of cams in succession like a juke box. The bird moves its beak, tail and head, and flaps its wings.

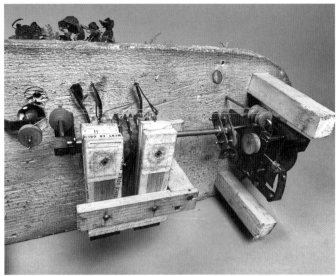

Bird twittering sounds are produced by this pair of reciprocating single chamber bellows sucking and blowing air through two metal whistles in the bottom of the bellows, their levers each with their own cams. The original covering is newspaper which surprisingly will last many years before splitting. This mechanism and automaton is fully described on page 68.

First appearing in the 1780s after the advent of the piston whistle made ranks of pipes obsolete, singing bird tabatières have been in continuous production to the present day. An expensive luxury item, they have an almost universal appeal – everyone who sees the little bird pop up and perform its beautiful song is impressed. Not least because when the lid slams closed it seems as if the bird must be squashed by the lid. The grille underneath the bird actually has a bird shaped aperture in it, this aperture is imperceptible as it is closed with a bird-shaped trap door. The door automatically lowers to accommodate the bird's body at the moment the lid closes and quickly rises again when the bird pops up.

Making singing birds in this small scale is very difficult, although I am hesitant to say that, because I once advised a jewellery maker in the USA who was enquiring by email that they were 'probably too difficult for him to make.' He promptly went away and produced a range of beautiful singing bird boxes, having taken my advice as a challenge.

Twittering flocks of birds
There is a much simpler mechanism for reproducing birdsong, but unfortunately it is more cacophony than melody. However, it does perfectly suit the sound of a large group of twittering birds all singing together.

It is used in tree dioramas with several moving birds flitting, turning and twisting in the branches. The sound is a gentle chaotic series of peeps and tweets produced, at a fairly low volume, by a pair of single chamber bellows. Each of the bellows whistles when they suck and blow air through a small hole in a pair of adjacent metal plates. The plates are stuck either side of a large hole in the baseboard of the bellows. The holes in the metal plates are slightly smaller on one bellows than the other, making a higher pitched whistle. They are opened and closed by a pair of notched cams turning quite rapidly. The notches are unequally spaced so producing a random sound effect of overlapping discrete whistles.

The singing bird, whistling a simple melody, is probably the most popular automaton subject in history. It is universally acceptable even to people who are normally scared of automata. I have demonstrated automata to the public for many years and there is a significant number of people whose response to an exhibition of 'normal' automata is 'creepy', 'nightmare fuel' etc., but to the automaton singing bird they soften into 'oohs' and 'aahs'. If a little hesitation is still perceived, I produce a small singing bird box; its ability to melt hearts is magical.

THE NATURAL WORLD

This category of automata is one of the most interesting, and for me is essential in picking up important subject matter that would not fit elsewhere. Hence the rocking ship can be featured in the 'water' section. It cannot be left out as it is one of the most relaxing and effective movements of any automaton. The windmill (*see* the section on 'wind') has always swept the skies with revolving motion and is a common way of introducing movement into a static landscape. There is a surprising variety of automata I could have included here which are to be found in different sections; for instance, sand power (gravity) defers to its acrobat subject and is in Chapter 6, Entertainment. So please enjoy this journey into the natural world, with its descriptions of the double compound pendulum and the menagerie that is packed into the Speaking Picture Book.

WATER

This element covers 71 per cent of the earth's surface. It is no wonder then that it features so often in automata and mechanical dioramas, from a single fountain to a raging sea. Water is depicted spouting, flowing, trickling and cascading. There have been some 'clunky' mechanisms used to depict water which show that it has always been a challenge for automaton makers to get right. Different creative solutions have been tried, varying over time, like fashion, some surprisingly effective in giving the illusion of water. The solutions fall into four main types:

- Waves: moving paper or silk crumpled to simulate waves.
- Lakes and ponds: static water, represented by glass mirrors or polished steel.
- Flow: the use of twisted glass rods in diverse arrangements.
- Modern wave machines: undulating wooden slats.

The last three are explained in detail in the second half of this section, but we shall start with what is, in my opinion, the most effective of the nineteenth-century representations: the mesmerising rise and fall of a three-masted sailing ship on the heaving waves of a very stormy sea – waves.

ROCKING SHIP ON A STORMY SEA, PHALIBOIS, PARIS, *c.*1870

A feature of the fashionable Victorian home was multitudes of decorative objects, cluttered onto sideboards, tables and mantelpieces. As many things as possible on any horizontal surface. The glass dome was very popular as a dust-free enclosure for arrangements of shells or preserved flowers and if you could afford it, an entertaining musical diorama. If you had run out of space these could also be purchased as dioramas within glazed picture frames with box backs to hang on the wall. The most popular of all these miniature scenes was the depiction

- Waves heaving up and down
- Ship motion: pitch, roll and yaw

Rocking Ship diorama by Phalibois, Paris, *c.*1870. The captive ships rise and fall on a visibly heaving sea as the music plays. The music box and its simple linkage that drives the ships are hidden under the waves in the base. The Victorians always called domes 'shades' and this splendid example is slightly ovoid, a sign of its age.

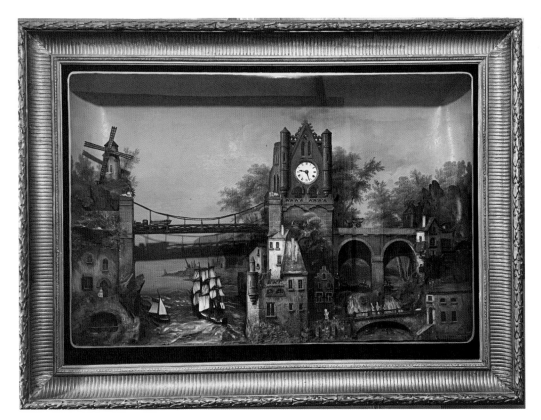

Rocking ships feature in these popular nineteenth-century picture frame or shadow box automata, designed to hang on the wall. This clockwork musical example dates from *c*.1890 and features two rocking ships on a sea of painted paper. Other movements include a clock, slow and fast trains, a windmill and even a herd of deer running in the woods.

Usually a ship will be lifted up and down by the sea on which it floats but the Rocking Ship reverses this relationship:

- The ship is glued to a bracket just under the surface of the sea; it pulls and pushes the crumpled paper as it is moved by a special linkage.
- The levers connecting the mechanism to the ship are loosely jointed, allowing the ship to 'fall' side to side and forward and back as it rocks.

of a ship on a stormy sea. Sometimes the seashore would rise up to a windmill with turning sails, or a tower with a soldier walking round and round on the top. There might be a river running into the sea with a bridge, over which a train or a line of people process. The size of dome and number of complications might demonstrate the wealth and wisdom of the owner but most memorable of all seems to be the ship itself, rising and falling on the stormy sea as the tinkling music box plays out of sight beneath the waves. The reason for the popularity of the Rocking Ship diorama is obvious to all who see one working, it looks incredibly realistic. Its movements are both hypnotic and almost inexplicable. Happily, the secret to this motion is also quite simple.

How it works

The paper sea

Key to the illusion and an important support for the ship, is the paper sea. The rolling movement of the ship relies on the stiff crispness of painted tissue paper for a damping effect.

To be effective it should have numerous waves of all sizes. The paper folds that make the waves can even be quite large and will stay creased despite the gradual opening and closing by the mechanism that gives it its movement. These high folds are foaming white crests and are picked out in white paint to attract the eye. An expert painter can even paint the wave troughs in a darker blue/green shade to heighten the perspective even more.

Although this is not intended as a 'how to' book, a brief description of how the sea is made will help in explaining the unusual contribution the paper sea makes to this automaton. We have restored many of these seas, as they are torn, not by a hundred years of wear but by attempts to access the mechanism for repair. The seas are glued all around their edges, effectively sealing the mechanism in the base of the glass dome, so they have to be torn to provide access, which means a total replacement of the sea is a common repair.

The paper sea. In this example with two ships that alternately rise and fall, the sea is relatively large. It is painted, before fitting, a dark blue to denote the depth of mid-ocean. After fitting, the folds are set in place and the top of each is painted white to denote the foaming crests of the waves blown by the wind.

The Rocking Ship. For realism the tiny flags fly towards the sails with the wind, not trailing with the speed of the boat, a mistake I made with my first restoration. The rigging ladders are easy to make by wrapping thread around a card vertically then horizontally, gluing the cross points and trimming with a scalpel into fine tapered ladders.

A good quality, strong tissue paper four or five times the area of the desired sea is prepared by painting it a dark green or blue to provide a base colour for the sea. The waves are then formed by crumpling the tissue paper into a tight ball in the hand. It does not seem likely to be successful but the tighter the ball is scrunched up in the hand the more complex and realistic the resulting waves tend to be. The crumpled ball of paper is then stretched out just a little and fitted over the mechanism to the edges of the base while still in a very crinkled state. The new sea is then glued around the edges to the wooden base of the dome and shoreline, if it has one. The mechanism can now be operated before the ship is fitted to check the movement of the crinkles (waves). They should rise and fall, opening and closing without any sign of flattening or tightness around the edges. Central on the sea and now underneath the paper should be the surfboard-shaped wooden stand for the ship. The ship is then located on two pegs that come out of this stand, perforating the sea, and into the flat bottom of the hull of the ship. The pegs are often just a tight friction fit and they sandwich the sea between the boat and its wooden stand. As the stand is lifted and lowered by the mechanism, so is the sea, moving the crinkled waves up and down like bellows. The effect is unnervingly realistic with movement of every wave and realistic movement of the ship in all directions, and of course, it's all done to music.

The ship

The ship is a fine model three-masted sailing ship, made of wood, with paper sails and fine black thread for the rigging and ladders. It is important to note that whatever the type of ship or boat featured in the automaton, some sort of mast, flagpole or even a fishing rod is included. This is not just for decoration: the extension upwards greatly amplifies the movements of the hull (the pivot point) and a flag or finial on the top will also help catch attention as it sways. The use of a bowsprit pointing forward can also amplify the perception of movement. The mounting of the ship is onto the two wooden pegs that extend out of the sea from the ship-shaped wooden platform under the surface. Usually the mounting is high above the level of the shore or edges of the sea, raised up so the mechanism can lower it a good distance downwards into the troughs. This rise in height of the sea at the ship is not a cause for concern, as it does not seem to affect the perception of realism – it even seems to focus the attention onto the ship, as if it's on a particularly high wave crest.

The mechanism

The clockwork drive for the Rocking Ship is of an unusual type. It does not have a dedicated drive motor with a separate music box mechanism like the majority of French automata. Rocking Ships, with the odd exception, almost always use a small 'snuffbox' size music box movement to both play the music and power the ship. The small mainspring of the musical movement works hard to power the automaton as well as the music via an extension shaft from the pinned music cylinder. This has the advantage of

The mechanism. The circular motion of the wooden pulley is converted to the rise and fall of the ship by the metal strap and a simple wire restraint stapled to the base. The ship's wooden mounting plate with two pegs overhangs the mechanism to bring it to the centre of the sea. The white cord drives the windmill in the tower.

Twin ship linkage. The music and drive motor has been removed in this picture but the pulley it rotates is still connected. The rotary action imparted to the pulley, at the lower right corner of the parallelogram, transmits a rocking action to the side members; this causes the ships to pitch and toss as well as rise and fall with each rotation.

The ship and the paper sea under it are joined to the revolving pulley by a metal strap that moves up and down as well as forward and back to cause the ship's rising and falling stern and prow. With loose linkages at the joints, the range of movements are a combination of up, down, forward, back and side to side.

being very low for mounting unobtrusively under the sea in the thickness of the base. The motor is wound, not by a key, but by a pull cord emanating from a hole in the side of the base. The advantage of pull cord winding is that there is no need to remove the fragile dome to wind it up. Inside the base, the winding cord wraps around a wide but thin pulley riveted to the winding square of the mechanism.

The ship's motion is usually achieved by a form of parallelogram linkage. The vertical member of one side of the linkage extends up to the sea and on the end the ship is fitted. At the lower end it is driven by a pulley, up and down and round and round, revolving from the music box. An additional horizontal member extends out sideways to be loosely fixed to a vertical stand where it constrains

the ship's mounting. The motion given is rather like a lazy horizontal figure of eight described by the bow and stern of the ship. The drawing shows a simplified version using a curved tie bar for the horizontal link which helps to explain the motion in a visual way. What is important to remember is that the motion is not just imparted to the ship itself but to the whole paper sea which is fixed to the underside of the ship.

It would be normal in a machine like this to make sure the linkages under the ship are riveted together tightly enough to allow free movement but with no excess play. Loose joints introduce 'sloppiness' and imprecision to the action. The rocking ship is different, because the paper sea plays a part in supporting the ship, side to side and forward and back. I have found that the most successful rocking ships have loose joints throughout. The complex and unpredictable interaction of a real ship with the sea is similar to the way the crumpled paper waves support the ship as it rises and falls. The movement is haphazard and changeable due to the complex folds, which will give it a very realistic series of jolts and tilts, but only if the loose joints allow it.

The impressive double rocking ship featured in the photo at the beginning of this section has its mechanism pictured above. It shows an elegant, simple solution for the motion of two ships. The rotary drive via a wooden pulley is the same as for the single ship but the linkage is extended symmetrically about a central stanchion which is the pivot point for the two ships. The lower tie bar is

A pair of ships on this 'picture frame' diorama is shown from the rear while the mechanism undergoes restoration. The linkage that causes them to pitch, toss, rise and fall is just visible, along with its cord-driven pulley underneath. Both the sloping paper sea and the different scales of the two ships are features that add perspective to the scene.

A still pond with a tree rising out of the middle. The pond is made of mirror glass distressed to appear rippled. The plaster and papier-mâché banks are painted and fitted with silk flowers and dried grasses. The whole scene is incongruously set within a large, gilded cage containing a clockwork singing bird. Made in Paris, *c*.1870.

not fixed except to the ships themselves, acting rather like a seesaw with parallelogram motion. The result is that when one ship rises on a wave crest the other falls into a wave trough. The ships' up and down motion pulls and pushes at the paper waves to keep them in motion at the same time.

VARIATIONS

Static water

Static water is usually replicated in nineteenth-century dioramas by using a mirror set around the edges with a shoreline of plaster or papier-mâché. The mirror can also be peppered with reeds at the edges and perhaps a small island of papier-mâché. The application of some careful distressing to the silvering under the mirror plate, using abrasives, in lines or pattern can also give the illusion of ripples on the surface. Features and treatments like these will add realism and help disguise the obvious use of a flat mirror. Thin mirror will allow the use of a moving magnet underneath the glass to power a swan or a small boat with a magnet set into its underside. This additional feature slides on the smooth surface of the mirror. Realism is enhanced if the swans or boats do not simply circle but move on a more circuitous path using a cam arrangement underneath.

Fountains and flowing water

Representing flowing water with twisted glass rods is a device that has been used in automata for centuries. The most famous extant work that uses rows of twisted glass

rods to indicate a lake is the 250-year-old Silver Swan currently in Bowes Castle, England. When operated, the glass rod 'lake' on which the Swan swims begins to ripple and flow, the Swan preens itself, looks around, then catches sight of fish leaping out of the surface of the lake. The Swan darts down and catches a fish in its beak. It then lifts its head back and swallows the fish. It performs its naturalistic routine to the accompaniment of bells playing melodiously. Made in the workshops of James Cox, London, in 1773 it has remained a wonder of technology ever since. James Cox used glass rods twisted into spirals in most of his clocks and automata that featured water.

Whether a single rod representing a water spout issuing from the mouth of a gargoyle head or a set of rods representing a waterfall or a cascade into the lake of a bucolic countryside diorama, the rods have to be revolving for the

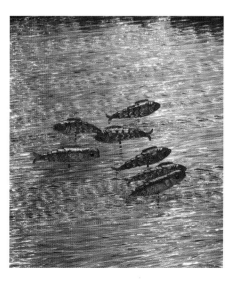

The shimmering lake of twisted glass is astonishingly lifelike in its action. It is part of the eighteenth-century automaton known as the Silver Swan in Bowes Castle, UK. The swan searches out the silver fish that leap between the turning glass rods, before darting down and catching one in its beak. The 32-second performance is accompanied by bells.

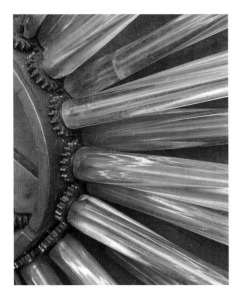

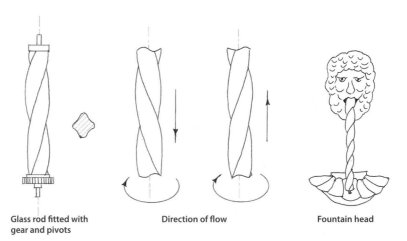

Glass rod fitted with gear and pivots

Direction of flow

Fountain head

Fountains and directional flows of water are traditionally represented by rotating glass rods, either singly or in groups. The twist of the spiral dictates whether flow is ascending or descending. A single glass rod can be powered by a thin cord around a pulley. This is fitted on the glass rod where it extends out of sight inside the case.

The glass rods in this eighteenth-century automaton are driven by small gears fitted onto the end of the rod by a plug or cap. The gears accurately mesh with their neighbouring glass rod's gear, turning it in the reverse direction. Only one of the rods needs to be powered from the weight-driven mechanism to rotate the whole group.

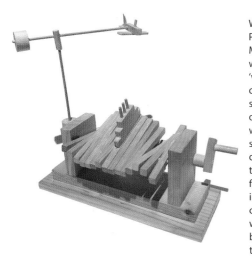

Wave Machine by Peter Markey, c.1980. Made entirely of wood with undulating 'waves'. The hand cranked mechanism simulates the action of large waves on which a small ship steams. The addition of a friction bevel gear to drive an aeroplane flying overhead adds interest. An adaptation of this automaton was later produced by Timberkits in the UK. (MAD MUSEUM OF KINETIC ART, UK)

effect to be realistic. Each rod is capped at each end with a brass cap terminating in a pivot at one end and a small-toothed gear at the other. The ends of all the glass rods are hidden from view under the scenery. The clockwork drive motor for the automaton has a gear train designed specifically to engage with the glass rod gears and causes them to turn. If a row of glass rods is employed, each gear meshes with its neighbour and therefore each spiral rod turns in a different direction to the one next to it, giving a shimmering ripple effect to the surface of the 'water'. It is worth noting that reversing the direction that the glass twists on alternate rods will simulate a one-way flow instead of a shimmer effect. The housings or framing of the glass rods were usually polished steel or silver, the reflective surface chosen to enhance the effect as the light reflected and shimmered off the glass rods.

The single twisted glass rod revolving to imitate a flow of water is the simplest version of the use of spiral twisted glass for water. The drawing above illustrates how it is used and shows how to reverse the flow. There is also a photo of a single glass rod waterfall in the 'twittering' variation of the Birdsong section in Chapter 3.

Modern wave machines

The modern craft automata movement has perfected a quite different representation of waves. Makers such as Peter Markey (1930–2016) made wave machines out of slats of wood, reproducing a very realistic motion without concern for a realistic appearance. The slats of wood are arranged side by side, and are usually pivoted at one end. Each slat rests at its mid-point on a shorter length of wood drilled and glued onto the rotating shaft. This acts as a cam to lift and drop the 'wave slat' above it. The row of cam wood pieces are each offset to their neighbour and look like a long helix without the waves above. When the camshaft is turned it imparts an undulating wave motion to the slats of wood which is considered very satisfying to watch. Floating features such as a boat or a duck can be fixed to the top of one of the slats of wood, or the 'sea' can be left empty for the sheer pleasure of watching the movement of the waves.

The wind is a very difficult thing to portray with mechanism because it is invisible. Air movements can be felt but not seen by the human eye. We have become so used to seeing the effects of wind on other things, such as clouds, rain, dust and trees that we might assume (without much thought) that we are seeing the wind itself, but we are not. In this section the common effects and indicators of air movement are explored using several different mechanisms and devices. There are even some extremely simple indicators of wind that I will describe which use no mechanism at all.

The turning windmill demonstrates the existence of wind and usually exhibits a large sweeping set of oversized sails to attract attention. It has been used to great effect in automaton dioramas over the centuries, sometimes in really complex mechanical landscapes but always using the same simple mechanical principle for success.

WINDMILL WITH DANCING COUPLE, PHALIBOIS, PARIS, *c.*1900

In this charming musical automaton, 40cm tall, the scenery is populated with three tiny characters acting out a joyful role in their story of love and domesticity.

- Windmill sails revolving
- Figure leaning in and out
- Dancing couple

The house they live in is the romantic ivy clad windmill, with large double doors and a single large window. From the window a tiny figure leans in and out, as if beckoning to the dancers. The large sails of the windmill are made of small sticks of wood and travel past in a smooth flowing sweep as they revolve. The makers, Phalibois, made a series of tableau automata featuring small people in microcosms of real life. The figures have a fairy or elven quality about them and consequently hold huge appeal for children and adults alike.

For another example of tiny people in a magical tableau and a detailed explanation of the dancing mechanism, please refer to the section on Dancing in Chapter 6.

The mechanism

All the movements of the automaton are powered using only the spring barrel that is part of the small musical movement. This is a standard musical box movement with

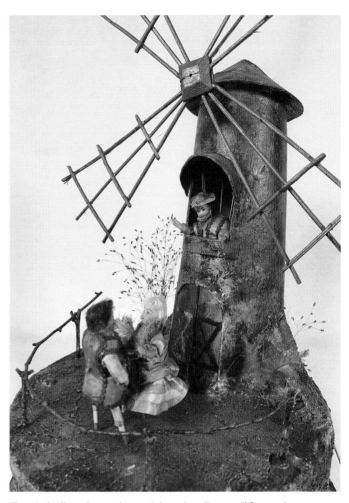

The windmill revolves as the music box plays. Two small figures dance together, spinning this way and that, oblivious to the beckoning figure who leans in and out of the window above. This symphony of three completely different movements begins when the clockwork is wound by pulling a cord and the start button is pulled out to begin the show.

The huge sails of the windmill are impressive as they revolve but even before the automaton is set in motion there is movement. The scenery is inset with tall seed grasses and dyed green feathers adorned with flowers, chosen and arranged *en tremblant*, meaning they have the ability to tremble at the slightest vibration of a floorboard or passer-by.

This automaton's success relies on three factors, the first two are found in most Windmill automata:

- The sails of the windmill are large, yet very lightweight.
- The mechanism is light and simple using pulley belts of thread and pierced tin bearings.
- Three different movements combine to tell a story.

The wooden pulley is both simple and ingenious in that it performs three different actions: the groove carries the cord that turns the sails of the windmill; the points act as cam lobes that cause the dancers to dance; and the two pins push down the wire lever to make the figure lean out of the window with spring return.

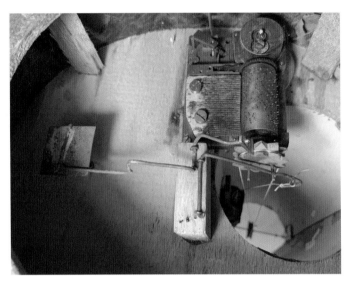

The mechanism, looking up underneath the base. You can see the cord loop for the sails ascending up the cardboard tube of the windmill body. There are two bent wire levers: one for the dancers to push them up and down; another for the figure leaning out of the windmill, pushed down by two pins as the wooden cam revolves.

an extension to the shaft of the pinned music cylinder and wound by a pull cord instead of a key. It is screwed onto the underside of the wooden baseboard and has a specially shaped wooden pulley grooved for the windmill sail cord. This wooden pulley is castellated with twelve points for a cam follower (the dancers) to ride up and down on. The face of the pulley has two stout pins projecting from it for lifting the short lever that pulls the figure in and out of the window. In short, this pulley is special: it is shaped and pinned to perform three separate functions, so providing all the means of motivating the automaton in one small component. The light loading of all the components enables the pulley to be a tight push fit onto the shaft extension of the mechanism.

The little man leaning out of the window has a small shaft along the front of his torso which is pivoted on the windowsill. A small coil spring around the shaft pushes our figure out of the window whilst a cord extending down to the mechanism pulls him repeatedly back inside as the mechanism turns. It is the two stout pins projecting from the wooden star pulley that act to pull down his lever and hence pull him back into the windmill against the force of his spring. The cord loop that transmits the power from the mechanism to the sails should be thin and light, it is usually button thread or, as in this case, bookbinder's twine. The pulleys at both ends of the windmill loop are grooved down to a sharp 'V' to accommodate the thread with maximum grip on both sides of the thread. If the pulley grooves were U-shaped the thread could slip as its contact area could be halved. The low friction and light loading designed into the whole arrangement make cord tensioners and special joints in the cord unnecessary.

The two levers that transmit and amplify the motion for the three figures are made of bent wire with a right-angle bend (for lateral stability) that is loosely stapled to a wooden block. The wire levers are economical and efficient in operation and are typical of a French 'lightness of touch' in small machines. A philosophy that helped undermine the heavy engineering of Victorian clockmaking in the UK.

The base and windmill
The tableau was made using card and papier-mâché on a rough circular wooden frame. The painted surfaces contain sand and grit to give texture. The railing is made of twigs and the body of the windmill itself is a cardboard tube extending out of a papier-mâché rock outcrop, which gives it strength as well as visual appeal. The sails are large so that the movement at the tips is really quite fast, simulating that of a real windmill. The whole assembly spins freely in loose-fitting plain bearing holes.

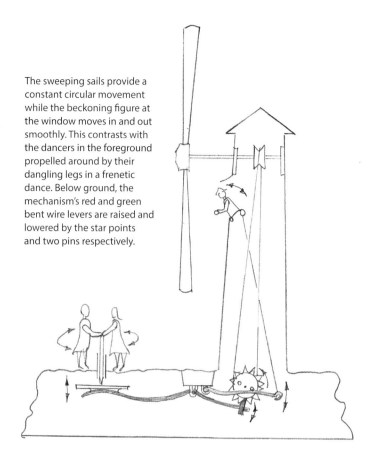

The sweeping sails provide a constant circular movement while the beckoning figure at the window moves in and out smoothly. This contrasts with the dancers in the foreground propelled around by their dangling legs in a frenetic dance. Below ground, the mechanism's red and green bent wire levers are raised and lowered by the star points and two pins respectively.

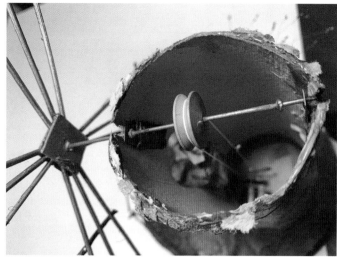

The sails are made of thin bamboo sticks, strong and light; these are pinned and glued together. The shaft for the sails is a straight wire rod with soldered stops to keep the sails located in their bearing supports. The bearings themselves are strips of brass pierced with a hole through which the sail shaft passes with a loose fit.

Picture frame diorama, c.1890. This example was originally clockwork but was converted to coin-operated electric around 1960. It was displayed at Jamaica Inn on Bodmin Moor. The many moving features are supplemented by the appearance of hot air balloons which traverse the sky from left to right, rising and falling slightly in the wind before disappearing behind the tower.

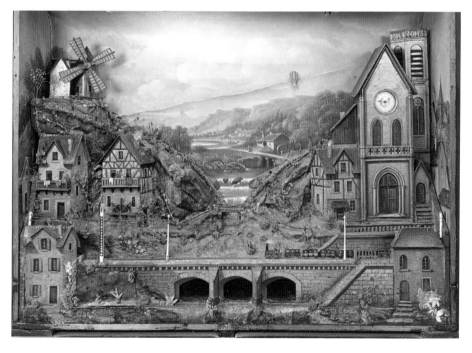

Various wind indicators

Hot air balloons

In the period in which French automata making was at its height (1850–1900), air travel was a breakthrough technology. There are several examples of dioramas displaying a range of technologies: rail, wind and water power – even the telegraph – and quite successful representations of air travel were incorporated.

The diorama illustrated dates from the 1890s and measures nearly a metre wide, it shows several of the nineteenth century's technological advances in action. Remarkably it features air travel in the form of a series of three hot air balloons that appear one at a time. They travel on an endless loop of ribbon that passes over a series of wooden pulleys. The technique used is the same as that for the trains that appear out of a tunnel, run over a bridge and then disappear again. Where they differ from

The balloons fly realistically due to the undulations the bracket rides up and down upon. They are painted onto thin card and glued to the ribbon via a bent card bracket. Although the card seems fragile, it can ride the edge of the tin sky for thousands of circuits without perceivable wear. The ribbon loop is from an old typewriter.

The balloon journey. There is something unbelievable about the machines that achieve human flight, and the automaton version is no exception. It seems impossible that the balloons can make this 'Heath Robinson' circuit without jamming and breaking. This diorama has been operated more than two thousand times with only the odd disaster due to paper curling and a broken ribbon.

trains on endless loops is that the ribbon deposits them not on a bridge but on top of a crack in the sky. The sky is composed of an upper background and a separate foreground painted onto a tin panel. The tin foreground panel is screwed to blocks to provide clearance for the ribbon with the extreme left and right of the panel hiding two large diameter wooden pulleys. The balloons are mounted on lightweight cardboard brackets that hang off the front edge of the ribbon at their mid-point and so ride over the front of the 'crack' in the sky. The rather obvious track of the balloon along the join is accepted and ignored by the audience in the same way that the strings of a marionette are. This natural suspension of disbelief is what makes entering the miniature 'world' of the diorama a pleasure.

The tension of the ribbon is fairly loose so that the long span of the 'crack' causes the bracket to ride up and down on the vertical undulations with the occasional tilt forward

and back of the balloon on the inadvertent horizontal bends. The whole ribbon is about 2 metres long and rides over a total of eight wooden pulleys (air travel uses a lot of resources!). One of the pulleys is a sprung tensioner and two of the pulleys guide the ribbon around three-quarters of the circumference of the large driving pulley to provide enough friction. The driving pulley is attached to the mechanism and is not shown in the photo; it slides out with the base of the main scenery when removed to show the background.

Wind without mechanism

The automaton as a dynamic object is all about the movement, and mechanically produced movement is complex and time consuming to make. The master makers were aware that the draughts from a window or vibration from a loose floorboard can set in motion a multitude of things with the ability to attract attention. The best makers exploit this phenomenon by amplifying the movement using the technique of setting grasses and foliage *en tremblant* around the scene. The technique uses thin stems, springs or feathers with a small weight attached at the extreme end. The weight is usually a felt flower, a glass bead or a dried seed pod. This mass at the end of the 'stalk' acts like an upside-down pendulum and will swing to and fro once vibration starts it in motion.

Feather foliage is structurally strong and light; it is usually dyed green and cut with scissors to leaf shapes. The example with beaded ends in the photograph is over a hundred years old and has drooped a little. When new it would have been more upright and very tremulous. The bunches of stems are wired together and then artfully glued into holes in the papier-mâché with painted ground features, sand and small pebbles to blend them in. The 'trembling' action attracts attention and was also used to good effect by makers of diamond jewellery in the nineteenth century, who named the gem settings 'en tremblant'.

Feathers are used in two different ways to make foliage in this Rocking Ship diorama. In the background many tiny feathers are dyed green and wired together like a fir tree; the ends are fitted with a glass bead to provide weight and momentum when in motion. The foreground plant is more like a fern with individual feathers cut to shape.

Dioramas under glass shades were popular in the nineteenth century. The whimsical tableaux contained in them were often complex and skilfully crafted. Foliage moving *en tremblant* with vibration was common. The feathers and springs were coloured green and natural grasses were often supplemented with woollen tufts to make a lush, tremulous scene reminiscent of a breeze blowing across the scenery.

Feathers with flowers Grass with beads Springs with beads Seed grasses Chimney smoke and flags

The vibration that initiates the motion can be caused by a person passing by or approaching the automaton and also by the vibrations of the mechanism itself once in action. The movements can be quite subtle but even so, contribute to an uncanny perception of life in the whole diorama.

As well as the movement of foliage and trees indicating the possible presence of wind, due regard should be given to objects such as chimneys and flags. A realistic smoking chimney or fire is achieved with cotton wool, or a little dirty white mohair teased out in the direction the wind is blowing. Flags are often found on buildings and ships. The flag should not be a simple rectangle but be shaped as if flapping.

THE RED MAGICIAN

The most amazing use of wind in an automaton that I have come across occurred in a Magician automaton in a glass case, from around 1860. The 'Prestidigateur' stood at a pair of tables laden with magical objects where he performed the cups and balls routine. Amongst the dice, jars and playing cards that stood on the table was a silk

covered cone with gold trim, about 30mm tall, on top of which a tiny dancer balanced on the toe of one foot. She carried two revolving parasols of hummingbird feathers in her hands to help her balance and amazingly she wobbled and gyrated without falling off. The whole thing was sealed from dust and air within its original glass cover.

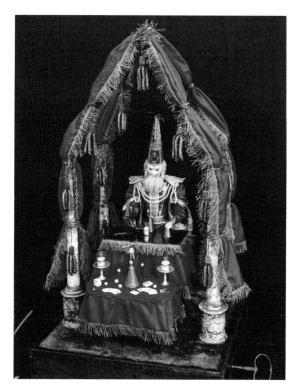

The Red Magician, *c*.1860, Paris, Théroude. The magician produces a range of different objects under his cups. On the table in front, a tiny dancer balances precariously and then pirouettes while spinning two parasols made of hummingbird feathers. She is operated by jets of air emitted through pinholes in the adjacent objects. The whole scene is sealed within a glass case.

The sun is a relatively rare object to see portrayed in automaton form. It is important for all life in the natural world but you cannot look at it directly and its main features of light and warmth are not easy things to replicate mechanically. The sun itself can be regarded as the ultimate regulator and power source for all living things. Today its ability to produce electrical power via solar panels has become important but its depiction as an automaton is often restricted to simple golden discs transiting the background of a diorama or stage backdrop with glowing lighting effects. However, the main featured automaton sun described below has much greater complexity and dates from the English 'Golden Age' of automata, c.1780. It is a clockwork representation of the sun itself, physically radiating light outwards from the centre of its orb. The second example is even older and demonstrates an unusual effect produced by the sun, which is sound: a mysterious pair of speaking statues guarding the Valley of the Kings in Egypt and powered by the Sun, the Colossi of Memnon c.1350BCE.

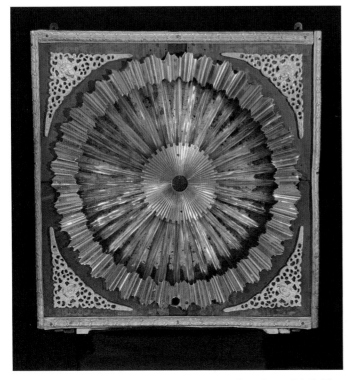

The Sun Machine is part of a spectacular automaton from the English 'Golden Age' of clockwork marvels that spanned the period 1780 to 1840. The rays of this sun appear to radiate light continuously, each spiral glass rod rotating automatically in the opposite direction to its neighbour. It was designed to hang above a table-sized moving diorama of automata.

SUN MACHINE, LONDON, *c.*1780

Designed to be hung above a large moving scene, this clockwork 'sun' appears to have radiating rays of light formed by a circular array of glass spiral rods emanating from its centre.

- The sun
- Radiating beams of sunlight
- A slowly falling star

It is housed within a square (40 x 40 x 20cm) wooden box frame and is double faced, with an identical array of radiating glass rods on the back. It can be viewed from both sides. Unfortunately the Sun Machine is not in working condition and requires significant restoration before it can radiate again powered by its own clockwork motor. All the main elements are still present, including the 'star' glass weight, and it is an exciting and rare automaton despite its condition.

The animated scene that this sun shone down upon is lost, but is possibly similar to this one described in the James Cox museum auction catalogue of 1772:

> A grand water-work of fountains and cascades, in all directions, the base of it is a large rock ... between the Sea-Nymph(s) above the rock is an irradiating Sun ... in the centre is a Triton striding a Sea-horse, surrounded by Sea-dragons, and otherwise finely decorated, it is near twelve feet high.

The sight of these room-sized walk around tableaux must have been very impressive, not least because the fashion of the time was to use gilded bronze, precious metals and gems to decorate as much of the visible surfaces as possible. Our Sun Machine is probably just one moving piece of a large microcosm of mechanical fantasy, and its movement gives a good indication of the superb effects that could be produced.

The mechanism

The eighteenth-century automaton maker who designed this device was a confident mechanic and obviously very familiar with clockwork. The two faces of the Sun Machine are arranged either side of the central mechanism just as dials of a two-faced clock would be. The central mechanism is a weight driven clockwork movement, the same as might be found in a musical clock of the period. The movement has a train of four gears with a gut line for the weight wrapped around the slowest gear's barrel and a

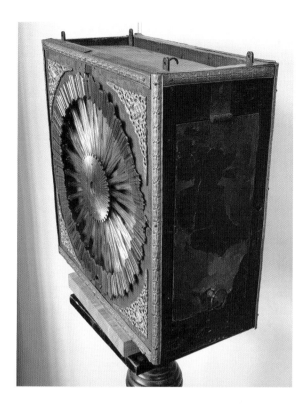

The double-faced sun is identical on both sides, with a total of eighty twisted glass rods turning continuously when in operation. The four iron suspension eyes are needed to hang the machine and its heavy lead driving weight at a height above the main diorama. The viewing audience would have been able to walk completely around the whole scene.

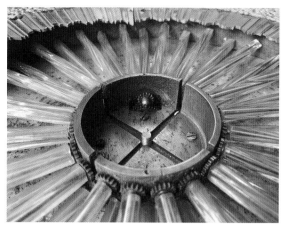

With the central cover discs removed this picture reveals the main features of the radiating mechanism. The spiral glass rods are hollow, and the little gears are mounted on steel shafts extending all the way through to the far pivots. Note the pair of driving gears for all forty rods in the centre and the two levels of the rods.

THE SECRET

- A circular array of 80 spiral glass rods geared together at one end.
- A mirrored background.
- A lead weight disguised as a crystal glass star.

One of the four quadrants of brass that form the centre support for the glass 'rays'. The maker's original layout lines for the blind pivot holes are still visible. Each hole is numbered to match a specific glass rod. The ten rods in each quadrant have central steel shafts graduated in length over a total of 1mm to aid reassembly.

worm and fly, the air brake, at the fast end of the train. The power is taken from the third wheel shaft extending either side to activate each face of the sun simultaneously.

The 'faces' are circular brass plates, 38cm in diameter, with a central boss of quadrant shaped brass 'L' brackets to hold the inner pivots of each glass 'sun ray'. The outer circumference is fitted with a thick brass band pierced with holes for the outer pivots of these rays. The impressive radiating effect is caused by forty glass spiral rods on each face of the machine which are turned by the clockwork motor. The rods have a small toothed gearwheel on their inner end which meshes with the gear wheel on the rod next to it. This direct gearing means the rods turn in the opposite direction to their neighbours, enhancing the visual effect.

In order to increase the radiating effect, the spiral rods are fitted not side by side but on two levels displaced by half a space, causing the gear of a lower glass rod to turn its higher neighbour which then turns the lower one next to it and so on, all around the forty glass rods of each face. The result of this zigzag placement of the rods is to give depth to the illusion and increase the perception of emanation from the inner boss where they appear to cross over each other. The precision with which the gears are depthed (a clockmaking turn for how smoothly they mesh) is very important. This is definitely not a mechanism that can be made to work with approximate accuracy in construction. The driving motor connects to each face via a simple right-angle pair of gears. These two pairs of right-angle gears drive a total of eighty meshing gears on

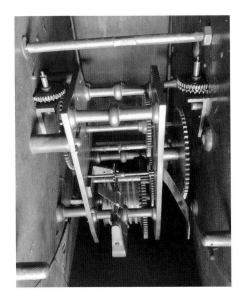

Peering through the side door of the Sun Machine reveals the driving motor. It has adjustable speed control via the vanes of the fly in the lower foreground. Beyond the fly is the drum for the weight line. The two pairs of horizontal gears on each side (R/H disconnected) transmit the power to the exterior faces of the machine.

The star weight that drives the clockwork sun machine is made of cast crystal glass with a central core of solid lead. At 6kg, it is very heavy for such a fragile object. The photograph shows it fitted with fourteen of the twenty-eight radiating glass points; the remainder for the second face are missing or broken.

the inner ends of the spiral glass rods. This results in a huge amount of friction and is a tribute to the skill of the makers. Behind the glass rods is a mirror finished steel plate, whose purpose is to reflect the light and double the perceived number of spiral glass rods.

The whole unit is housed in a strong wooden box reinforced with internal iron straps to suspend it safely above head height over the automaton scene below. The square box is decorated with spandrels, ornate gilded corner pieces that adorn a circle fitted into a square frame as most clocks are. Incidentally, the automaton can be dated accurately by looking at the clockwork construction details. Items such as brass pillars, collets and spandrels changed in style almost every decade for nearly two hundred years, giving a useful indication of the date. No one wanted an old-fashioned clock.

The star weight

The Sun Machine has the most reliable of all clockwork power sources, a falling weight. The weight pulls on a strong line wrapped around the 'great wheel' drum of the clockwork gear train. The lead weight is twice as heavy as required to enable it to be doubled up, with a pulley on the weight itself. This doubles the run time for a given drop of the weight. This is standard English clockmaking, as found in all grandfather clocks for the last 300 years; what is extraordinary is that the driving weight has been decorated to look like a shining star.

The 'star' weight is comprised of a solid lead cylinder with a circle of decoratively incised glass on each end. An annular groove behind each glass end is used to fit crystal glass points radiating outwards. Each of the glass points is

cast with deep grooves on the reverse to refract the light in many directions. The size of the star is roughly two thirds the diameter of the sun and it catches the same generous candlelight in its striated glass rays as the turning glass rods of the sun above.

The glass star weight is damaged and missing many of its glass spikes (for its second face) which act as the rays of the star. This damage and loss is not surprising, as it is very difficult to store safely unless hung because of its heavy lead core and fragile glass points. I consider it very fortunate that it is still here, having been kept together with the sun ray mechanism for more than 200 years.

> **VARIATION: THE SUN AS A POWER SOURCE**

THE COLOSSI OF MEMNON, EGYPT, 18M TALL, *c.*1550BCE

Two immense seated statues of Amenhotep III sit on a desert plain in Egypt. The stone figures are taller than a six-storey building and were built 3,500 years ago to guard a now ruined mortuary temple. So impressively huge are the statues that they are described in the travel writings of several ancient writers such as Strabo, Pliny and Tacitus. It was not just the size of the statues which has earned them such a distinguished place in history, it was the fact that they could 'speak'.

How they made sound is a mystery and demonstrates that sometimes the best kind of automaton is one that no longer works. Broken, the sound is now in the realm of the imagination. The Colossi of Memnon benefit from this effect having stopped working nearly 2,000 years

Speaking statues. As these stone Colossi are over 3,500 years old it is no surprise that they have gathered many stories and legends about them. They are said to have made a 'vocal sound' according to the Roman writer Tacitus, and many other reports confirm some sort of 'singing' sound. Now silent, the mechanism that made the sound is a mystery.
(© VYACHESLAV ARGENBERG, CC BY 4.0)

ago, perhaps following an earthquake. This 'broken effect' means that some writings describe hearing singing, a whistle, hissing, low moans or even a bang; now we are not sure what the exact noise was. The sound is reported over a period of at least two hundred years. The most often reported time of the noise occurring is coincident with the rising sun. This is useful for understanding the 'mechanism' causing the sound. Most theories suggest that as the cold night air expands in the heat of the morning sun, it issues through an opening or fissure making a sound as it does so. Another possibility is that dew in the porous structure or in certain cracks in the rock is heated by the sun and hisses as it evaporates out. When reading the actual reports behind the legend a different cause suggests itself. Strabo says it sounded 'like a blow' and Pausanias compared it to the sound a lyre string makes when it breaks. If their descriptions are accurate then this sound could have been made by expanding stone 'snagging' and releasing suddenly under the heat of the sun, a process that would repeat as the relevant stone contracts again in the cool of the night. The Colossi of Memnon are a testament to the power a lifelike quality in an inanimate object can wield, even when broken.

SOUND

An automaton can use sound very effectively to surprise and entertain us. The most common type of sound is a tune from a music box mechanism inside the automaton; beautiful as this can be, I am not looking at musical accompaniment in this section. Many makers of automata realised that despite the technical challenges, the voice itself is a worthwhile addition to the mechanism.

The Speaking Picture Book magically brought stories to life with sound. Immensely popular, different editions were published in English, German and French; happily, the animal sounds remained the same whatever the language. This English copy of the book was made in Germany 130 years ago for the F.A.O. Schwartz Toy Shop in New York, which still exists today.

A well-timed miaow or roar can enhance the illusion of life, by adding the sense of hearing to what is being seen.

One intriguing object can make a range of nine individual sounds, each sound produced using bellows to make distinctive calls and cries. It is a storybook produced for children in the nineteenth century. The book is designed to be read and, at the appropriate time, brings the sounds

Mysterious knobs line up along the edge of the book. On each page an arrow points to a knob. As the knob is pulled and released, the subject of the story cries out. This page features a goat, and the sound realistically mimics the bleating. Modern electronic versions are popular today but not many will still work in 140 years!

The secret compartment at the back of the book is normally firmly glued shut. It has to be opened for repair when a cord breaks. Unusually, the fragile paper bellows rarely split or tear despite their sharp creases and hard use. The cords are used to pull the bellows open, and the sound is made as the sprung bellows intake and exhaust air.

of each story to life by pulling cords to operate mechanisms hidden within the book. The same mechanisms using similar bellows and valve designs are used, not just in books, but in actual automata of the animal they represent. The Parisian makers activated the bellows by lever and cams driven by the internal clockwork motors to bring life to everything from pigs and cockerels to cats and dogs.

THE SPEAKING PICTURE BOOK, PATENTED BY THEODORE BRAND, GERMANY, 1878

This Speaking Picture Book was published in Nuremberg in 1880, famous for toy making for over two hundred years. It is a large book whose story is told across only twenty-four thick card pages. Behind the pages is a sealed section, effectively a box containing the mechanisms for nine different sounds. The box is perforated with ornate carved wooden grills at the top and bottom to let the sound out. Along the fore-edge of the book is a row of nine pull cords which disappear into the sealed compartment. Pulling these cords produces the sound indicated by an arrow on the respective page of the story.

A range of different sounds.

- The Cock, Donkey, Lamb, Birds, Cow, Cuckoo, Goat, Mamma and Pappa

The ingenuity with which the mechanism produces the variety of sounds is impressive and dependent on subtle adjustments of dimension and spring pressure to be effective. The descriptions given here are a guide to the general principles only and replication of the sounds will require an experimental test rig for each sound, balancing and adjusting the necessary elements carefully. What I will describe here is the imaginative complexity that an ambitious Theodore Brand had to resort to in order to get the result he wanted. His achievement was to produce this complex sound system with minimal material expense. The noises and sounds were excellent and good enough to convince a sceptical public to buy the book as soon as they heard it.

THE SECRET

Although each of the nine sounds has its own unique system of valves and pipes the principles are:

- Paper-covered wooden bellows are used to blow various pipes and horns.
- The bellows closing may be interrupted by friction against serrated or shaped wire.
- Wire-operated valves on the bellows or pipes open and shut automatically.

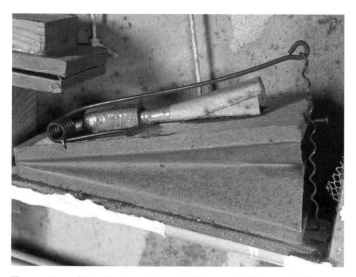

Three parts work together to make most of the sounds. The paper bellows supplies compressed air, a horn or whistle amplifies a musical note, and a wire mechanism controls the supply and pressure of the air. This is the bellows from the goat mechanism: the serrated wire causes the bleating noise as the nail runs down the side of it.

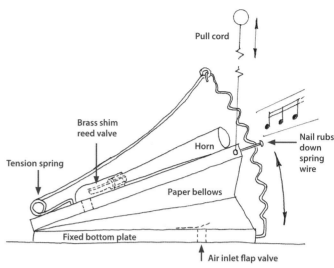

The bellows' coverings are carefully made from folded stiff paper to neatly fold in on themselves under spring pressure varied by friction. This closing action expels the air through a small hole into the air chamber around the 'reed' valve. Both the 'reed' and the horn can be used to tune the pitch of the note by varying their length.

How it works

The bellows

The box section of the book is made to look like many pages sealed tight together. Once the temptation (or necessity) to open it up has been succumbed to, prising open the cover page of the box will reveal eight simple bellows with complex valve and whistle assemblies stuck to the top of them. The eight bellows are stuck firmly to three wooden shelves. Leading away from the top plate of each bellows is a strong cord that passes through a hole in the fore-edge and terminates in a wooden pull knob. Each sound is produced by pulling out its respective cord and letting it return by spring pressure. As the cord is pulled out it opens the internal bellows which draws in air. The bellows are quite simple in construction and consist of two rectangular wooden boards hinged at one end and covered in strong paper. The bellows are precisely creased to collapse neatly inwards as the air is expelled. The air issues out of a small hole on the top wooden board and into the sealed shroud that leads to the horn or pipe that makes the sound. The springs that keep each bellows closed at rest are a short wire coil, strong and similar to a clothes peg spring but with extended ends inserted into the wood. The valve that allows the air into the bellows is a flap of paper over a small hole inside the lower wooden

board. Air pressure forces the paper flap closed against the hole as the bellows compress. The air must escape when under pressure as the bellows close, so it flows out through the only escape available, the reed of the whistle or horn, making it sound. To prevent air sucking back through the whistle, there is an exhalation valve, which is also a paper flap fitted inside the whistle air chamber. So air can enter the whistle from the bellows but not be drawn into the bellows from the whistle.

The controlled bellows close

As it closes under even spring pressure, the paper bellows will usually expel air in a smooth flow. Two of the sounds, the bleat of the goat and the cry of the cockerel, require the air to be expelled in a staccato fashion, stopping and starting rapidly eight or nine times during the close of the bellows. This is achieved by a nail on the leading edge of the collapsing bellows board. The nail rubs against a static bent wire, bent zigzag fashion, causing the bellows to stop and start repeatedly as the spring pressure closes it. The cockerel sound is not regular but a timed cock-a-doodle-doo. The bends in the wire impeding the collapse are therefore not regular but vary in size and spacing to reflect this timing, slow-fast fast fast-slow, pulsing out the air to match the cockerel's cry.

The cow lowing bellows is the longest in the Speaking Picture Book and to achieve the correct pitch the whistle pipe is double the bellows' length. It is doubled over with a join at the bend requiring the air to resonate the whole length, around the corner and back again, a length of nearly 300mm, before escaping from the pipe.

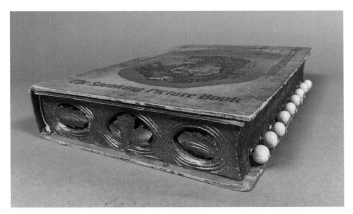

The perforated sound grilles at the top and bottom of the book are made of wood, ornately carved with oak leaf designs similar to that found on cuckoo clocks from Germany. The carvings are painted gold and backed with a metal mesh to keep out spiders and incoming debris that might block the delicate whistles and valves of the mechanism.

The brass reed is held firmly by the glue that holds it in the horn. The purpose of the thread binding is to tune the pitch of the reed. The shorter the free part of the reed, the higher the pitch when it vibrates. The cardboard canopy that forms the airtight chamber over the reed is shown in the background.

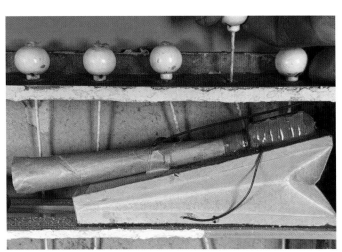

The donkey achieves its two tone 'ee-orr' cry by a valve. Pulling the cord opens the bellows and causes the curved wire to slide through its eyelet and close off most of the air supply to the horn with an internal flap. As the bellow closes the wire lowers the flap and the sound changes halfway. Ee-Orr!

Special whistles

The sounds are produced for most of the book's creatures by expelling air through a cardboard horn. The horns are cone shaped and fitted with a simple reed valve, like a party blower. The reed valves used in this nineteenth-century mechanical book are stamped tin tubes with a flat open side. The reed is a flap of thin brass shim which exactly covers the open side of the tube, bound on with thread at the approximate mid-point. This binding point can be varied to tune the pitch of the reed, as the free part will vibrate as the air escapes. When glued into the mouth of the horn, the reed assembly is covered with a little cardboard canopy. This is glued all around its edges to create an airtight seal. When the bellows closes, air rushes into the reed canopy via a hole from the bellows' cavity. The only escape for the air is via the brass reed which vibrates as the air flows out via the cardboard horn to amplify the sound.

In some of the sound mechanisms, the closing motion of the bellows is used to move a wire control lever that opens and closes an internal flap in the body of the whistle. These flaps alter the effective length and hence the pitch of the whistles. Longer whistles have a lower pitch.

The Mama and Papa sounds are made by the human voice and are at the limit of what can be achieved mechanically. Throughout history many inventors have struggled to make machines that can replicate the human voice. It is interesting to compare contraptions like Von Kempelen's 'Talking Machine' made in 1778 and now in the Deutsches Museum, with the devices in the Speaking Picture Book. The principles and method used to produce human words have inevitable similarities. It seems that a designer of a

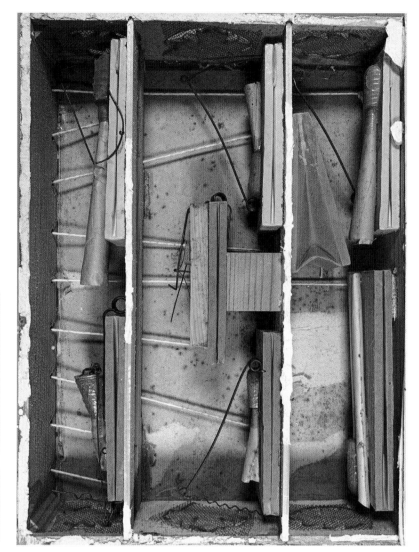

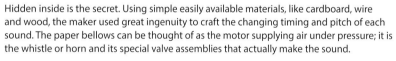

Hidden inside is the secret. Using simple easily available materials, like cardboard, wire and wood, the maker used great ingenuity to craft the changing timing and pitch of each sound. The paper bellows can be thought of as the motor supplying air under pressure; it is the whistle or horn and its special valve assemblies that actually make the sound.

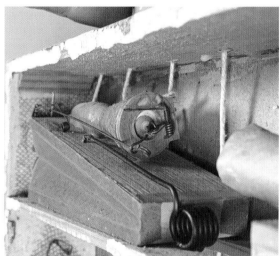

Human speech is difficult to reproduce. This bellows has a complicated horn and valve assembly which makes both 'Mama' and 'Papa' sounds. The end of the horn has a sprung poppet valve to snap it open and shut. Halfway down there is a separate valve to alter the effective length of the horn for the deeper pitch of 'Papa'.

speaking machine, of whatever complexity, starts by listening and then painstakingly reverse engineering the sound syllable by syllable.

There are two distinct components to the words Ma-ma and Pa-pa – the pitch and the timing. In the Speaking Picture Book the sound for 'Mama' is of a higher pitch than 'Papa' but the timing is the same. Theodore Brand achieves the distinction by using a single bellows for both sounds with two separate pull cords. One of the pull cords inflates the bellows as usual but also closes a flap valve inside the whistle horn reducing the effective length for the higher

pitched 'Mama'. The timing of each syllable is particular in that the syllables are very separate with no gentle blend of the sound between them, almost staccato. Friction timing does not work for this as it tends to fade the sound in and out as the bellows close rather than separate. The solution is found by opening and closing the mouth of the whistle intermittently using a spring-loaded 'pop' valve inside the mouth of the whistle. This is activated by the closing of the bellows against a specially bent wire that snaps the valve open and shut twice at each operation.

THE TIGER'S ROAR

The Leaping Tiger features a method of growling that slowly changes to a roar. This alarming sound is produced by the rapid beating of a tiny drum. The spinning metal fly (air brake) of the mechanism is the part that beats the drum. The fly strikes the drum via a short feather quill glued firmly to the centre of the drum skin. The thin quill tip is struck a blow by the outer edge of the blade of the fly each time it passes.

The fly can spin fast, up to 500rpm in a clockwork mechanism, but with the least power of any of the other rotating parts. So little power in fact, that it is easy to stop if anything gets in the way of its spin; that is why a thin feather quill is used – the end is effectively 'tickled' by the fly. The light blows are transmitted down the quill and amplified by the drum skin producing a throbbing growl sound. The sound accelerates and changes to a roar because the drum is moved closer to the fly as the tiger crouches. The drum mounting is on a moving tie rod that connects the front and back legs of the tiger. The tiger slowly bends his legs to crouch and as he does so the drum moves a small distance closer to the fly. The quill now slows the spin of the fly as it is moved further into its orbit and the sound changes in tone and pitch to a deeper and louder sound, a sonorous roar. The moment of leaping has the legs straighten in an instant and therefore the drum is moved quickly back, silencing the roar at the moment of leaping. The leaping mechanism of the tiger is fully described in Chapter 3 'Birds and Animals'; also see the Drumming section in Chapter 6 for more sound produced by the automata themselves.

The tiger's growl and roar start as it begins to crouch before jumping. When the legs bend forward, the drum, soldered firmly to the legs' tie bar, moves closer to the spinning fly of the mechanism. A feather quill is glued to the centre of the drum skin and the pointed end is vibrated as it touches the spinning fly.

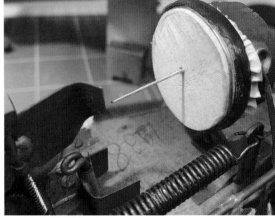

The feather quill moves nearer as the tiger crouches, this ingenious action slows the spin of the fly, and increases the deflection of the quill at each passing blow of the fly blade. The sound deepens to a roar and the leap action slows before... Bang! The tiger leaps into the air and the drum is withdrawn in an instant.

GRAVITY

From the flapping wing and the falling ball to the acrobat's twirl, most of the movements described in this book have used the downward force of gravity. The ubiquitous nature of gravity can mean it is easy to ignore when designing mechanical movement. Power sources are more easily thought of as clockwork, electric, or human powered. But gravity is the oldest, and a strong and reliable way to power an automaton. Gravity is also a great co-partner, working together with another power source to keep restoring the movement in an automaton. A once common machine that uses the power of gravity in two different ways is the grandfather clock. The driving weight (gravity) hangs beneath and powers the train of wheels to turn in one direction, while the escapement at the top gives a gentle push to the pendulum, which always swings to its lowest point due to gravity. The pendulum is heavy and inertia swings it back up again to repeat the process. The gentle push of the escapement is used to restore its decaying swing for eight whole days until the driving weight hits the floor.

Most automata use gravity in some way to perform but one class of automaton quite obviously exploits the pendulum effect to the full, the 'nodders'. The purpose of most 'nodders' was to display a large and amusing movement over a long period of time using the head as a pendulum. Powered by a very simple clockwork motor, these often humorous or grotesque figures were made in their thousands, destined to stand in shop windows. They attracted attention with the gentle swing of their oversized heads, to and fro or sometimes forward and back for a subliminal affirmation that the product was good.

The 'nodder' I have chosen to feature is special in that it compounds the action. It is an automaton for the home, made to entertain and amuse. It is full of movement and particularly impresses me as it appears to use gravity twice in one simple action – the Nodding Duck with opening and closing beak.

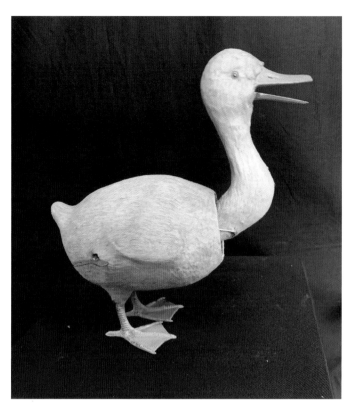

The Nodding Duck is a life-sized clockwork automaton which runs for approximately thirty minutes at each wind. The duration is achieved by the slow ponderous swing of the head accompanied by a snappy beak movement, opening and shutting at each swing. The heavy metal legs and feet provide stability, necessary for the pendulous swing of the neck's heavy weight.

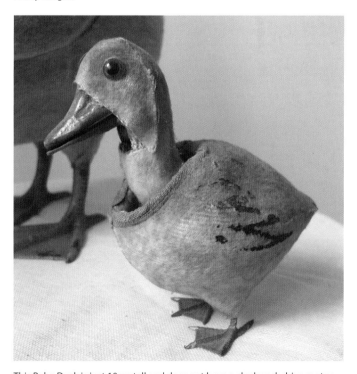

This Baby Duck is just 10cm tall and does not have a clockwork drive motor. It has the same head and beak movement of the full-sized duck but a completely different character due to its small size and pure pendulum power. It runs for about forty frantic seconds with at least a hundred swings and beak snaps in that time.

THE NODDING DUCK, FRANCE, *c.*1900

The Nodding Duck is a 30cm-tall clockwork automaton with a cloth-covered hollow papier-mâché body. It stands

- Slow, controlled nodding action
- Beak movement
- Relaxing tick-tock sound

securely on heavy cast metal feet. The neck extends forward and up from a hole in the front of the body. The well sculpted head features glass eyes and a wooden beak, both of which move as if the duck is nodding and quacking at the same time. The movement is large, slow and very purposeful. The movement continues for at least twenty minutes on each winding with a loud tick-tock accompaniment.

THE SECRET

- The head is a heavy compound pendulum.
- The head is pushed and pulled at each swing by a rod from the clockwork motor.
- The beak is a horizontally balanced beam pivoted on the moving head.

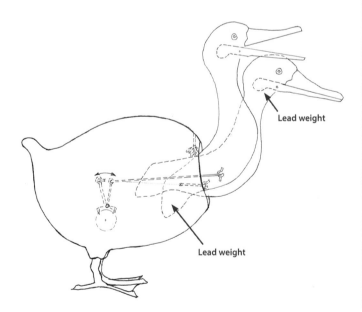

The duck's head rocks backwards and forwards, suspended on two wire hooks. Both the neck and the beak have heavy lead counterweights built into them which cause them to swing slowly about their pivot points. The beak opens and shuts at each swing. The key-wound clockwork escapement inside the body provides a gentle push and pull via a wire link.

The mechanism

The pendulum is normally comprised of a suspended rod and a heavy bob. Variations of a pendulum bob swinging to and fro are used to bring life to many types of automaton. Gravity powers the pendulum bob down to the lowest point and momentum sends it past and up again. The role of the clockwork mechanism is to restore the energy lost to friction. The pendulum's inertia keeps the bob swinging in a regular arc. This arc of swing decays and becomes smaller because of friction (mainly air) which is why clock escapements give the pendulum a gentle push at each swing to maintain the arc of swing. Interestingly the size of the arc of swing does not affect the time of each swing of a simple pendulum, a wide energetic arc taking the same length of time as a small arc. Only the length of a simple pendulum affects the time of swing, a short pendulum being faster than a long one. For most automata a slow swing of the pendulum is often desirable and one way to achieve this is by using a special compound pendulum

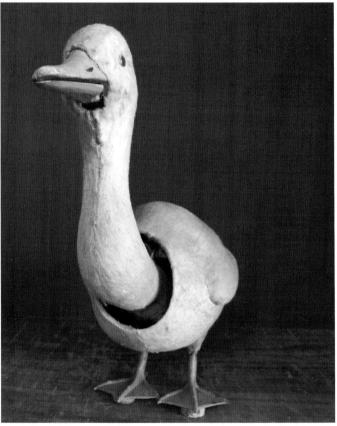

The inclusion of a clockwork motor to augment the power of gravity and momentum results in a long duration automaton. Note the cloth covering of the papier-mâché body. The two slips of cork under the metal feet indicate the duck was 'out of beat' at the time the picture was taken, an issue of adjustment with all pendulum mechanisms.

with an additional weight above the pivot point. In our duck the pivot point is a pair of hooks very near the bottom of the neck. The actual bottom of the neck is a lead block (the pendulum bob) and high above the pivot point is the additional weight in the form of the head and beak. This compound pendulum is like that of a metronome which has a movable weight above the pivot point and a hidden heavy bob below it. Moving the metronome's weight upwards results in a dramatic slow swing and lowering it a fast swing.

Therefore, the head and neck of the duck is a compound pendulum counterbalanced inside the body by a heavy lead weight. The weight is nailed onto the end of the neck and is hidden beyond the pivot point inside the body. The ratio of the distance that weight and head are positioned from the pivot point is approximately 1:5. The suspension of such a heavy head and neck is accomplished by using two iron hooks side by side on the top of the neck. These two hooks fit into two holes in a steel plate set firmly into the papier-mâché body. The suspension is best described as 'knife edge'. The lower edges of the holes are sharpened to offer the least friction possible at the point of swing. This results in a satisfying slow oscillation of the head to and fro. The nodding action is accompanied by the loud tick-tock noise from the clockwork escapement.

The clockwork motor

The clockwork motor's job is to keep the head nodding for a long period of time by giving it a little push at each swing. Close to the point of swing at the bottom of the neck, a metal eye is screwed into the side. Into this eye the push/pull rod from the mechanism is hooked. The rod is about 12cm long and is connected to a short link of wire which extends from the pallets. 'Pallet' is a clockmaking term for the anchor-shaped (or U-shaped) component that spans six or seven teeth of the final wheel in the gear train. It rocks to and fro, alternately releasing and catching one tooth at a time. This 'escape and catch' action prevents the gear train whizzing down uncontrollably. The pallets also have a second purpose: to impulse the pendulum. Each time a tooth is caught, it presses on the pallet as it slides off; this pressure is enough to maintain the arc of swing of the pendulum or, in our case, the duck's head.

To sum up, the mechanism is fixed inside the body and has a mainspring which powers a simple clockwork train of wheels, the last wheel with an oscillating escapement to trip the anchor-shaped pallets. The pallets have a wire

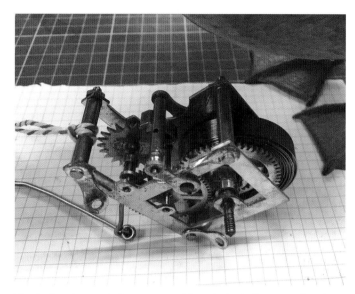

The clockwork motor is shown removed from the body. The pointed teeth of the escape wheel work with the steel pallet anchor, which allows one tooth to pass as it rocks to and fro catching and releasing in turn. The wire rod is connected to the pallet arbor and leads to the screw eye in the neck of the duck.

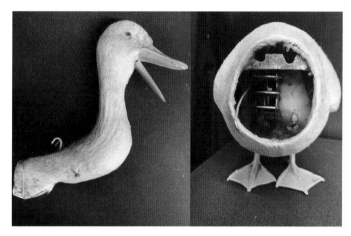

The head is made of papier-mâché moulded onto a wooden neck. It terminates in a lump of lead securely fixed with nail and wire. The balance point of the head assembly is a pair of suspension hooks. The hooks fit over the knife-edge scoops of a metal plate in the body beyond which the clockwork motor is visible.

extension attached onto which a push/pull rod is fixed by a hook and eye. This rod pushes and pulls the head at each swing to make up the energy losses due to friction. This is the common method all clockwork nodders use. The final mechanical nuance that is vital for successful operation is the knife-edge suspension for the head, the two wire hooks fitted into holes in the metal plate, ground thin at the contact points and firmly fixed into the top of the neck hole.

The beak

The Nodding Duck also has a moving beak, fixed of course to the nodding head of the duck. The lower beak is effectively an independent balance beam that extends into the duck's head, pivoted at the jaw to open and shut. The beak is made of carved wood with a lead weight attached at the opposite end. This weight is calculated to balance the beak and keep it horizontal. As the duck's head tips upwards the beak opens, and when the head tips back the beak is closed and is pushed further down, on rising it opens again and so on. The positive action is accompanied by the sound of the clockwork motor and the beak slamming shut with a 'clack!' sound.

Sometimes these antique nodding automata were converted to electric motor operation with a crank and rod driving the head. Electric drive does not rely on gravity and can run indefinitely. However, the movement with electric drive is nowhere near as realistic and is as disappointing to watch as clockwork is pleasing. The slowing and acceleration of the pendulum due to gravity is very important to a natural motion and is different to the smooth motion of electric motor drive. I often convert them back again using old metronome clockwork mechanisms or the alarm clockwork from an old clock. They seem grateful.

VARIATIONS

THE BAKER

This is a nineteenth-century clockwork advertising automaton designed to perform in a shop window with a delicious looking cake on the tray to which he points. His oversized head attracts attention, and the exuberant nodding action seems to say 'Yes' to the product.

Most good 'nodders' have one additional moving feature – the duck has its moving beak and the baker has counterbalanced glass eyes which keep their gaze level, looking straight at you, as the head rocks back and forth. This is a mesmerising and lifelike action and is achieved using the same mechanical principle as the beak of the duck opening and shutting. The eyes are fixed on a common wire frame pivoted at each side of the head. The wire frame has a lead weight suspended on a rigid rod downward. The result is that whatever position the head is in on its wide nodding arc, the eyes remain level and looking straight ahead. The same principle is used for the eyes of dolls that 'sleep' when they are laid down.

The large head of this nodder is suspended in a different way to that of the duck. Just below the collar line on the neck a steel plate has been inserted all the way through the neck, extending a centimetre out each side. The underside of the extensions are notched and then sharpened inside the notch. This enables them to be placed on two round wire loops that are firmly fixed each side of the neck hole, the knife-edge suspension. This is the most common and successful form of suspension and allows the head to be unhooked from the push rod and lifted off for travel or servicing. The clown head pictured below shows an identical knife-edge suspension on the neck.

The blue eyes of this automaton nodder are of high-quality blown glass. They are fixed in a weighted, gimballed frame to remain staring straight at the audience as he nods to and fro. The lifelike effect is enhanced if the eyes are adjusted very carefully to be snug against the eyelids with the minimum clearance, like a real eye.

PUSS IN BOOTS

This life-sized cat is an anthropomorphic figure of Puss in Boots. The moving components are similar to the duck: the head nods and the lower jaw opens and shuts, with the clockwork mechanism hidden within the torso of the figure. This imposing figure shows some of the variation possible using exactly the same mechanical principle. Stability of these nodding automata is crucial to reliable operation. They should not sway with the movement of the head or the energy will dissipate and the mechanism will stop. It is the same with pendulum clocks, they need a firm base. Puss in Boots is tall, at 80cm high, and stands on two feet with the rigid tail extending behind and acting as a third point of contact, like a tripod.

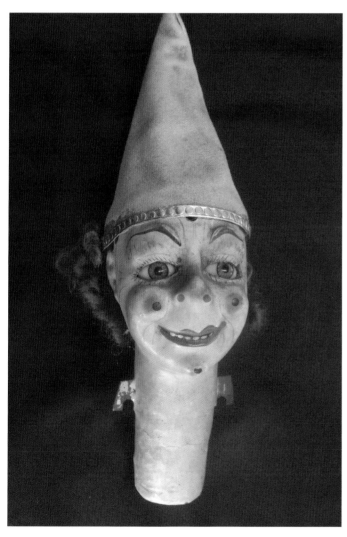

This clown head has been removed from the body to show its use of the same knife-edge suspension system as the baker nodding automaton. The clown has original face paint, and the lead weight is moulded and painted to match the neck. Both baker and clown feature tall hats to emphasise the movement of the head back and forth.

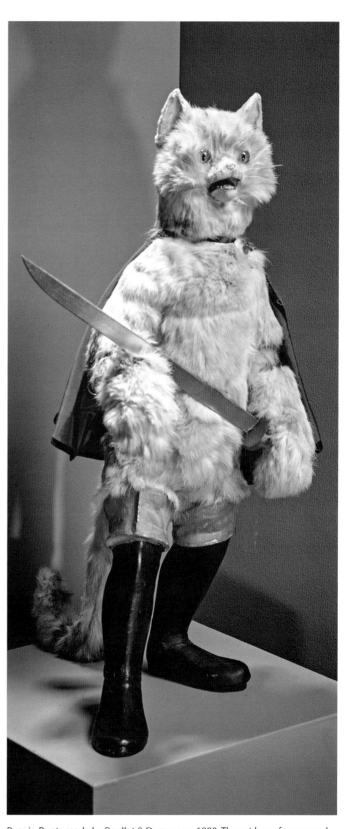

Puss in Boots made by Roullet & Decamps, c.1880. The cat has a fur-covered papier-mâché and wooden body with a clockwork drive to the nodding head and counterbalanced lower jaw which will run for about twenty minutes before stopping. The proud figure of Puss is enhanced by the beautifully moulded papier-mâché boots and large green glass eyes. (PHOTO © EUAN MYLES)

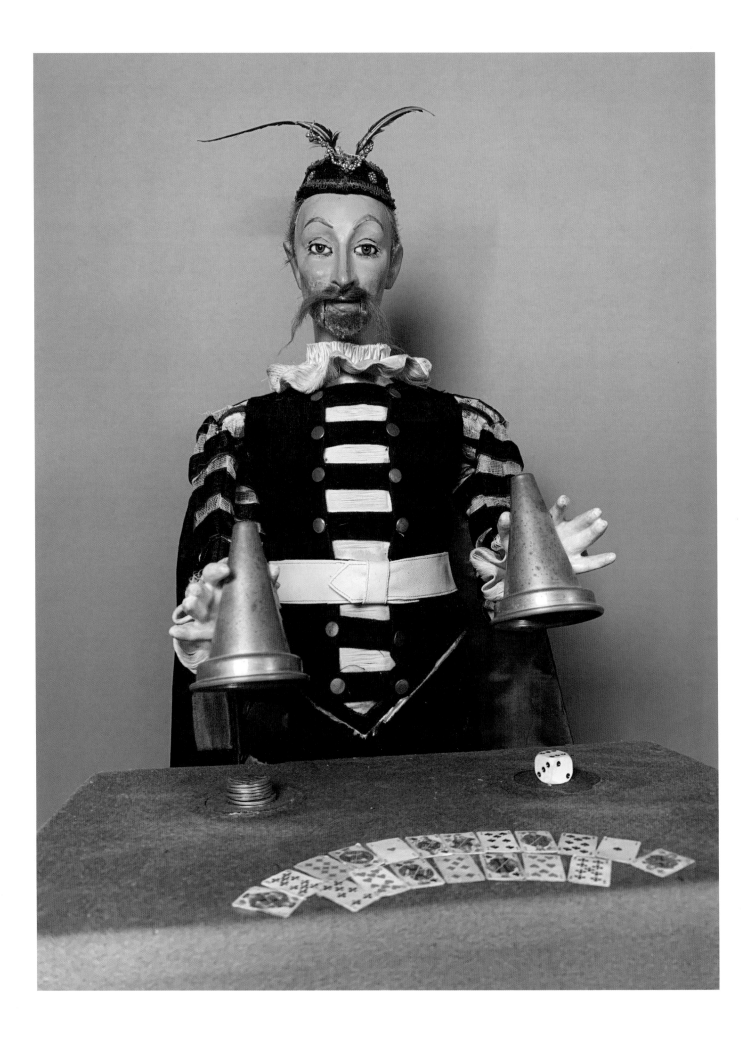

MAGIC

This category of automata is unusual in that automata are famously part of the magician's repertoire of magical objects. The French magician Robert-Houdin was a nineteenth-century magician who pioneered the use of mechanical automata in his performances. Robert-Houdin's Little Acrobat and the Orange Tree were two of the complex automata that actually performed magic for his audience under his direction. The 'magic' automata looked at here are mechanical portrayals of different illusions and this chapter looks at five different performances with variations. Regurgitation may seem a little out of place, but historically it was a common and popular act in circus and fairground, so it has earned its place here as a fine and entertaining automaton, where let's face it, the act is probably a lot more palatable.

CUPS AND BALLS

One of the oldest and most surprising magic routines: a colourful ball is revealed when a cup is lifted off the table to show what is underneath; the cup is replaced and when lifted again the ball has disappeared. The cup is replaced again and when lifted this time a dice appears, and so on for perhaps six changes of the object. As the routine progresses the magician looks around at the audience and down at the object while 'talking' incessantly. This is the important 'patter' that entertains and misdirects attention. The routine has historically also been used by street conmen to trick passers-by who are persuaded to bet on what they think is under the cup.

THE MEPHISTOPHELES MAGICIAN, 82CM, PARIS, c.1895

This automaton is a large and imposing figure of the devil's representative Mephistopheles, popular in legend and literature for his magical power. The choice

- Musical performance of a magic trick
- Disappearing and reappearing objects

of this figure to perform the trick sets a sinister scene for an automatic presentation of the classic cups and balls routine. Mephistopheles is carefully posed with one foot forward in a commanding posture standing behind the table with its green baize covering, as if prepared for card play. There are two metal cups held upside down on the table, the magician appears to speak, and the cups are then lifted and lowered repeatedly to cover the magical disappearance and appearance of various objects. At each reveal the magician pauses, holding the cups up while chattering away. The music box mechanism that plays along helps disguise the clicking and clunking of the mechanism which might give away that there is a mechanical solution rather than a magical one to the performance. A close examination from a viewer able to look down onto the top of the table will see the circular hole around each object that suggests where the objects come from, within the table.

Magician automaton. Each time the cups are lifted a different object is revealed. The unnerving figure of Mephistopheles, agent of the Devil, stands behind a table wearing a fine silk cape and pointed red boots. He performs magic with authentic magicians' cups on the card-strewn table. Mephistopheles appears to chatter before looking down and falling silent at each reveal.

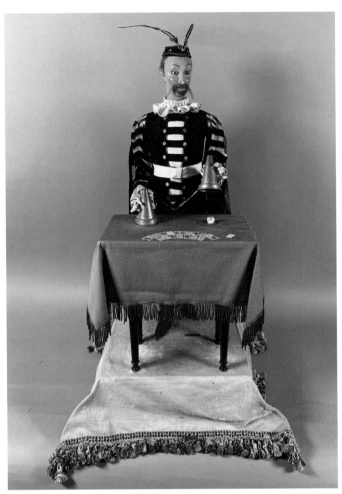

This clockwork automaton is nearly 130 years old and so large it is difficult to imagine the grand houses he was made to inhabit. An almost overpowering figure made of papier-mâché and wood with a musical clockwork motor contained within the base, he was probably used as after-dinner or soirée entertainment in an age where mechanical life was itself magical.

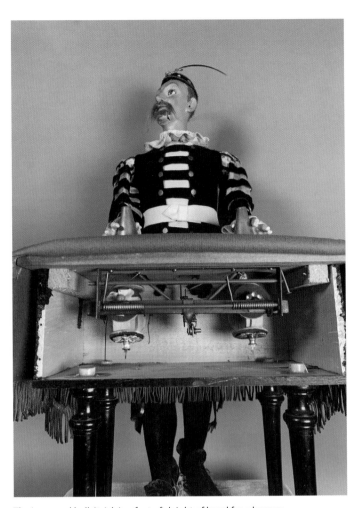

The 'cups and balls' trick is a feat of sleight of hand for a human performer. The automaton magician, however, uses mechanism to make the different objects appear from under the cups. Lifting the tablecloth reveals that the table is packed full of mechanism. There is a rotating carousel holding the objects before lifting them into position at each reveal.

The mechanism

The main clockwork mechanism (opposite) is firmly attached underneath the base of the automaton. The clockwork motor is spring driven and its gears power seven revolving cams and the musical movement. The cams are distributed each side of the mechanism, two on

THE SECRET

In contrast to the sleight of hand artistry of the human magician, the method used by the automaton version is completely mechanical.

- There is a revolving carousel of objects under the table that starts and stops.
- The carousel is lifted up and down between revolutions, raising the highest object up to fill a hole in the table while hidden by the cup.

one side and five on the other. They are positioned to allow their pull rods to ascend up both legs of the figure, except for one cam whose movements are led away by levers to ascend up the table leg. This single cam operates the object change carousel within the table via the hollow table leg. The group of four cams controls the eyelids, mouth, and the turn and nod of the head via wires ascending up the magician's front leg. The last two cams, whose wires rise up the back leg, control lifting and lowering of the arms which hold the cups.

The carousel assembly consists of a wide U-shaped frame almost the entire length of the tabletop. Between the arm tips of the 'U', a shaft is mounted to revolve a quarter turn at a time when the U frame pivots downward. The shaft has three discs mounted on it. The central thin metal control disc has four pins for indexing the shaft round and the two outer discs are wide boxwood wheels mounted exactly beneath the holes in the tabletop. On

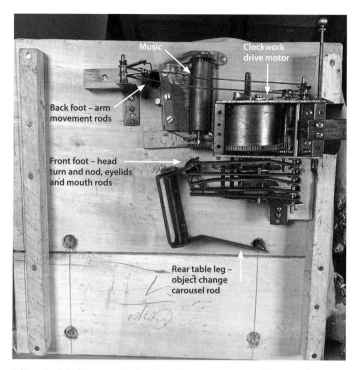

Lifting the lid of the wooden box base the cams, levers and clockwork motor become visible. They are attached to the underside. Note the four table leg holes with a control wire entering the hollow table leg; also visible are holes entering the front and back feet. At the top, the musical movement is driven from the powerful clockwork motor.

each boxwood wheel four felt-covered discs the same size as the holes above them are glued on the wide edge at 90° intervals. These discs are covered in the same material as the tablecloth, green baize. Each disc has one of eight magical objects firmly glued onto it. The objects are a single gold coin, a pile of gold coins, a dice, a diamond ring, a dog, a waving baby, and a pair of candlesticks with candles – eight objects in all.

The carousel frame is pulled down by a wire rod that enters the compartment under the table, via the hollow table leg. When the carousel descends a sprung hook (also called a one-way ratchet) catches on one of the four pins on the central control disc and causes the carousel to index around exactly one quarter of a turn. As the carousel rises again the hook clicks over the pin without hooking on, ready to catch the following pin at the next descent.

The control disc's job of turning the carousel is made snappy and accurate by the shape and pressure of a steadying arm called a 'jumper'. The jumper is spring-loaded upwards and as the carousel turns, its triangular-shaped tip rides over the pins and snaps the carousel round smartly as a pin crests the tip. The jumper then fits snugly up between pins ensuring the carousel is exactly level as it rises into the table holes. The cups then lift to reveal the new objects.

The carousel of objects is attached underneath the tabletop and swings up and down, pulled by a rod. On the downward movement a pin on the pin wheel catches on the fixed ratchet hook and turns the carousel by one quarter turn clockwise. On the way back up the pin can raise the ratchet hook out of the way.

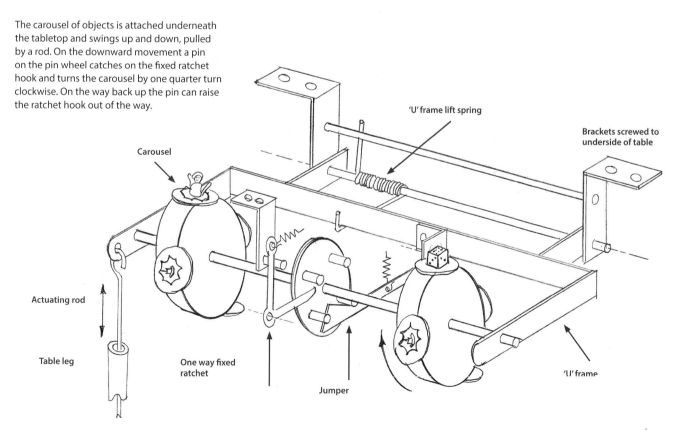

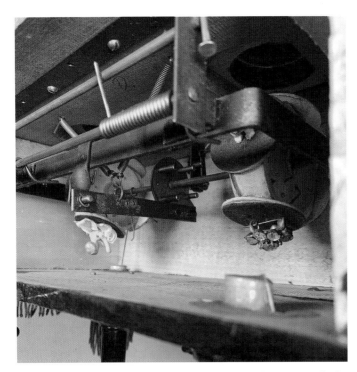

The jumper lever is shown here with two brass springs pulling it upwards. The pointed end of the lever is positively located between two of the pin wheel's pins, ensuring the objects are held precisely in position for the elevation into the cups. At the far end the pull-down rod can be seen coming out of the hollow table leg.

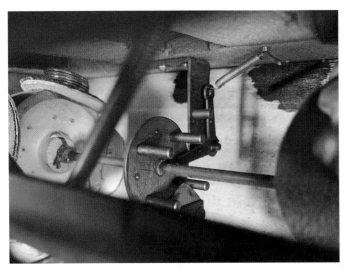

A close-up of the pin wheel and the one-way ratchet hook. The bracket of the hook has a firmly riveted pin which the hook contacts as the carousel descends, forcing it to turn. Note the extra punch marks in the pin wheel, suggesting the same wheel blank could be fitted with eight pins in another type of automaton.

The essential nuances

Timing of the cup-lifting cams is critical in hiding the change-over of the objects, which must take place unseen while the cups are down. The distance the carousel drops down is necessarily small and hence it is important to choose objects that are smaller than the drop of the

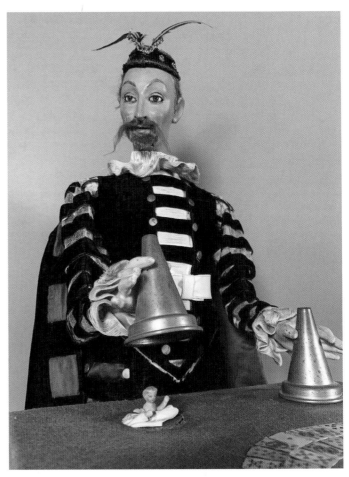

The metal cups are miniature copies of a real set of magicians' cups; they are stackable and the dimple in the top would normally be used to stand a ball or fruit on. A viewer able to look down on the table will see the circular hole around each object that suggests where the objects come from, within the table.

carousel or they will catch on the edges of the hole. The patter (mouth movements) and the head nods are important to coordinate, as the magician must look down at the right moment and direction as each cup is lifted. The holes in the tabletop are rather easy to spot and some automata magicians utilise a heavily patterned tabletop to disguise the hole edges. Our Mephistopheles magician uses a green baize table covering and relies on the viewer's eye level being nearly the same as the tabletop so the hole cannot be seen. This has the advantage of the viewer looking up at the magician's face.

VARIATIONS

Carousel variations

The following carousel variations described both operate on the same principle as the magician above but use just a single cup to produce objects. They also have other interesting features in their construction.

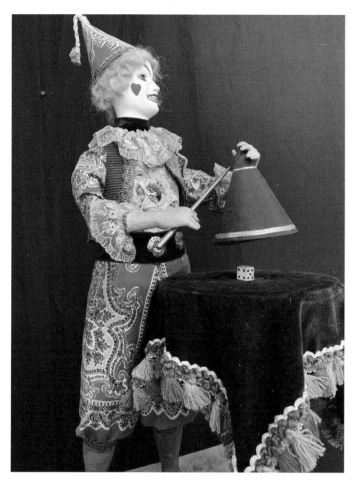

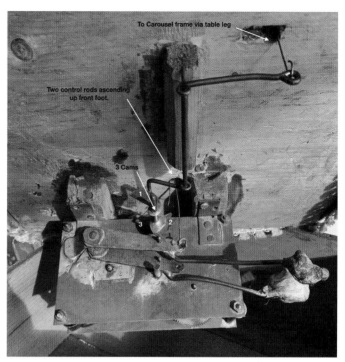

This clockwork mechanism looks like a horological nightmare but works perfectly. Three cams are visible on the one output shaft. Number 1 operates the object-change carousel in the table via the cranked lever wire; number 2 operates the arm holding the wand (note the four 'wand tap' lobes); and number 3 operates both the head raise and arm lifting the cup.

Magician with Cup and Wand. A large German automaton from the late nineteenth century standing 70cm tall. This figure performs without music and for a relatively long time. This usually indicates an automaton designed for use in a shop window display, attracting attention – and requiring a hard-working assistant who would have to wind it up twice an hour at least.

MAGICIAN WITH CUP AND WAND, MULLER, GERMANY, c.1890

The 1890s Muller is a crudely made clockwork automaton yet operates for longer than any other I have seen, at twenty-five minutes. The mechanism is reminiscent of a nineteenth-century toy train power unit. It has an open mainspring between steel plates with the fly spinning directly from the last pinion in the wheel train without the expense of a worm. Coil springs are not used; instead, weighted rods provide the downward force for the cup and carousel. The cams are crude and liberally soldered into position. Despite this crude construction the automaton is reliable and sure enough in operation to use for display purposes. Some automata confound all the carefully considered principles of mechanical precision to achieve reliability and this is one of them. It whirrs, clicks and clonks its way through the long performance and is what I call a 'happy mechanism'.

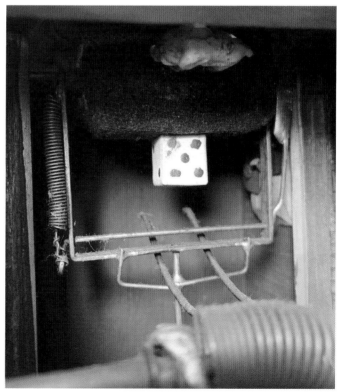

The pedestal table is supported on a single column, allowing the carousel to move directly up and down without pivoting the U-shape frame from the side of the table. The carousel axle moves in wooden grooves and is positively elevated by the substantial forked spring in the foreground. The four objects are a dice, elephant, horseshoe and gold coin.

GIRL MAGICIAN WITH BOX, RENOU, PARIS, c.1870

This single 'cup' Renou magician produces five different objects from under her box. At just 38cm tall, the maker Renou typically uses a very small clockwork drive motor to achieve a lot of movement. This automaton features a bisque porcelain head and distinctive French magician's costume of the nineteenth century. The five objects are produced from under a decorative box held in both hands, and music, from a small musical movement, plays as the performance progresses.

The method used to produce the objects is similar to the carousel and ratchet described above. The five objects are equally spaced out around the carousel and are matched by the number of selector rods at the end of it. When indexing round the space between the rods, the angle turned is smaller with five than with four objects so the height of the objects needs to be lower for clearance within the table. The addition of objects generally means greater precision is needed and five is probably the maximum for three-dimensional objects using this method.

A maker called Théroude uses the carousel method in his Red Magician of c.1860, to produce sixteen different objects. He does this not by lowering and raising the whole carousel as here but by indexing round the carousel and lifting each object individually into place with a pair of wire push rods. The objects are mounted on individual hinged slats of wood, eight either side of the central carousel disc. They are retained inwards with an individual light spring to keep them 'parked' while the carousel indexes around. When they are uppermost the push rod rises underneath them, lifting the object and holding it in position on the table. For a special reason (his use of jets of air), a picture and more information on this magician is to be found in Chapter 4, page 93.

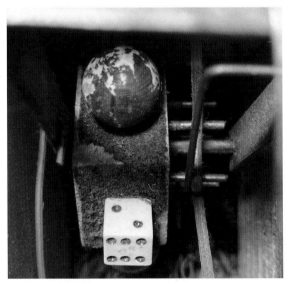

Inside the Renou table. The photograph shows the pentagonal disc for the objects with their five horizontal locating pins. Renou were clever and economical with their levers and made them from bent wire. The 'jumper' lever and the bent wire indexing hook are shown here to the right of the disc. On the left is the carousel's pull-down lever.

The push rod method

The Magician is a very popular subject for an automaton, and the 'cups and balls' trick is one of the oldest magic acts – it was even described by Seneca in Roman times. It is no surprise that there are many other methods used in a variety of automata to produce the illusion. The push rod method below by the St Leger in England is one of my favourites because it is so brazen yet effective.

This musical automaton looks up and down and raises her arms to produce a range of coloured balls and dice from underneath the decorated 'magic box'. Having five different objects appearing under the one cup, the carousel cannot turn a full 90° between objects, which causes a clearance issue under the table when they are in the raised position.

THE MAGICIAN BY LAURENCE AND ANGELA ST LEGER, ENGLAND

This hand-turned Magician is a modern micro-automaton produced by Laurence and Angela St Leger in England. They are extremely small automata made of folded tin, wire and wood and measuring just 30mm high overall.

The mechanism is simple in that the operator's hand turns a cranked wire shaft in the base which has two metal flags soldered at 180° to each other. The two flags raise vertical rods alternately. The first rod ascends through the table to push up on the underside of the magician's right elbow. Both arms of the magician are fixed to lift together on a common shaft. When the left arm lifts, the right arm lifts at the same time, raising the cup to reveal the ball. The cup lowers to cover the ball. The shaft turns further, and the second flag now lifts the other vertical rod which is bent and attached to the *back* of the ball. The ball ascends into the cup pushing the cup upwards from the inside and also raising both arms. The ball is now invisible, hidden inside the cup. The rod pushing up the ball is set back on the table and the size of the cup obscures sight of the rod at normal viewing angles. If the rod is perceived, it appears as if static because the top of rod is not visible.

This magical micro-performer is the size of a dressmaker's pin. Hand turned with the fingertips, it requires just one slow 360° turn of the crank handle to make the ball disappear and appear again. In a larger, more complicated automaton the main shaft could be geared down to require perhaps four turns for the two lifts of the cup.

THE SECRET

The secret is the use of different push rods that alternately lift the arms, one of which is attached to the ball. The small size means that the two push rods that activate the figure are in the field of vision yet are not at all easy to see. The performance features a figure wearing a kimono with large sleeves seated at a table. The brightly coloured ball on the table in front of him is covered by a large cup. When the cup is lifted the ball has disappeared. Repeating the process the ball appears again, as if by magic.

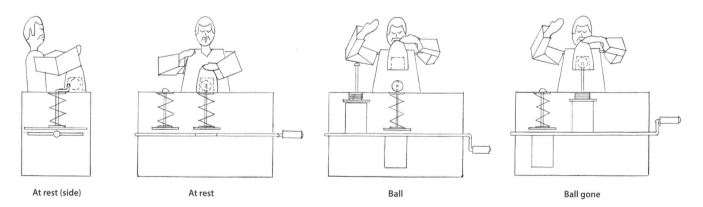

At rest (side) At rest Ball Ball gone

The Magician sits with his cup covering the ball. At rest, both lifting rods are down. They are held down by two very light springs as the weight of the two rods is not enough to reliably retract them using gravity. To perform, the metal flags revolve, pushing up alternately on rectangular plates soldered to the base of each rod.

The two methods described above are examples of the most common ways that automata have replicated this feat of human prestidigitation, but they are not an exhaustive list. I have not space to mention indexing by use of a Geneva wheel, as used by the 'Timberkits' magician or the rather obvious 'magnet' method that retains a metal ball in the cup until attracted down by a stronger magnet raised up in the base. There are also any number of variations that allow more numerous or taller objects to be produced. It seems the constraint of staying faithful to a well-known routine gives rise to a wonderful variety of creative mechanisms.

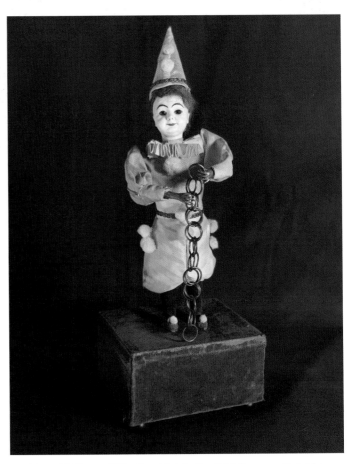

Magician with Rings, *c.*1880, 48cm high, by Roullet & Decamps, Paris. The white porcelain face has an enigmatic smile. As the music begins to play, this whirring clockwork clown raises one hand and releases a ring to tumble end over end to the bottom of the chain. He lowers the hand and another ring falls in a similar glittering descent.

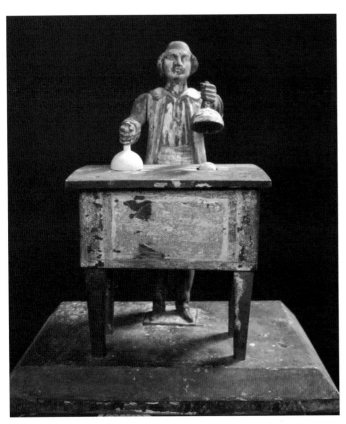

Clock Magician. *c.*1870, 28cm tall, Germany. Standing on top of a clock this magical figure performs the cups and balls routine with eight objects. He is triggered automatically every hour. The mechanism is simply but beautifully made. The clock is from the Black Forest area of Germany, famous for its cuckoo clocks, wood carving and clocks featuring unusual automata.

THE RINGS MAGICIAN, PARIS, *c.*1890

This clockwork automaton has a smiling porcelain head with the benevolent expression frozen on to it. He is the Pierrot clown and wears a silk suit quartered into opposing colours. With both hands he holds up a brass chain of many rings in front of him, reaching almost to the floor. He obviously has something clever to show you. Winding him up starts the music and he moves his head from side to

An automaton performs a captivating illusion where a ring tumbles from top to bottom down a chain of rings.

- Musical performance of a magic trick
- A tumbling ring down a chain of rings

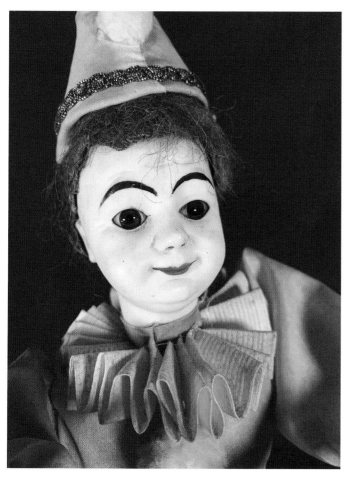

The Pierrot is a white-faced clown with a serious character and in this case he is also a magician. The particularly expressive character head is made of fine bisque porcelain by the specialist makers Simon & Halbig. The head is set with high-quality blue glass eyes and a two colour mohair wig. The body is made of papier-mâché.

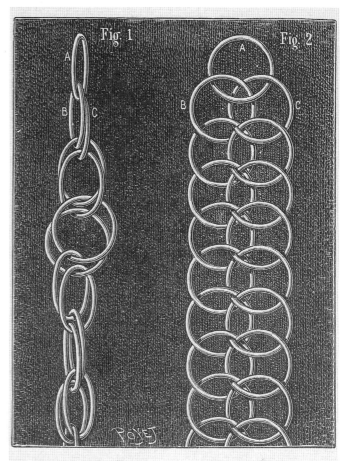

The brass rings are linked together in a special double chain. Two chains are laid side by side and the links joined together between as well as above and below each other. A single terminal link begins and ends the chain. This engraving from a nineteenth-century German magic book *Kolumbus Eier* shows two views of the method of linking.

THE SECRET

The chain of linked rings is actually a double chain with alternate links. It creates an illusion of a tumbling link when one side is raised enough to cause the chain to realign by releasing a link in turn all the way to the bottom.

side. Without further delay he smartly raises and lowers one hand. A ring peels away from the top of the chain and tumbles all the way down the linked rings, eventually hanging from the last link of the chain. As it comes to rest at the bottom he raises his hand again and starts another ring tumbling from the top in an endless cascade of rings. To the audience it seems that a ring is linking and unlinking repeatedly as it tumbles down, an impossible feat – that's why the little clown smiles.

The mechanism

The clockwork mechanism is contained within the base of the automaton. It is simple with only two cams and levers. One of the cams moves the right arm of the clown up and down. The other cam turns the head from side to side. A small musical movement is driven from the great wheel of the drive motor. The real magic happens in the special chain of interlinked rings. The chain is a double chain with pairs of rings at each level. The individual rings of each pair are linked to different rings above and below. It is probably easier to understand by studying the above illustration of 1890 showing the linking method. Interestingly this engraving is the earliest reference I can find of the linking method although it is worth noting the automaton pre-dates it as this model features in a Roullet & Decamps catalogue of 1878. The ring tumble is initiated by the right hand raising and lowering enough to free the top ring and begin the cascade. In effect the illusion is similar to a Jacob's ladder illusion.

Most of the rings were missing on this automaton. As part of its restoration, I had to make new rings of exactly the right size and thickness. A brass wire was first wound into a coil on the lathe. Removed from the lathe it was then slit down its length which separated the coils into individual rings ready for linking.

The hands are made of a cast soft metal inset with a hook that extends from each palm. In this picture you can clearly see the one remaining original ring, with a trace of gilding. It had remained firmly fixed by its hook into the left hand of the figure. The original paint was left chipped to reflect its age.

The ring in the static left hand must be held firmly so as not to dangle loosely. The ring held in the right hand is hooked onto a loop in the palm and dangles freely. The height by which this loose ring is raised and lowered is carefully adjusted to release a ring to tumble at both the highest and lowest points of its movement. A very important component of the illusion is that the right (moving) hand must pause at the top and bottom of its movement, from the moment the ring tumbles until the ring has apparently reached the bottom of its chain. This pause is essential to allow the tumbling ring to be the centre of attention with no other moving part to distract or shake the chain.

VARIATIONS

The automaton in this section is very much a one trick act, designed specifically to operate the chain of rings. The act can be made a little more explicit by alternating the colour or patina of the rings – silver and gold, for example. In this case it can be arranged that an alternating colour of ring seems to fall and take its place at the bottom of the chain each time. A very 'wizardy' modern version was also made by Frank Nelson in around 1990. The Roullet & Decamps Rings Magician is very rare with only a few examples known; most are in major collections including the Magic Circle in London.

LE MAGNÉTISEUR (THE HYPNOTIST), PARIS, *c.*1910

This large clockwork automaton is 1 metre tall and features an illusionist performing a levitation on his female subject. When wound and set going the hypnotist blinks and moves his mouth as though speaking to his female subject, who gently lowers her eyelids and falls into a trance. He directs with his wand as she rises slowly until

An automaton magician performs with his wand and raises a lady lying on the table up into the air, without any visible means of supporting her. He then passes a hoop around her body.

- Levitating a lady into the air
- Passing a hoop around the body of the lady

apparently suspended in mid-air and then, with a smooth motion, he passes the hoop over her body and moves it up and down. After several seconds the lady descends to the bench, opens her eyes and fans herself as if unaware of what has taken place.

THE SECRET

A hidden central rod raises the lady into the air. Just as in a real magic performance, the success of the automaton is enhanced by diversionary movements of both figures.

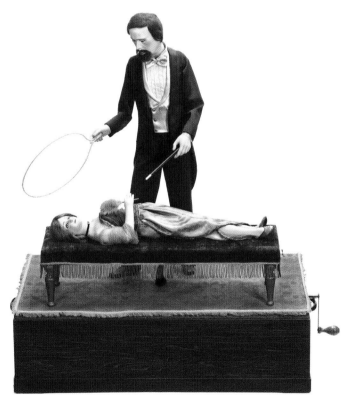

Levitation of a Hypnotised Lady. The inspiration for this dramatic automaton would have been a real stage performance that caught the public imagination. This could have been the film maker and magician George Méliès who performed levitation, with his wife as subject, around this time; another possible candidate is the 'Levitation of Princess Karnac' by the American magician Harry Kellar. (PHOTO: © AUCTION TEAM BREKER, GERMANY)

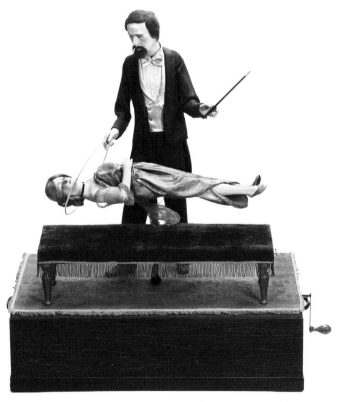

This impressive automaton is a mesmerising subject! It is powered by clockwork; the winding key is visible on the right. It was also made in an electric version for use in shop windows. Large display pieces like this were expensive to buy and many were sold across Europe and the USA to distributors for rental to shops as sales aids.
(PHOTO: © AUCTION TEAM BREKER, GERMANY)

The mechanism

The mechanism is contained within the wooden base that acts as the stage for the performance. It consists of a clockwork drive motor that turns a music box movement and a central shaft upon which nine boxwood cams are fitted. The hardwearing wooden discs make durable cams even though their edges are traced by steel followers under quite some pressure. The first five cams animate levers whose control rods ascend up into the left leg of the hypnotist; these animate the eyes, mouth, head (nod and turn) and the tapping of the magic wand. A sixth cam is led off via a seesaw lever to a rod that goes up the right leg and connects to a crank at the shoulder. This crank moves the right arm to sweep the hoop down the raised body of the lady. The actual levitation is achieved by a barely disguised vertical rod running in a tube in front of the magician's legs. It has been clad in the same black material as his trousers which help to camouflage its presence. As the rod raises the lady, her scarf drapes underneath her to hide it from view. This technique is commonly used in real performances of levitation. Two additional control wires ascend alongside the lifting rod; these are pulled down by levers to animate the eyes and fan.

Once aloft to a height where the head of the lady is in line exactly with the centre of the hoop, the magician then sweeps his arm across, encircling the lady with the hoop to 'prove' there is nothing lifting her other than magic. Importantly the hoop is held in the hand, not vertically, but at an angle of nearly 45° which allows the hand and the leading edge of the hoop to sweep down almost to the lady's knees. Of course the lower part of the hoop cannot pass the central rod but the illusion is effective and is used in real stage performances with a flourish to good effect.

Like most good magic performances, it is not just about the illusion itself but the context and surrounding story. The clothing and demeanour of the Hypnotist suggest a competence and power to levitate anyone or anything. The lady is shown entranced but alive, fanning herself when floating in air above the table. Whilst in most cases the audience assume there is a mechanical method, even if they cannot see it, most people actually have little interest in working out 'how it's done' – they are watching primarily to be entertained. As important as the levitation itself are the diversionary attractions of the Hypnotist and his subject that provide a lot of the entertainment. These attractions include movements of the hoop and wand, the opening and closing of the lady's eyes, imitating a hypnotic trance, and the flapping of the feather fan held in her hand.

VARIATIONS

There are other methods of achieving levitation off a chair or couch in an automaton, most of them use diverse ways of disguising or hiding a strong steel rod and platform on which to elevate the levitated person. Because the automaton is a smaller version of the real act it is a feature

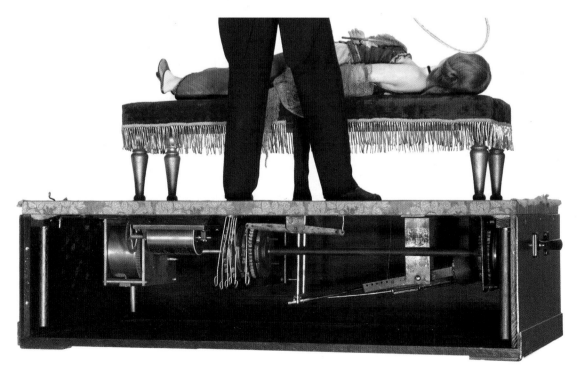

The mechanism is attached to the underside of the stage floor. To service the mechanism, circular dowel legs, visible at each corner, are provided to stand the floor on when removed from the base. The wooden cams benefit from an occasional rub with candlewax. Note the musical cylinder driven by the spring barrel gear of the clockwork drive motor. (PHOTO: © AUCTION TEAM BREKER, GERMANY)

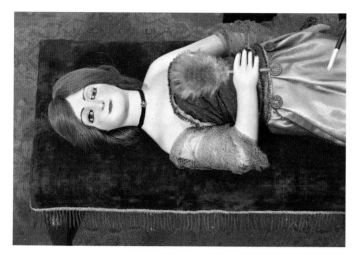

The young lady is made of papier-mâché. She is ready to close her eyes and rise up off the couch. It's obviously very hot in the theatre as she is lightly clothed and carries a fan. The fan demonstrates the automaton maker's skill in making even a levitating figure move, impressive assuming there is no connection to the mechanism. (PHOTO: © AUCTION TEAM BREKER, GERMANY)

of the world of magic that I am not able to go into more detail. Laurence and Angela St Leger, the British makers of miniature automata, have no qualms about exposing their methods, and indeed make automata that flaunt it. They have produced tiny versions of a hypnotist (who exudes green hypnotic rays from his fingertips) and a magician levitating a lady with no legs. Both make no attempt to hide the method and are great examples of automata that are confident and self-assured in their ability to entertain.

Micro-automata measuring just 22mm tall. The mesmerising hypnotist has green rays joined from his fingertips to the eyes of the lady who sways to and fro as he moves. The levitating lady has two wires in parallel: one pushes the lady up into the air; the other goes to the magician and raises his arms. Made by Laurence and Angela St Leger.

Magician with Disappearing Head, made in 1895 and measuring 54cm high. Known as 'The Great Aldow', a Parisian variety magician re-created in automaton form. The key-wound clockwork motor with music box accompanies the humorous performance of this popular magic act, the magician's disappearing head followed by its re-appearance from a dice on a pedestal next to him.

CLOWN MAGICIAN, PHALIBOIS, PARIS, c.1895

This clockwork automaton is realistically modelled on a nineteenth-century performing clown known as 'The Great Aldow'. From contemporary publicity posters we know what he looked like and that he regularly lost his head as part of his act. The automaton version was made by the firm of Phalibois in the Marais district of Paris in the same period he performed. The makers would have seen the stage act and modelled the figure from life, giving the automaton its authentic lifelike character.

Musical performance of the classic 'disappearing head' illusion.

- Head disappears
- Head appears out of a box
- Head re-appears on body

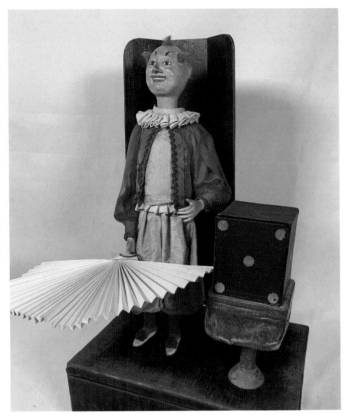

The automaton as we received it was in a very poor condition, with damage from sunlight, damp, moth and woodworm in addition to the wear and tear of its 130 years. It has now been restored very carefully to retain the original clothes and paint. The mechanism is now in full working order, presenting every nuance of his mechanical performance.

The mechanical performance begins with music; the clown magician smiles, nods and covers his face with a large fan. The fan is lowered and his head has disappeared. He stands upright but headless, whilst next to him is a large black dice on a pedestal. The top of the dice opens like a box and his smiling head rises up out of the dice and turns to look left and right. The fan is raised again and the disembodied head next to the figure lowers back down into the dice. The fan is lowered to reveal the magician now with his head back on his shoulders, smiling and nodding to the audience.

The live act would probably have used an oversized costume with The Great Aldow sinking his head down into the chest of his costume and producing a fine wax head replica from the dice.

The automaton is not constrained by the same physiognomy to doing it this way and can happily hinge the head backwards and out of sight in one smooth motion.

- The head is hinged to fall backwards at the neck and lie flat against the body.
- A second identical head resides always in the dice box.

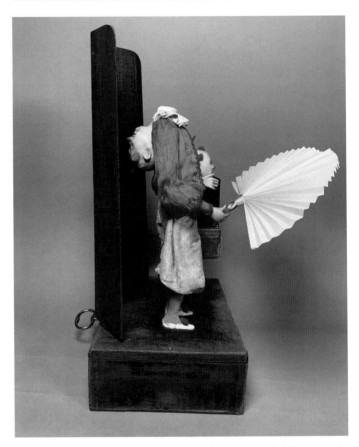

This side view of the automaton gives the trick away instantly. When viewed from the front the head is completely out of sight. A black screen prevents rear viewing and serves to provide an uncluttered backdrop for the white-faced clown. The control rods for the head transposition rise up the clown's hollow legs and the pedestal of the table.

The mechanism

The clockwork mechanism is contained within the base of the automaton. It has three cams and levers. One of the cams swivels the head of the clown back and out of sight. The second cam raises and lowers the arm holding the fan. The third cam controls the raising and lowering of the second head in the dice box. The lid of the dice box is pushed up and open by the head itself, closing again by gravity.

Just like the real magic act, restricting the audience viewing angle is important. The head on the body must hinge backwards and out of sight unobserved for the illusion to work. Two things work together to achieve this: the

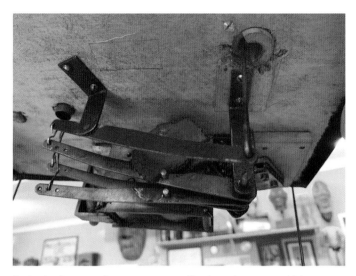

Under the floor, wooden cams are turned by the spring motor which move the levers up and down to co-ordinate the movements. The wire rod on the right is ascending up to the head in the dice. The other two rods are entering a tube which goes up the leg of the clown to the head and right arm.

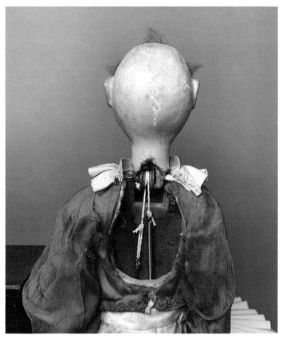

The cut-out in the back of the clown fits the head when it rotates back down. The string is attached to the pull rod just visible on the left. The string then wraps twice around the neck pulley before being tied off on the strong spring whose purpose is to retract the head down when the pull rod rises.

fan and the screen behind the magician. The screen is a fixed structure modelled as a trifold screen and positioned close enough to allow just enough clearance for the head to swing back. The sides of the screen fold around the magician to further restrict the viewing angle. The corrugated paper fan is large and rigid and just the right shape to hide the 'magic' when raised in front of the face and provide a dramatic moment of revelation when lowered.

The head on the body

The head is made of papier-mâché moulded onto a long neck made of wood. The bottom of the neck has a wooden pulley firmly fixed to the underside by two stout staples pressed into the neck core. The pulley does not turn and its axle serves to secure the head to the shoulders by two more staples which act as the hinge for the whole head assembly. The head rotates backwards and up again on the pulley axle. The wooden pulley has two cords, wound in opposing directions, each taking a complete turn around it before being knotted through a hole in opposite sides of the pulley. The first cord coming up from the mechanism pulls the head upright and keeps it looking forward. The other cord is under tension and pulled by an extension spring fixed to the wooden body plate. When the lever in the base rises it relaxes the first cord and allows the spring to pull the head back. Both cords act on the diameter of the pulley at the base of the neck, which effectively acts as a short lever by which the head is levered up and down.

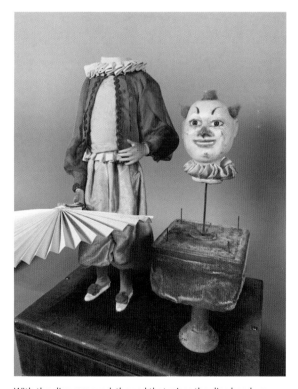

With the dice removed, the rod that raises the dice head up and down can be clearly seen. The other end of this same rod is shown in the earlier picture of the mechanism where its wooden cam can also be seen; the serrations in the wooden cam move this rod up and down in a bobbing action when raised.

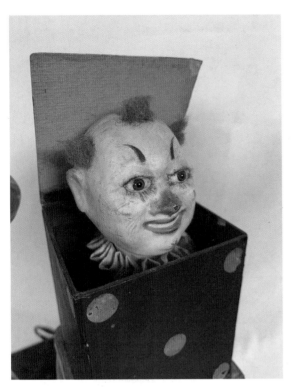

The 'disembodied head' pushes up the lid of the dice by itself, as the lid is made of very light card on a fabric hinge. Lightness is important so the hair is not crushed and the load on the mechanism is kept low. This head bobs and turns due to a loose linkage, the two movements reinforcing the perception of life.

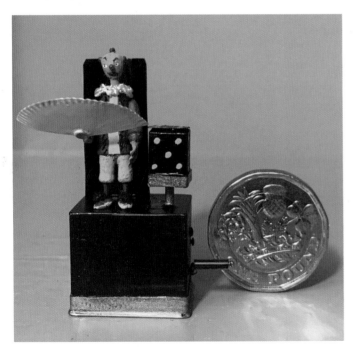

This tiny replica of the Disappearing Head Clown is just 50mm tall (2 inches) and was made by Laurence and Angela St Leger in 2018 as a tribute to the Great Aldow automaton. The mechanism is hand cranked with the fingertips and just three metal flap levers inside the base achieve all the movements perfectly. Made of soldered tin and wood.

Nuanced movements

There are three small movements that greatly increase the lifelike nature of the performance. On their own they are quite insignificant, just small turns and bobs of the head, but in the context of the performance they play an important role in increasing the sense of the uncanny. The wooden cams for both the heads have a series of notches acting when the heads are in the upper position. The 'embodied head' nods repeatedly, engaging the audience with his affirmative gesture before raising the fan and disappearing. The head that rises out of the box also nods up and down with a similar gesture that helps to associate the heads as possibly being one and the same. In addition to this movement there is a deliberate loose linkage where the raising rod is bent around the lever in the base. This loose link causes the dice head to turn slightly when raised, and the up and down movement against the lid of the dice causes the turn to repeat left and right.

VARIATIONS

Before we leave The Great Aldow for something more esoteric I must mention this tiny, fully working version made in tin and wood by the St Legers as a commission to celebrate the demanding and ultimately successful restoration we undertook of the Great Aldow automaton.

DECAPITATING HEAD WALKING STICK

The walking stick with decapitating head is a completely different interpretation of this section's theme, but one that appears frequently in the oeuvre of classical magic and automata. The walking cane has a well modelled human head as the handle. A small sword is removed from within the hollow body of the stick and is used to decapitate the head at the neck. The sword enters the back of the neck and passes all the way through and out the other side without the head falling off or becoming detached. The effect is impressive and the steel sword can be examined closely by the audience.

The mechanical principle is based on that outlined by Heron of Alexandria in his book *Pneumatica*, written 2,000 years ago. The book gives detailed information on several automata that use the principles of hydraulics and mechanics combined. The mechanism used to keep the head on the walking stick while the sword passes through is the same as that used for Heron's Decapitated Drinking Horse.

Heron's automaton features a horse on a plinth which drinks from a bowl in front of it, the level of the water visibly diminishing. While the horse drinks, a sword can be passed through the neck without decapitating the animal and without interrupting the flow of liquid out of the bowl and into the horse. It works with a combination of two clever mechanisms side by side in the neck slit. As

The Enchanted Head. London, J. Bland, *c.*1890. A magician's walking cane topped with a finely carved ebony head. The head unscrews from the body of the cane, exposing a compartment in which is concealed a small knife. The knife can be passed through the neck of the carving without separating it from its brass mounting. Overall length 100cm.

(PHOTO: © POTTER & POTTER AUCTIONS, USA)

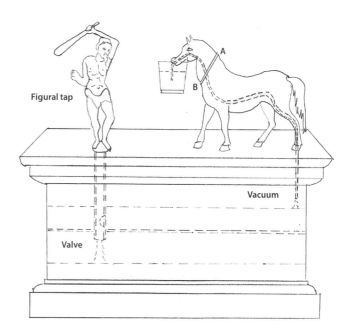

The Decapitated Drinking Horse of Heron is shown on top of a sealed vessel containing two chambers. The upper chamber is full of water and when the 'man' is turned a valve opens to allow flow into the lower chamber. The vacuum produced in the upper chamber draws the water down the tube through the horse from its drinking vessel.

well as the three-dimensional locking gear that keeps the head attached, there is a secondary mechanism using inclined plane sector gears pushed by the sword, to firstly disconnect, and then reconnect the water pipe within the neck as the sword passes through.

The fine drawing below from Alfred Hopkins' 1897 book *Magic, Stage Illusions and Scientific Diversions* is fairly self-explanatory regarding the pipe connection. To keep the horse's head in place a segmented wheel is used; the wheel has a widened circumference, giving it a wedge shape in a sectional view. The wheel runs in a matching wedge-shaped channel allowing it to keep the head locked in place as the sword passes through. The specially shaped 'wedge' channel for the wheel is only necessary in the head section of the wheel's circumference. The arbor of the wheel itself fixes the wheel in the body of the neck (or horse!).

The walking stick is a version of the Heron's Horse mechanism adapted for the magician's performance. In his mechanism Heron of Alexandria has provided us with a clear example of a three-dimensional design for a wheel that is usually thought of in two-dimensional terms. It is a revelation that the segmented wheel is not just round but increases in thickness towards the rim in order to retain the head. This is the kind of thinking that offers opportunities for automaton designers who are prepared to look and think sideways, like magicians.

REGURGITATION

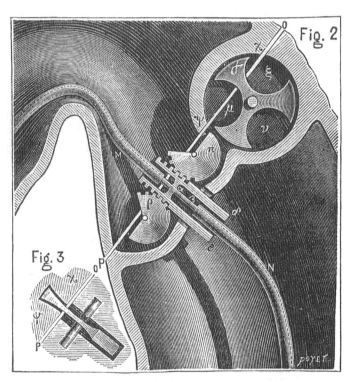

A section through the neck of the cast metal Heron's Horse. The line of decapitation is shown as '0 P'. The three cavities in the wheel are large enough to receive the 'sword'. The lower detail drawing (Fig. 3) shows the thickened rim of the wheel and its matching channel in the horse's head that locks it on at all times. HOPKINS, A. *MAGIC, STAGE ILLUSIONS AND SCIENTIFIC DIVERSIONS*, 1897

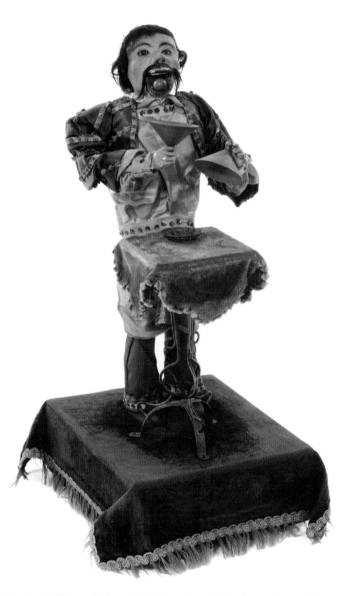

Mexican Ball Regurgitator, *c.*1890, 48cm, Renou, Paris. Strangely enough, the act of swallowing objects and then bringing them up again has been a common sideshow act for centuries. Stones, water, razor blades and live frogs are just some of the things that come up. Regurgitation has become slightly 'niche' in the last century but is still performed.

THE MEXICAN BALL REGURGITATOR, PARIS, c.1880

The figure seems to be a caricature of a grotesque magician standing at a table. As he performs his trick it becomes evident that the oversized wide mouth is there for a reason. The clothes are traditional Mexican entertainer's clothes, and this origin explains the dark complexion and drooping moustache that surmounts the wide lugubrious mouth. The automaton holds a cone-shaped metal cup in each hand: one upside down to catch and the other facing the table to cover. The table in front of him supports a small, pierced plate or basket. When operated the music begins to play and the Magician raises a metal bowl. The mouth opens wide and a large coloured ball appears in the throat and is ejected with some force. It falls with a clank into the metal bowl, which then lowers and tips the ball onto the plate on the table. The plate is now covered by the metal cover held in the other hand. When the covering is lifted, the ball has disappeared. The 'catching' cone then returns towards the mouth to receive another ball, The brightly coloured balls are relatively large, about 10mm in diameter, and quite heavy.

An unusual illusion where a sequence of large coloured balls issues from the magician's mouth. The ball is caught in a cup and then deposited on a plate in front of him. The plate is covered momentarily and when uncovered, the ball has disappeared.

- Producing a sequence of large balls from the mouth
- Vanishing the large balls as they appear

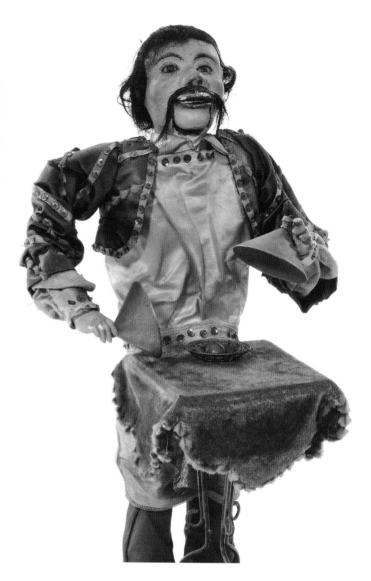

The original costume worn by the automaton is of a professional entertainer and the finely sculpted character head brings the character very much to life even before he starts to move. At this point the blue ball is about to be covered and when the metal cone raises again it will have disappeared. The fine glass eyes twinkle with delight.

THE SECRET

On the table the coloured ball falls through a trap door in the plate down an angled tube into the body of the figure and joins a long line of coloured balls in a vertical tube that extends up to the back of the magician's throat. A wire lever pulls the line of balls up the tube, forcing the ball at the top to be ejected from the mouth. The use of a variety of clever springs and subtle timing differences are essential to the success of this automaton.

The wide mouth is shaped to guide the passage of the ball into the bowl. This close-up shows a blue ball waiting to be ejected next at the back of the figure's throat. The distorted proportions of the head add a surreal aspect. Distortions of proportion such as large hands or an oversized head are often successful attributes in automata.

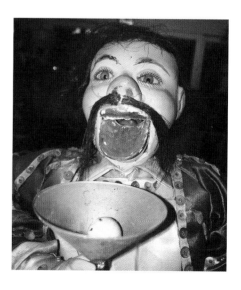

The mechanism

Clockwork motor and cams

The maker, Renou of Paris, is well known for achieving extraordinary movements from very small and simple (cheap) clockwork mechanisms. The Ball Regurgitator is a good example. The whole performance is achieved with a mechanism that turns a single circular 'cam' which operates all four levers. How does it do it? The 'cam' is a plain-edged disc of 25mm diameter with four stubby pins riveted on at exactly 90° spacing; they protrude from each side of the disc alternately.

Renou realised that the action of the automaton can be separated into two groups of movements, each group operating at roughly the same time. The first set of movements consists of: mouth opening, ball expulsion and raising of the plate. And the second group is: covering the ball and opening the trap door. The timing of the movement within each group is varied slightly by using two interesting techniques: firstly, each lever has its pointed follower at a different position around the midpoint of the lever; secondly, in the case of the mouth opening which occurs just after the catching bowl starts to rise, by pulling open the mouth with a running loop and stop on the same wire pull rod that raises the catching bowl. This delays the moment the mouth is opened. The result is that although it appears that the levers work side by side in unison, on the pair of pins that protrude on 'their' side of the cam disc, in fact variation in timing is achieved by the methods described.

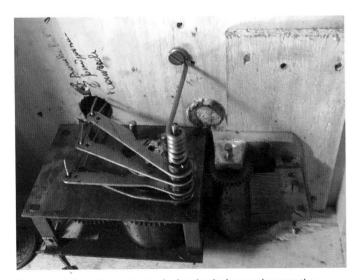

The clockwork mechanism is attached under the base and powers the musical movement and four control levers. There is only one cam, just visible between the levers; the cam has four stout pins riveted onto its faces (two either side) which pull down the levers as the cam turns. The control rods ascend up the leg of the Mexican.

The balls' journey

The fourteen coloured wooden balls are only seen one at a time. They move in an endless loop, spending most of their time rising up the vertical tube in the body of the automaton. When pushed to the top a curved spring ejects the uppermost ball out of the mouth whereupon it falls into a metal bowl held in the right hand of the automaton. The bowl is lowered until the ball is tipped onto the dish on the table. The left hand covers the dish, and a trapdoor opens under the ball which now falls into a hidden tube and rolls down to join its compatriots at the bottom of the vertical tube. The tube has a space for the ball to roll into, as a clever pair of holding springs support the column of balls from falling back when raised by the 'lifting cylinder'. The 'lifting cylinder' rises up enough to eject a ball at the top of the column then it retreats back down far enough to leave the space for the incoming ball to roll into.

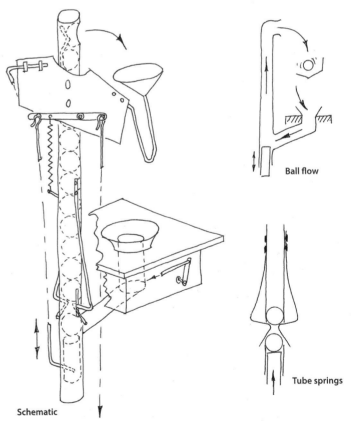

Ball flow

Tube springs

Schematic

The ball mechanism. The wooden cylinder at the bottom of the tube is raised by the chest lever, this squeezes a ball up past the claw springs, pushing the whole stack up. The cylinder drops and a ball from the table rolls into the space above it. I have omitted the trap door, both arms and mouth mechanisms for clarity.

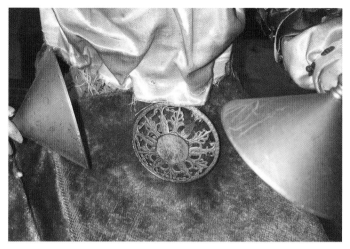

The circular base of the pierced brass bowl is hinged to open and allow the ball to fall down a tube inside the table. The lever that opens the trap door is operated by the same pin on the cam that operates the left arm covering the bowl. This ensures the door will only open when the ball is covered.

The performance

The automaton's performance is one that is full of surprises. The appearance and disappearance of such a numerous variety of different coloured balls is augmented by the deft catching and tipping of each ball on its downward journey. The show is made all the more fascinating by the sound of the wooden balls in the metal bowls accompanied by the mesmerising music played on a musical movement within the base. The whole automaton is as captivating as it is weird. The Mariachi style and grotesque wide mouth of the figure make this a very special automaton and, once again, it is probably modelled from life.

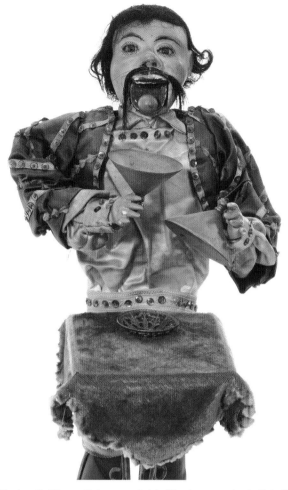

The Mexican Ball Regurgitator uses a total of fourteen wooden balls to fill the tube inside his body. Only one ball is visible at any time, and it is very much on show, being juggled from mouth to catching bowl and onto the table bowl. It is an attribute of an ambitious automaton that it can manipulate a 'loose piece'.

VARIATIONS

The action of the mechanism is quite difficult to reproduce reliably, so it is unsurprising that there are few other versions of it. I know only of an American patent drawing for an electric version that seems to be inspired by our Renou example and a superbly engineered rather scary version made by the artist Thomas Kuntz for use in the Guillermo del Toro film Crimson Peak.

The appearance of a ball out of the mouth of the performer is magical enough, but the automaton compounds the trick by first catching it in a moving dish where it lands with a clang. Then the dish is upturned, accurately tipping the ball onto the dish on the table. The performer then covers the dish for a moment and when lifted the ball has disappeared! This one automaton displays magic and dexterity to excess, so earns its place as one of my favourite magical automata.

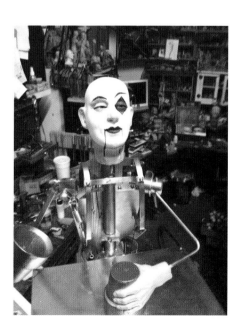

This stylish clown-faced ball regurgitator was made for use in the movie Crimson Peak by the American artist and automaton-maker Thomas Kuntz. The mechanism is strikingly similar to the Renou regurgitator described above, but was designed without knowledge of it. The specific actions required of the automaton as he performs an identical routine probably dictate the mechanism required.

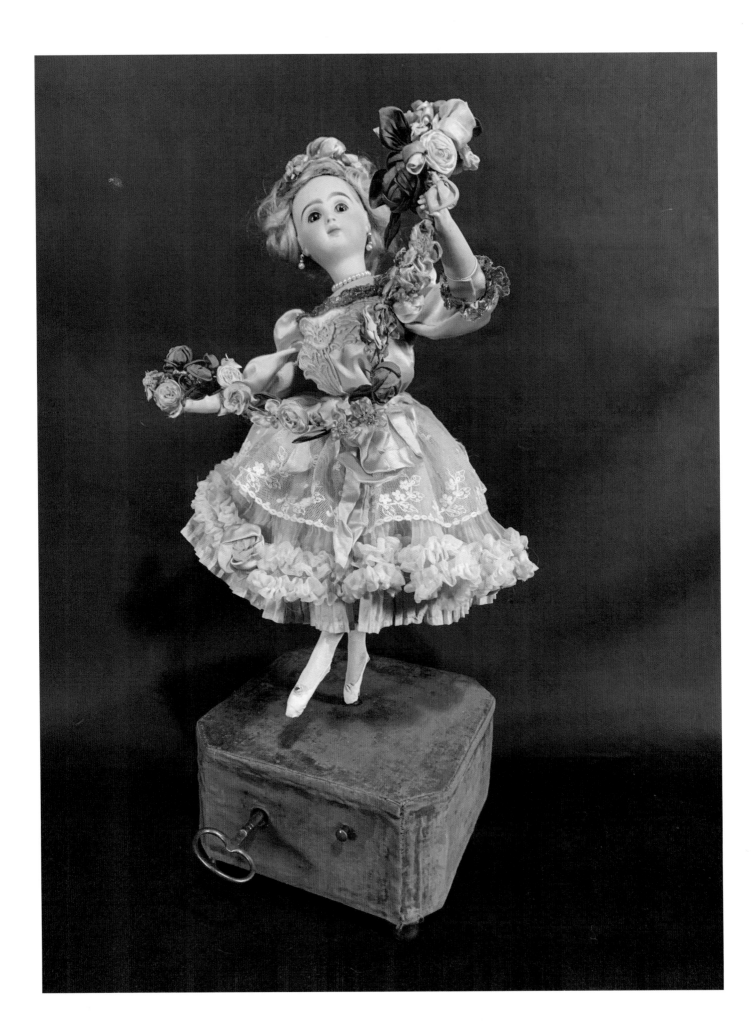

ENTERTAINMENT

utomata are all in the entertainment business by nature, but many automata subjects were actually of well-known entertainers and celebrities – stage acts like the skirt dancer Loie Fuller, comedian Little Tich and Jules Leotard who performed on the trapeze. Commercially it made good sense to build automata of popular figures whose acts could be bought for home entertainment; the cult of celebrity was just as irrational in the nineteenth century as it is now. Also included in this chapter is the section on dancing, which is a very important automaton activity. For many people hearing the word 'automaton' conjures up the image of a dancing 'girl on a music box that's wound by a key' – to quote from one of my favourite films, Chitty Chitty Bang Bang. The character in that film performs her song with movements which I am sure are based on the antique ballerina by Roullet & Decamps described below.

DANCING

There are many different types of dancing automaton and I have chosen the two most popular to describe: a classical ballerina and a twirling step dancer. They are two very different automata in speed and style, with completely different mechanisms. I will start with the Ballerina, who gracefully swoops and extends her leg to a point, whilst pirouetting on the spot.

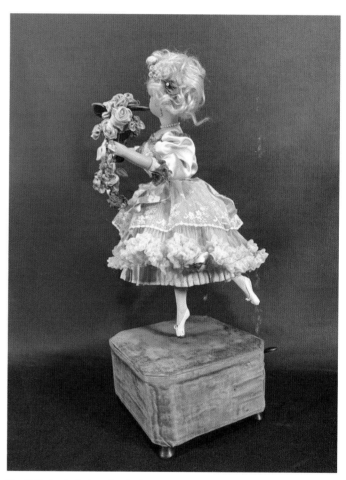

The Ballerina is designed to look impressive even when not moving. She is wearing a fine silk and lace dress with a bisque head and shoulder plate. The garland of silk flowers stretched between her hands is an automaton device to exaggerate the subtle movement at the waist, possibly the same reason a real dancer might hold garlands.

The Ballerina. Automaton dancer by Roullet & Decamps of Paris, c.1880, 45cm tall. The movements are precise and controlled, performed with rigid discipline. As she pirouettes, balanced on point, she stretches her left leg backwards and then swings it forwards while swaying at the waist and raising her garland, moving her head to look up to each side in turn.

THE BALLERINA, PARIS, c.1880

A ballerina that pirouettes on the point of one foot on top of a music box is an automaton cliché. The child's jewellery box ballerina simply revolves when the lid is opened, but the example described here is different. Our Ballerina

- Revolving on point of left foot
- Forward and backward extension of the right leg
- Bending side to side at the waist
- Head turning to look up

is around 45cm tall and has a very complex set of dance movements. Pulling the start button causes the music to start playing and the beautifully dressed figure to revolve on the point of her right foot, a pirouette. As she turns, she bends sideways at the waist, her head looking upwards, whilst kicking out her left leg straight forward. She continues to turn and bends the other way at the waist with her leg now moving gracefully backwards. Amazingly, four movements are produced in an automaton doll whose only connection to the floor is the toe of one foot upon which she continuously revolves.

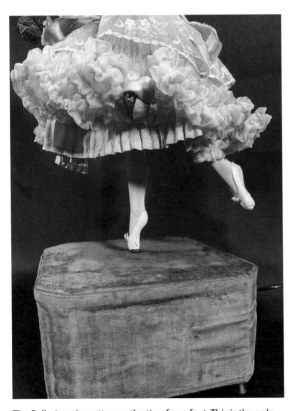

The Ballerina pirouettes on the tip of one foot. This is the only point of contact with the clockwork mechanism in the base. Despite revolving continuously, the figure has four separate body movements. The movements are produced without using a single cam or lever. Here the left foot extends backwards and as she continues to turn, it gracefully moves forwards.

The mechanism

The idea that extra movement can be caused by the doll revolving around a fixed shaft with 'bends' in it, is a simple one. Roullet & Decamps have added clever complications to achieve exactly the controlled precise movements we would expect from a human ballerina. One of the interesting problems they have solved here is that turning the doll around the shaft is a rotary motion, yet the leg, waist and head movements are side to side in one plane only. The mechanical journey described below from the drive motor in the base to the last turn of the head is quite a tortuous and twisty one, but if you can follow all the turns it's very satisfying.

The movement starts with a standard clockwork drive motor hidden in the wooden box base. The musical movement is, as usual, driven from the spring barrel gear of this motor. Unusually there are no other levers or cams, only a rotating output shaft which turns a bevel gear. The

THE SECRET

The secret is deceptively simple:

- The Ballerina is mounted on a tube that revolves around a fixed shaft that does not turn.
- The shaft is offset, cranked in two places which act to push and pull parts of the figure as it revolves.
- The levers to the offset cranks are hinged to convert the rotary motion into side-to-side or reciprocating motion.

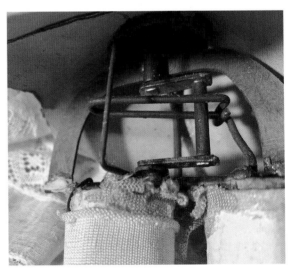

The hip structure and the leg kick mechanism. The long wire loop is soldered around a short brass tube attached firmly to the lifting left leg. Moving the loop to and fro makes the leg kick back and forth. The whole dancer moves around the static crank, allowing it to revolve within the loop's length, pushing it to and fro.

gear meshes with its partner at right angles under the very centre of the base. Now the mechanism starts to get really interesting. The shaft of the central bevel gear is a hollow brass tube extending right up into the figure and fixed firmly into the whole length of the ballerina's leg. Turning this gear turns the tubular axle and the whole ballerina revolves.

The hollow brass tube revolves around a fixed steel shaft which extends up from a bracket in the bottom of the base, into the hollow tube, through the leg and right up to the head of the automaton. This fixed steel shaft is soldered to its bracket in the base and cannot turn while the ballerina, mounted on the hollow tube, turns around it. Visualising the way the mechanism works can be a little tricky because the revolving figure causes its own movements as it turns – a bit like rubbing your tummy while patting your head.

The body frame

The body of the Ballerina is wasp-like in its segmented design to allow for the waist and head movement. The legs are carved from wood and the right leg which contains the tube on which the whole body revolves is a structural part of the figure. Attached firmly to the top of the right leg is the arched flat metal frame of the hips. This has a round bar along its lower edge to hold the short tubular bearing on which the left leg moves back and forth. Rigidly soldered to the top of the arch is a strong curved rod, like a backbone extending upwards to the next section. These connector rods have to be curved to allow clearance up the core of the figure for the cranked shaft around which it all revolves. This upper section is a flat metal shoulder plate. This plate is attached to the rigid hip rod by a bend in the top entering a perpendicular tube bearing; this allows the upper body to bend left and right. The upper body is restrained from collapsing each way by fabric straps attached to each side. Along the bottom edge of this upper plate is another short tube bearing to mount the lever that moves the plate. This lever extends downwards into a loop on the main fixed shaft. The short tube bearing allows the lever to sway back and forth whilst being pushed side to side and so converts the body's rotary motion to sideways waist movement, rather like a connecting rod in a car engine.

The head turn

Our journey up the mechanism finishes with a flourish: the head turns left and right to always look upwards as the body bends down to each side. The head is mounted on a

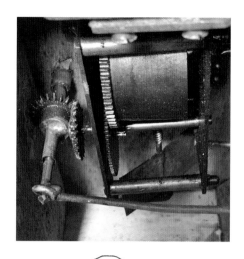

The base contains the clockwork motor whose only output shaft turns a bevel gear. The horizontal gear it meshes with is fixed to a brass tube on which the ballerina revolves. Running through this brass tube is a stationary rod soldered to a cross bar to prevent it turning; this is the hidden cranked rod around which the ballerina turns.

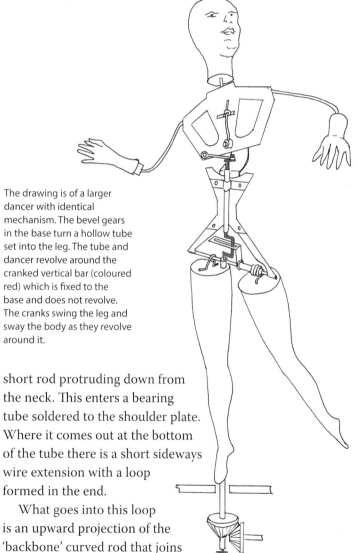

The drawing is of a larger dancer with identical mechanism. The bevel gears in the base turn a hollow tube set into the leg. The tube and dancer revolve around the cranked vertical bar (coloured red) which is fixed to the base and does not revolve. The cranks swing the leg and sway the body as they revolve around it.

short rod protruding down from the neck. This enters a bearing tube soldered to the shoulder plate. Where it comes out at the bottom of the tube there is a short sideways wire extension with a loop formed in the end.

What goes into this loop is an upward projection of the 'backbone' curved rod that joins the hips to the shoulders. That rod, described above, passes through a bearing in the shoulder plate and is bent upwards and into the eye of the head loop. As the shoulders tilt left and right the loop is moved by the (rotating) fixed 'backbone' and hence the head turns.

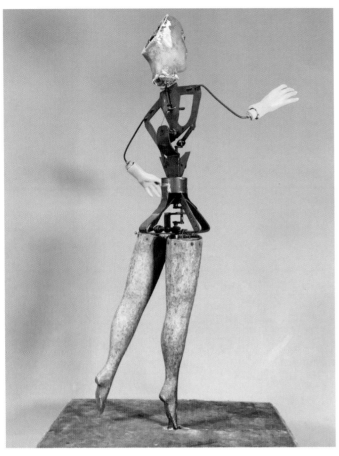

The dancer's body is segmented like a wasp. This rear view of the large dancer shows the curved bracket that holds the upper torso via a tubular bearing to allow it to sway. The hinged 'sway' lever that attaches to the top crank, the head turn lever, and the leg sway lever looped around the lower crank are also visible.

Never has any automaton mechanism been so simple in principle and yet so complex to comprehend in reality. Using the bevel gear on a hollow tube to effect a rotation is the simple part; it is the added kick, bend, arm and head movements that make this maker a true master of the art of automata.

<div style="background:gray">OTHER APPLICATIONS</div>

WIGGLING FIGURE

A variation on the central shaft mechanism used in this enigmatic hand-turned dancing provocateur known as the Wiggling Figure.

Turning the fixed shaft principle described above on its head, this figure is mounted on a hollow tube that, this time, is fixed; in it the central shaft revolves. The shaft has just one revolving eccentric cam or crank in the 'stomach' of the figure. When turned, the stomach is forced to move in a rotary motion, orbiting with the crank but without

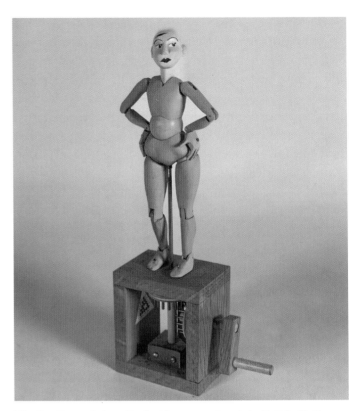

Wiggling Figure, designed by Paul Spooner and made by Matt Smith. The hand-turned mechanism is made of wood with pinned wheels. The figure rotates its hips via a crank on a rotating tube which rotates around a fixed shaft connecting the head to a clamp in the base. The figure is carved from lime. The box is made of beech.

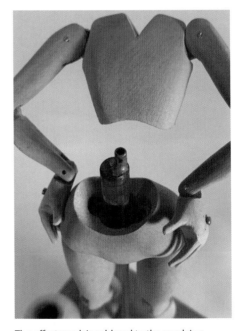

The offset crank is soldered to the revolving tube. The stomach is a sphere with a hole, in which this crank revolves, moving it in a circular motion. The contact area with pelvis and chest provides friction to stop the sphere spinning. The head is on a steel rod that goes through the tube to be clamped in the base.

revolving (like an exotic dancer). It is friction from the beautifully made sockets above and below the stomach 'ball' that prevent it spinning. The friction can be adjusted by the clamp screw for the central rod. This fixed rod is firmly glued into the head and is clamped in the base plate by a grub screw. The friction ensures the stomach moves in a mesmerising, smooth gyration, keeping the same side to the front the whole time. The automaton is remarkable for its fine carving and movable intricate joints. The stomach movement causes every joint from ankle to shoulder to move a small amount, imparting life to the whole figure.

THE STEP DANCER, GISELLE, PARIS, *c*.1900

An 'attractively' dressed dancer who makes up for her lack of grace and beauty with the sheer musicality of her frenetic dancing. The small figure is just 18cm tall and her shapely legs dangle down to stand at the centre of her inlaid wooden stage, a small box. On winding the clockwork motor, she commences her dance with a slow rhythmic rise and fall as the musical box grinds into life. After one or two bars she spins as the momentum picks up. Within a few moments she is at full speed spinning this way and that, legs flailing. Giselle automata are always fitted with short hypnotic tunes, to which the automaton is designed to run for twenty minutes or more. What is extraordinary is that the sequence of spins and turns seems to be synchronised to the music. The long run times encourage the audience to try to work out why the dance appears to match the music, is it random chance or is the dancer really co-ordinating the frequency and speed of her spins with the music?

Chaotic leg movements produce fast spinning and hypnotic dance moves.

- Rise and fall step dancing
- Twirling and spinning at random intervals
- Long duration with hypnotic quality
- Lifelike tempo changes of the dance

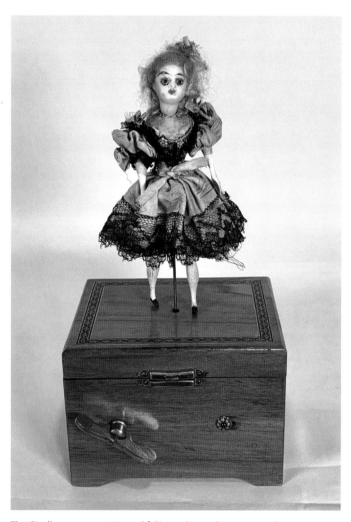

The Giselle automaton 'rise and fall' step dancer, late nineteenth century, Paris. She dances an enthusiastic twenty-minute routine of spins and foot taps that is often in time to the music. The doll has a porcelain head and carved wooden limbs. She rises and falls up to a hundred times per minute and spins when she has a mind to.

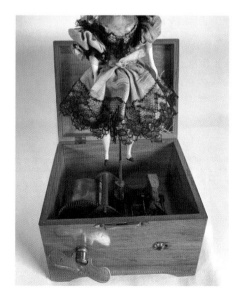

The box base contains a surprisingly large clockwork mechanism to provide the drive to the dancer and music. Here the dancer has been replaced in the guide tube showing how she is supported with her feet either just raised off the base or just lowered onto it so the feet can impel the figure round in a fast twirl.

> ## THE SECRET

Rising and falling: a wire rod pushes the dancer up and down rapidly and repeatedly. The dangly legs hang from wire loops at the hips. Each time the dancer descends, a pointed toe contacts the lid of the box and propels the dancer around. The legs fly out and whichever toe contacts the base first, and at what angle, determines the direction and speed of spin.

The mechanism

This substantial clockwork motor drives a single two-lobed cam on its fastest wheel, shaped like a double-lobed snail cam. The motor is large compared to the size and weight of the dancing doll, and this accounts for the long duration of the dance. The cam turns rapidly at about 50rpm and twice each turn, the flat side of a cam lobe smartly taps up a roller that is riveted to the lifting lever. This lever lifts the steel rod that supports the doll. The cam's 'smart tap' is designed to prevent dragging of the feet with the rise of the doll. The use of rollers and a flat-faced cam makes sure energy is used for spinning, not overcoming friction. The snappy speed of the lift allows the momentary contact of the feet to translate into a glorious free spin of the doll when conditions allow. The lever has a small roller on the lifting end which contacts the pointed end of the doll rod to eliminate friction and to allow it to

spin freely as it is lifted and dropped. The rod runs upright in a short brass tube screwed to the mechanism; the tube ends flush with the hole on top of the box. The steel rod itself is about 120mm long and supports the doll upright where it enters a brass-lined hole between the doll's legs. The smart tap upwards produces a movement of no more than 8mm up and down. Because the rod is smooth and polished, it is not seen to be spinning and going up and down, which lends more mystery to the movement of the doll.

The legs

An important part of the mechanism are the legs: it is the foot's contact with the lid of the box that propels the dancer around. For that purpose, the feet are deliberately pointed. The other important quality is the free-swinging dangly nature of the legs. As the legs swing it is impossible to predict which foot will contact the floor first and at what angle. The suspension of the legs is by two screw eyes, one into the top of each leg. These screw eyes are fitted into holes at either end of a slim brass beam that is fixed under her skirts where the steel rod enters the dancer.

Adjustment

The rise and fall of the dancer is only 8mm and when at rest at its lowest point both feet should touch the box by an equal amount. To adjust the lengths of the legs, the slim brass beam they hang from can be bent for precise adjustment. The dance relies on the phenomenon that when dancing each leg flails outward and drops down again in a chaotic and random manner.

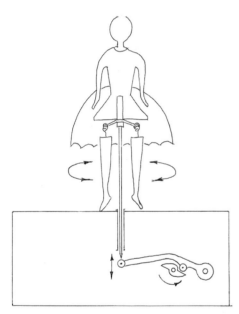

The lever that pushes up the support rod is pivoted at one end and raised by a special double-lobed cam. The cam turns flat side first and strikes a brass roller mounted halfway along the lever. This raises the lever (and the doll) snappily and lets it down at a slower pace over the curve of the cam.

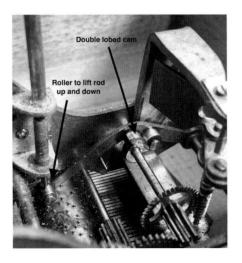

Double lobed cam

Roller to lift rod up and down

The dancing doll's lifting lever is shown in detail here. It is arched to provide clearance for the cam arbor which drives the worm wheel. This wheel is chosen for its high speed of rotation. The two rollers are visible, one for the cam to strike and the lever end roller to lift the pointed steel shaft of the doll.

The legs dangle loosely from their special hooking on a bendable wire stirrup. This allows for precise adjustment of the foot height above the base. When lifted the feet must be clear of the base. It is most important that the legs be adjusted to exactly the same length or there will be a bias in which direction she spins.

THE GROTTO, PHALIBOIS, PARIS, *c.1875*

The rise and fall method of automaton dancing is also used for scenes involving multiple automaton dancers. My favourite is The Grotto, which features a number of Lilliputian dancers in a secret garden. The garden is hidden in a green hillside. The foliage parts and big green doors open like a curtain to reveal the dancers in the hill. The magical scene shows them dressed in fine silks and rising and falling in unison, spinning in different directions as their feet touch the ground while the music plays. The garden is bounded at the sides and rear with walls of mirror glass, angled to reflect the dancers. When the automaton was made the only lighting was candlelight or gaslight and the reflections in the mirror would have made it look like an endless number of dancers cavorting in the dim light when in fact there are just five. Before the viewer can count them, the hillside automatically closes again, hiding the scene. Mechanically the five dancers are raised and lowered by a large plate that elevates and drops all the supporting rods at the same time, just as if they are dancing in time to the music.

Encore

The two styles of dancing described above are used by the four automata in very different ways. Nevertheless, they are just two of the many different styles of dance that automata have been created to perform. I hope the principles of how they work are explained clearly enough to illustrate the creativity and innovative thinking of the finest automata makers. Just arrived in the workshop is a large automaton from 1880 of La Goulue (the inventor of the can-can). When repaired I think it will show the double half kick followed by the high kick.

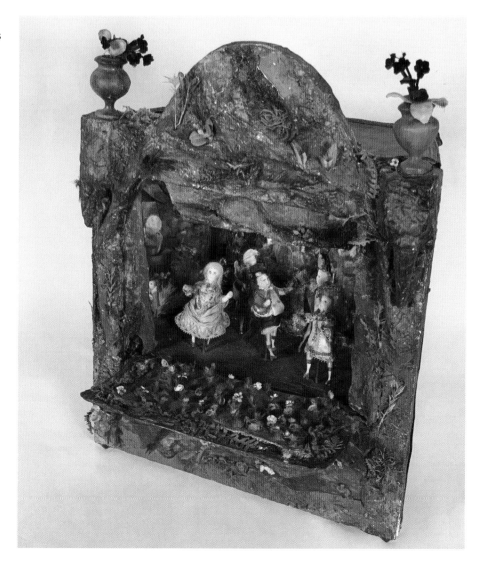

The Grotto, by Phalibois of Paris, *c.*1880, is shown open to reveal the dancers in their original clothes with a garden of tiny shrubs and flowers. Note the mirrored walls to reflect the spinning figures and give the illusion of a multitude of dancers. The support rods for the dancers can be seen between their dangly legs.

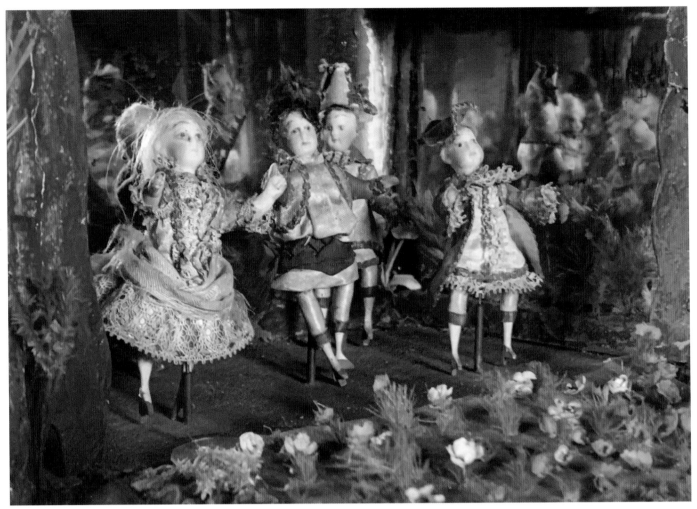

Five tiny dancers just 5cm tall are dancing in a magical mirrored dance hall. Each little figure is equipped with dangling legs and pointed heels. They rise and fall, spinning and twirling to the music. The metal plate in the base contacts all five dancers' push rods at once, making a significant contribution to the music with its tapping rhythm.

LADDER ACROBAT

LADDER ACROBAT, VICHY, PARIS, c.1880

A large luxury automaton based on a real circus act, the Acrobat balancing on a ladder. The height, including the base, is over a metre tall. The acrobat figure himself measures 45cm and when inverted the height increases to more than 1.4 metres. The clockwork motor is wound and the music starts to play. The ladder gently sways and the acrobat nods to his audience in greeting. With his hands

> A single-handed handstand on top of a swaying ladder.
>
> - Handstand on ladder
> - Raising hand off ladder
> - Ladder sway
> - Head and leg movements

on the very top of the ladder it sways suddenly forward and he lifts his feet free. He swings his perfectly straight body upward in a large arc until he is upside down. The acrobat's legs bend back over his head and he struggles to keep the ladder straight. Craning his head back to keep his balance he then raises his left hand up and away from the ladder.

The audience are looking up at the balancing figure. They see that incredibly, the only connection the figure has to the ladder is via the palm of his right hand. It does not seem rational that the mechanism can move this large figure with so little connection to its base where the clockwork motor with its cams and levers is hidden. A handstand with just one hand on top of a swaying ladder. The audience is tempted to believe that the acrobat is alive. There does not seem to be any way to connect the mechanism to the figure. How does the automaton do it?

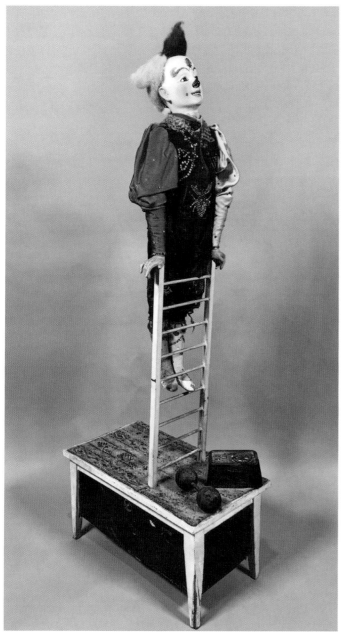

The Ladder Acrobat, Vichy, Paris c.1890. The figure rises to a height of 1.4 metres tall. A real nineteenth-century performer would have modelled for this impressive large automaton that performs a handstand on top of the ladder. When upside down he raises one hand off the ladder and balances on just the palm of the other hand.

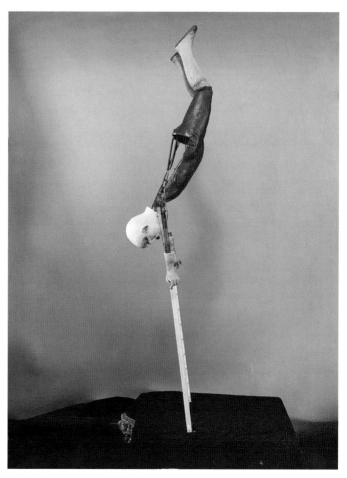

Upside down on top of the ladder is a precarious position, especially with all one's clothes removed. The complete restoration of this rare automaton gives us the opportunity to really examine the mechanism in detail. The clothes would normally obscure the fine modelling of the acrobat and his sculptural poise. Remarkably, the ladder sways to increase the sense of excitement.

THE SECRET

- The maker uses the techniques of the Magician to hide the components. There are wires hidden in the 'solid' side rail of the ladder and the hollow hand.
- The large body of the Acrobat is very light relative to the head, which is heavy and acts as a counterbalance.
- A compact T-shaped folding lever in the shoulder transitions to pull from the front and then the back of the acrobat, to turn him upside down.

The ladder is made of brass and is hollow. It hides three steel control rods from view. They come up from the mechanism in the base and pass through the hollow ladder into the palm of the acrobat's hand and up to the shoulder. The shoulder has two short levers and a bell crank on which the rods are fixed.

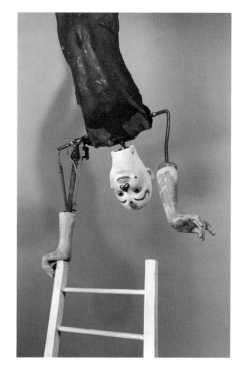

The mechanism

Ladder and arm

The ladder is painted a cream colour and looks like a normal wooden ladder. This is an illusion, as the ladder sides are a hollow box section. The sides are made of sheet brass with round brass rungs soldered into place. Hidden within the right-hand side rail are three wire rods connecting the clockwork mechanism in the base to the figure on the top. The wire rods pass out of the top of the ladder and through the palm of the acrobat's hand. They continue up the hollowed-out arm to the shoulder. Short levers are hidden in the puffy sleeves of the costume. One

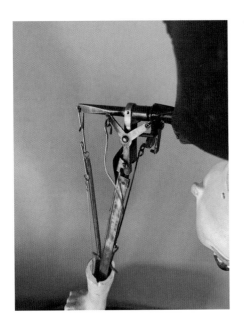

The support arm is a stout right-angle shaped brass gantry; the hinge is visible for tilting the figure. The bell crank is for the head nod, while the steel extension executes the tilt and hand lift. At the rear is the rod and a special hinged lever for inverting the acrobat. The force pulling down on this is very strong.

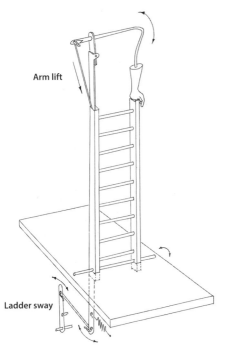

Arm lift

Ladder sway

The acrobat pivots around a fixed steel shaft that passes through both shoulders. This shaft does not rotate but tilts at the hinge on the gantry when pulled by its rod for the hand lift. Omitted for clarity is the hollow tube and lever fitted to the horizontal section of the shaft on which the body and head revolve up.

lever protrudes out front to invert the acrobat when its wire is pulled. The second lever extends out to the side to tilt the whole figure and so lift the other hand up off the ladder. The third wire transmits motion to the head via a bell crank lever on the shoulder and another on the chest.

Hand lift

The lever for the hand lift is small. It extends straight out from the shoulder and is only 4cm long, enough to be hidden by the puffy sleeves of the costume. There is a fixed shaft around which the body rotates passing through both shoulders. This shaft's mounting plate extends up from the ladder and is hinged at the top to allow the body to tilt when inverted. It is this tilting that lifts the left hand free of the ladder, showing how detached the acrobat is and challenging the viewer's perception of what is possible.

Hand stand

The lever for the hand stand inversion has the most demanding work to do. It has to raise the whole weight of the figure out horizontally and swing it up to the inverted vertical position. This lever is in two parts, hinged to allow the body to be raised vertically through 180°. The lever extends out of the front at collarbone level and is only 2cm long in the folded position. It is hinged to 4cm in length to keep pulling past the body's 90° position. The lever gradually opens out as the figure rotates upwards. This opening out keeps the angle of downward pressure effective through the 180° movement.

The weight of the acrobat figure must be kept as low as possible for the clockwork to pull it upwards by the shoulder. This is done using especially thin papier-mâché for the body and counterweighted with a relatively heavy fibrous plaster head. The elevation is further helped by a set of four parallel springs within the body. The springs are fixed to a small 15mm extension on the fixed shoulder shaft at one end and the moving waist of the figure at the other. The extension is angled so the springs act most strongly when the legs are extended out at 90°. The shortness of the extension provides only a very small range of extension for the springs, which is why four parallel springs are used.

Lower legs

A small horizontal extension from the front of the fixed shaft is connected by wire all the way to the lower legs. As the body rotates up and around the fixed shaft, the changing geometry pulls the lower legs. The legs are hinged at the knees and bend back realistically as if the figure is trying to keep his balance.

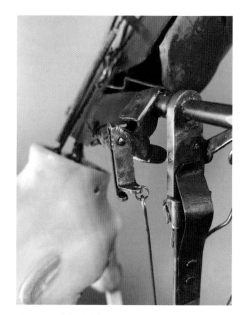

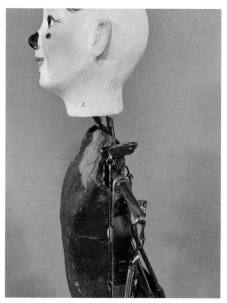

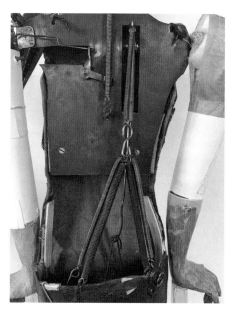

The special double lever that lifts the acrobat from the standing position on his ladder, 180° to the handstand. The two-part lever is very short and subjected to strong pulling forces. In order to keep the angle of pull effective, the lever is hinged to open up. Without the hinge the angle of pull would be limited to 90°.

At rest the double lever that pulls him upside down is above the shoulder and folded shut. It is T-shaped, to pull down from the front of the figure. As the figure revolves upwards past 90°, the hinge opens up and transitions to pull from the rear of the figure via the steel hinge pin of the T-bar.

The back removed, showing the springs that help lift the acrobat. They are connected to a short lever on the fixed shoulder shaft. As the body revolves they contract to assist the lift. The papier-mâché is also unusually thin. Just visible are pull rods leading to the back of the knees, which bend the legs back over the head.

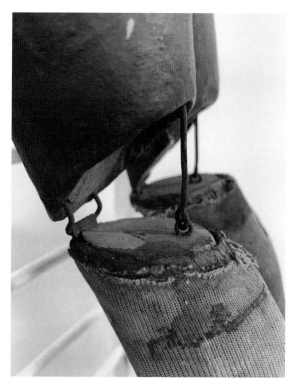

The legs are shown straight in this picture; when bent this triangular gap will close completely. It is often the small movements that the audience are unconscious of that make an automaton uncannily lifelike. This little bend at the knee happens when much more dramatic moves are also happening, but it is important to the natural movement of the acrobat.

Clockwork motor and cams

The base contains the large clockwork drive motor and a high-quality musical movement playing three operatic tunes. The four cams are arranged as one stack and the first three control the figure's movement via metal rods ascending up through the hollow ladder. The fourth cam facing us in the photograph below is the ladder 'wobble' cam. The ladder's feet are hinged on the base and one side of the ladder carries through into the mechanism. The two coil springs are pulling at the base of this ladder extension, whilst a curved wire link leads over to the upright lever which is riding on the cam on the opposite side. The lever is moved left and right, effectively battling against the springs and causing the ladder to wobble as dictated by the cam.

The base hides the large clockwork drive motor and music. This base was rebuilt during the restoration with new wood, as the original had been eaten by termites in Australia. The ladder extends through into the base to provide a means of 'wobbling' it with the cam and lever. The performance the acrobat does is a tremendous feat of balance.

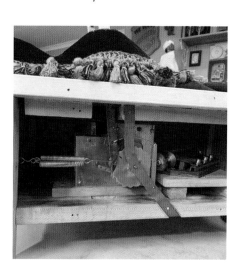

An alternative method

The Parisian makers Roullet & Decamps turn gravity on its head in a different version of this acrobatic feat. This time the handstand is performed on the back of a chair which contains the mechanism. To dispense with the huge strain of lifting the acrobat upside down with the limited power of clockwork, they used a powerful spring to hold the acrobat in the upside-down position when at rest. The clockwork motor uses its cams and levers to pull the figure down into the standing position. When the tension is relaxed the figure rises back up into a handstand as its spring contracts. This method simplified construction slightly and was effective until it broke, when the figure would suddenly flip upside down!

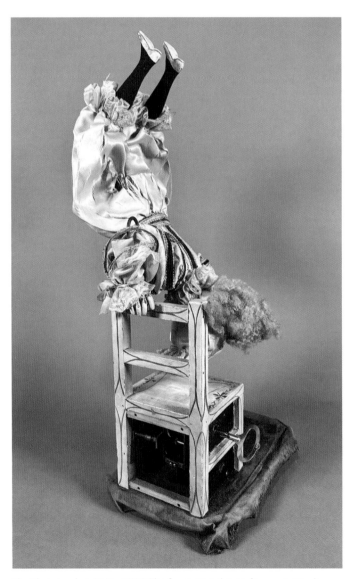

The Chair Acrobat, Paris, *c.*1880. The figure starts his performance standing next to the chair with one hand on the back of it. He then slowly rises into a handstand and lifts one hand off. This version of the acrobat is 'spring loaded' to be upside down at rest and the mechanism pulls him down to the standing position. (PRIVATE COLLECTION)

The two features described above, unexpectedly hollow furniture and small levers for big forces, are found in clocks, magicians' props and scientific novelties. The mystery clocks of Robert-Houdin used delicate-looking pierced brass mounts to hold their glass dials which were drilled with fine channels for transmission rods. These rods turn a worm gear which is hidden in the thin bezel of the glass dial. The worm turns a fine brass ring of gear teeth fitted around the edge of the circular glass dial. To the viewer it looks like the glass dial and bezel are supported on a solid mount of fine metal tracery, but the channels for the transmission rods are similar to the Acrobat's ladder and hand which appear to be solid but are actually hollow.

Balancing toys and novelties often use the natural assumption that a larger object is heavier than a smaller one. This assumption about the materials gives an opportunity to confound the viewer with gravity-defying tricks as well as levitating a muscular acrobat to a handstand.

The Ladder Acrobat. We were lucky enough to have two examples of this automaton in the workshop at the same time. The one on the right is original, and the left was very distressed – it had a missing head, cams and clothes. We are copying the original's clothes and have made an identical head. The restoration here is nearly complete.

THE ROPE DANCER, PARIS, *c.*1880

The tightrope walker and slack rope dancer have been an exciting entertainment for centuries, going back at least to Roman times. The automaton scene portrayed here, by the maker Phalibois, is one of circus performers and musicians in a country idyll, perhaps at the edge of one of the big country fairs popular in Europe during the eighteenth and nineteenth centuries. The large tree framing the performance is integral to the act, both in supporting the aerial artistes and in hiding the mechanism that animates them. This automaton features a loosely jointed male acrobat performing on a bar high in the tree, whilst the graceful female equilibrist dances on a slack rope beneath. The rope is suspended between two colourful A-frames in a manner that adds authenticity to the show. The diorama is designed to be enclosed in a tall glass dome insulated from dust and everyday life. When wound up and brought to life, the music begins to play, and the little figures succeed in bringing the wonder and magic of the fairground into the drawing room.

A tightrope dancer demonstrating high kicks and jumps whilst balanced on a rope, and a method of portraying a classic traverse along a high wire from end to end.

- Dancing on a rope
- Jumping into the air and landing back on the rope
- Trapeze, knee hang turns

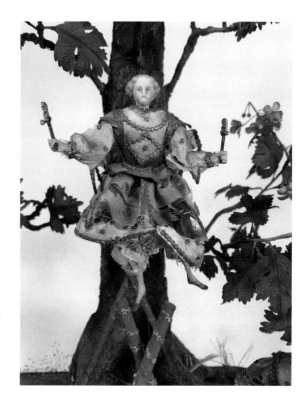

The Rope Dancer, Phalibois, Paris *c.*1880. Height 74cm. A clockwork scene featuring two musicians playing as a tightrope walker dances on her rope. High above in the tree a handsome acrobat performs somersaults on a bar. This rare automaton is in original but somewhat distressed condition, having lost its glass dome. Happily, it works and all the elements are present.

THE SECRET

The secret combines the following:

- The tree with its branches to hide the supports.
- The view being face on rather than side on.
- The distraction of the jumps and kicks.
- The sprung jump rope that flexes on landing.

The rope dancer jumps up and down, kicking out her legs and lifting her hands for balance, holding the remains of a silk flag in each hand. Her china head is mounted on a body plate onto which the wooden arms and legs are pivoted. The dress is fine silk with gold paper trims arranged in swags and points.

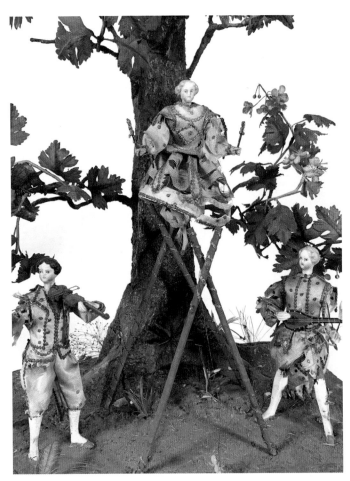

The tree is a beautiful backdrop for the animated scene. It is designed so the leaves and branches disguise the presence of the supports, pulleys and cords that move the figures. When made 130 years ago, before the vibrant colours of the foliage, flowers and clothes had faded, the kaleidoscope of colours would also have contributed to distract the viewer.

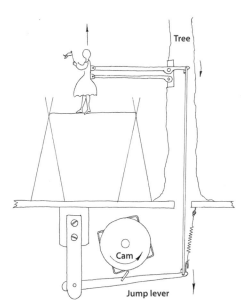

The jump action. The rope dancer jumps vertically due to a parallelogram linkage that connects her to the tree. The drawing shows the staples in the wooden cylinder which will cause her to jump four times in one revolution of the cylinder. Mounted behind the lever and cam will be the other three levers for the arm and leg movements.

The mechanism

While it may seem disappointing that the little figure is not actually balancing on the rope, this feeling is short lived. The moment her arms lift to 'maintain balance' we are encouraged to suspend disbelief and watch as she bounces up and down on the slack rope before ascending upward in a sudden jump. The jump is repeated and each time she descends, her feet land precisely on the rope. The jumps are augmented with a pronounced set of three kicks outward of each leg whilst in mid-air. Down below the musicians play to the tempo of the dance with sound from a hidden music box in the base.

The coded cylinder

The clockwork mechanism is located in the base and drives a wooden cylinder studded with wire loop staples and pins. This wooden cylinder is an economical and exact alternative to a stack of four brass cams. It performs the cams' task with precision but without the risk of the cams displacing relative to each other. The cylinder is made on the lathe and three equally spaced grooves are cut as it spins. Each of the grooves is fitted with loops and staples of wire to animate the dancers' movements, just like the lobes and hollows of a brass cam. The fourth 'cam', for the action of raising the arms, is effectively replaced by four stout pins protruding from the end face of the cylinder. It is these pins, lobes and hollows that are the code on which the dancers' movements are recorded. A line of pivoted levers, each with a protruding follower tab soldered half-way along its length, is arranged to follow its respective groove on the cylinder surface. The follower tab's end is rounded so it sweeps along the surface of the revolving cylinder, riding up and down on the loops and staples.

The transmission of movement from the cam cylinder to the levers and then to the figure is by wire and fine cord or string rising up inside the hollow back of the tree. A change of direction is necessary at the pivoted branch of the tree to reach the arms and legs of the rope dancer. At this change of direction two small free-running pulleys are used for the right and left leg cords as it's important that these light wooden limbs rise and fall quickly without friction.

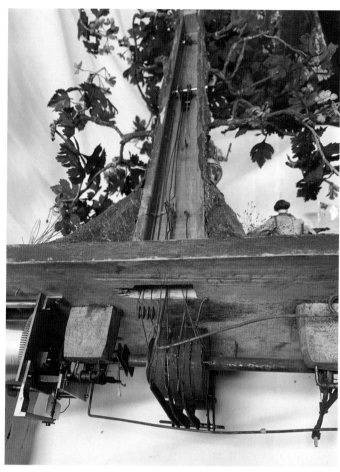

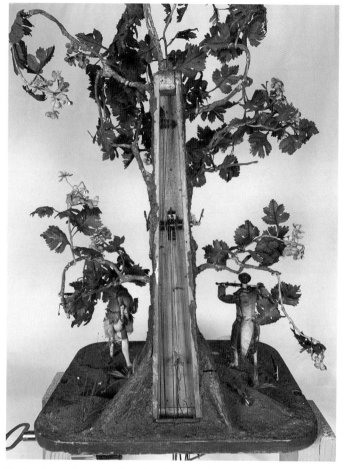

A clockwork drive motor turns a single long shaft upon which the wooden cam cylinder revolves. The central wood cylinder controls the dancer on the rope. The long thin spring on the right is fitted to counter the weight of the dancer via a cord to her support beam, resulting in a sprightly jump replicating the spring of the tightrope.

The tree is usually covered by a thin green wooden panel. It is removed here so you can see the cords and wires transmitting the movements. Halfway up, the support beam for the dancer protrudes and is linked back to the mechanism which pulls it up and down. The topmost wooden pulleys guide out the endless cord for the acrobat.

The pulley for the somersaulting acrobat drive is in the foreground, in front of the main cam cylinder. You can see the shape of the wire staples that act to lift and drop the levers. The use of small groups of three and four staples denotes little groups of fast kicks in the dance, hopefully in time to the music.

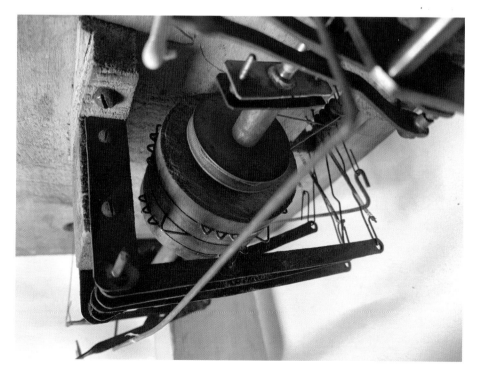

The equilibrist figure

The dancer is carved of wood with a metal body plate at the rear. Attached to the back of the body plate are the brackets for her support beams and at each corner, the jointed shoulders and hips, each with a small, cranked extension for attaching the control cords. The jump into the air is given added realism as the rope, already bending under the weight of the figure, is spring loaded under the floor, to propel her upwards as it straightens out with a snap. The apparently 'wooden' branch behind our little rope dancer is a support lever for her as well as a metal conduit for hiding the control wires going into her back. Underneath the 'branch' is a parallel thinner lever. This is the parallel linkage that keeps the dancer exactly vertical as she jumps. Without this linkage she would jump above the rope in a barely discernible but definite arc, pivoted on the tree behind. The height of the jump is only 20mm but the audience would instinctively know that something about the jump was wrong.

Special feet

It does not go unnoticed to the audience that our tiny tightrope dancer has excellent kicks and flings of the legs while jumping up. Just as impressive is the way the feet always land back on the rope one in front of the other, the rope exactly at the mid-sole of the foot, with toes pointed slightly down. The weight of the figure landing so accurately on the rope causes it to flex downwards in a realistic way. To provide this level of accuracy some help is needed to locate the foot, and this can take two forms. The first, used in our featured example is that the shoes are carved with a pronounced heel. This heel catches the rope and prevents the foot from sliding off; this also causes the knee to bend as the dancer descends, adding to the realism. The second way that feet are encouraged to land on the rope is in the form of a short black guide wire of 3 or 4mm length extending from the heel of each shoe. The legs' descent is adjusted as accurately as possible with a bias to one side of the rope. The foot is then guided by the wire as it descends, sliding along the rope until the foot is planted exactly mid-sole. This process is fast, almost a flicker; the wire is black and its presence so totally unexpected that it does not register as visible unless the viewer is made aware of it.

The tightrope dancing figure is similar to a miniature marionette. She is lightly made and a spring in the base counterbalances her weight. The four cords that link her to the mechanism are as thin as button thread. The cords must be completely soft and flexible to navigate the turns

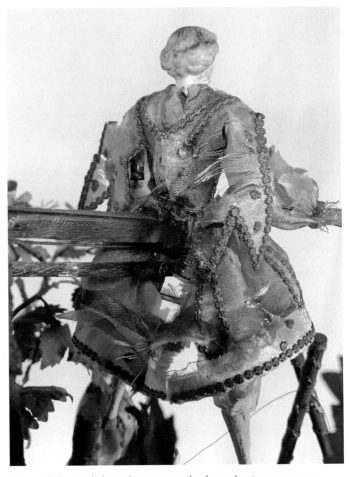

The parallelogram linkage that supports the dancer has two purposes: the brass top beam is hollow and hides the control cords as they enter the back of the dancer; the lower beam constrains the tendency of the dancer to describe an arc as she ascends and descends. This loose-jointed beam completes the parallelogram and therefore ensures she remains vertical.

1 – arched 2 – pin guide

The feet of the dancer are specially shaped to sit securely on the rope. There are two types. The first foot type shows the simple style with a defined arch and pronounced heel to the foot. The second type takes a different approach and ensures a secure landing on the rope by the insertion of a pin into the heel.

The continuous somersaulting movement is very lifelike with a built-in pause using leg hooks – small wire hooks extending unseen from the back of the acrobat's calves. The photograph shows them engaged on the bar as they slide down over it, pausing the inevitable drop in a knee hang pose. Eventually the bar revolves sufficiently for them to drop off.

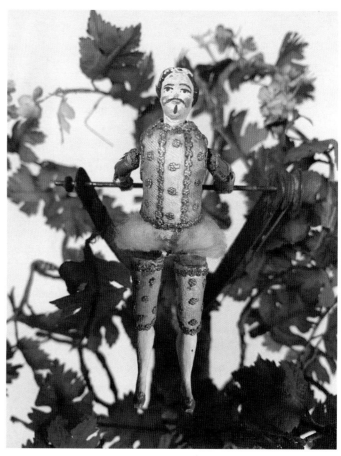

The acrobat has the face of a strongman. His hands are securely fixed to the turning bar as he revolves over and over, showing off his backward somersaults. The pulley and support beams are lost in the foliage of the tree. At the point the driving cord enters the tree a pair of idler pulleys are mounted to ease friction.

to the figure, and hence give sharp, quick movements. Once inside the dancer the cords pull on small bell cranks fixed to the body plate which divert the movement to limb extensions which act as tiny levers. Phalibois, the maker, obviously relished this delicate challenge and dealt with the mechanical nuance with a lightness of touch that was a hallmark of French nineteenth-century horology in all its forms.

The trapeze acrobat figure

This small figure is the male partner to our rope dancer. He performs high up in the tree as if the bar he revolves around is fixed to the highest branches. His movements are a gentle and continuous backward somersault around the fixed trapeze. At each turn, before his legs and body fall to vertical, he hooks his knees over the bar and pauses. The figure turns by way of a large loop of thread-like cord running around a pulley on the wooden cylinder shaft in the base. As it rises up the tree it goes over two small pulleys where the loop exits the tree at acrobat level, and finally around a small disguised pulley on the end of his bar. The hands of the figure are fixed firmly to the bar. As the loop is pulled round, the acrobat turns too. The dramatic knee hang is achieved by two small wire hooks on the back of his lower legs. At each somersault the hooks catch and delay the loosely jointed figure's descent in a most realistic way.

TIGHTROPE DANCER CLOCK

A variation that works on the same principle is this tightrope dancer designed to fit inside a clock.

This dancer is more complex. He has separate mechanism to control the lower leg from the upper leg. Hence, he can raise a leg and then kick out the lower leg from the knee in time to the music. The tiny limbs are constructed with pin pivots much like a miniature marionette. Each limb has an extended lever fitted behind its joints for attaching the threads that animate it.

The mechanism under the base is very compact and can be triggered by the clock to perform at intervals throughout the day. The scene still has the necessary 'tree' to hide the strings that control the figure. The turbaned rope dancer is carved of wood and the body is jointed to enable six different movements, whilst a seventh movement has it leap up and down. Two of the six body movements are as described already, but compounded: the lower leg is attached to the thigh yet both move independently. It is a great accomplishment to achieve precise definitive movements in such a small, 10cm tall figure like this, especially whilst it is at some distance, and two 90° turns, from the mechanism. The mechanism is to the same design as our first featured example, but with three extra levers and their respective tracks in the wooden cylinder. This is all achieved despite the space constraints forcing every component closer together.

Within the glazed brass box he inhabits, much thought has gone in to making him visible. A mirror back reflects the light, and he has been made as large and as bright as possible. The wooden cylinder programmed with staples to animate his dance is located at the very front of the mechanism. This is to allow the row of levers, whose fingerlike followers are on top of the cylinder, to be as long as possible. The length of the pivoted lever is important, the rise and fall of the follower (usually mid-way along the lever) may only be 2 or 3mm over the cam staple, whereas movement at the other end of the lever is increased to perhaps 6 or 7mm, enough to jump or kick a leg. This turbaned dancer carries a balancing pole which amplifies the small movements of the arms. The white segmented overskirt also contributes to showing off the movements of the leg kicks.

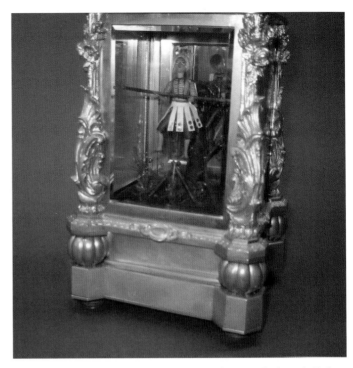

This Carriage Clock Tightrope Dancer is designed to sit in the lower half of a two-tier carriage clock with glazed sides. The automaton and its mechanism would probably have been ordered from Phalibois by the clock maker. The clock maker would then fit it and add the linkage from the clock mechanism to operate the dancer automatically on the hour. (PRIVATE COLLECTION)

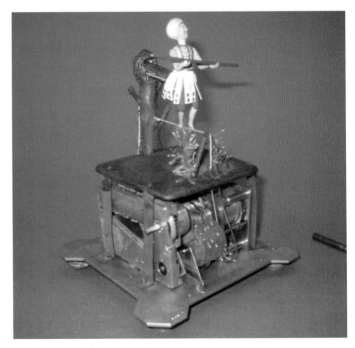

The dance programme is coded into the seven grooves of the cylinder by pressing in staples of varying length and height. Each of the grooves for the rope dancing figure is responsible for a different part of the movement. Unusually, each leg is articulated at the knee as well as the thigh, with specific cam grooves dedicated for each part. (PRIVATE COLLECTION)

Acrobatic Dancer, 1983, by A.J.L. Wright. This drawing is very comprehensive and shows the parts of a similar automaton. It differs in that it has individual cams and a different style of parallelogram linkage; it also has a much-improved adjustable counterbalance for the dancer. (REPRODUCED WITH KIND PERMISSION OF THE MUSICAL BOX SOCIETY OF GREAT BRITAIN)

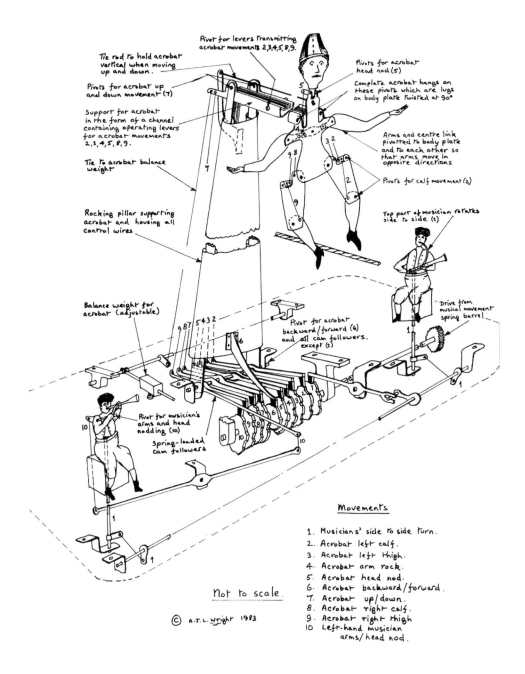

Pivot for levers transmitting acrobat movements 2,3,4,5,8,9.

Tie rod to hold acrobat vertical when moving up and down.

Pivots for acrobat up and down movement (7)

Pivots for acrobat head nod (5)

Complete acrobat hangs on these pivots which are lugs on body plate twisted at 90°

Support for acrobat in the form of a channel containing operating levers for acrobat movements 2,3,4,5,8,9.

Arms and centre link pivotted to body plate and to each other so that arms move in opposite directions

Tie to acrobat balance weight

Pivots for calf movement (2)

Rocking pillar supporting acrobat and housing all control wires

Top part of musician rotates side to side (1)

Balance weight for acrobat (adjustable)

Pivot for acrobat backward/forward (6) and all cam followers except (1)

Drive from musical movement spring barrel

Pivot for musician's arms and head nodding (10)

Spring-loaded cam followers

Not to scale.

© A.J.L. Wright 1983

Movements

1. Musicians' side to side turn.
2. Acrobat left calf.
3. Acrobat left thigh.
4. Acrobat arm rock.
5. Acrobat head nod.
6. Acrobat backward/forward.
7. Acrobat up/down.
8. Acrobat right calf.
9. Acrobat right thigh.
10. Left-hand musician arms/head nod.

FLEA CIRCUS, SCOTLAND, 1995

Traversing the high wire from one end to the other. This is a method used in my mechanically assisted Flea Circus and is adaptable to any automata that feature the traverse high wire act. The high wire artiste, in this case a 'flea' wearing a large feather costume, is placed on to a wire balance beam at one end of the high wire, with tweezers. After some coaxing the flea starts to walk along the length of the wire, stopping and starting – it may go back a little way then stagger forward. When eventually past the halfway point it runs to the end to the loud applause of the crowd. This flea circus uses elements of automata mechanism to give the illusion that the fleas are performing traditional circus acts, whereas in reality a flea often chooses not to co-operate.

The mechanism

Flea circuses are traditionally housed in a suitcase. This enables any mechanism required to be housed under the floor of the circus in the case itself. As a stand-alone exhibit a wooden box base is sufficient with a circular circus ring painted on the top. The high wire is comprised of two 'wooden' support poles, the wire itself apparently stretched between them. A faux knot at each end helps the illusion. The poles are in fact brass tubes painted to look

The wire moves. The high wire itself is a large endless loop, going up and down the supports and under the floor where it loops around a pulley on a reversible motor.

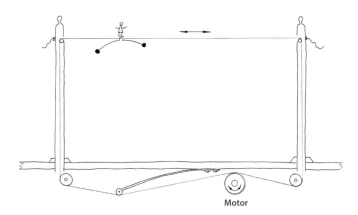

Motor

The wire is moving in an endless loop, so anything placed on it moves as well. It goes through holes in the hollow poles and is powered by a turn around a pulley under the stage. The wire is kept taut by a simple spring tensioner with wooden roller and is a smooth monofilament line which cannot be seen moving.

like wood. The tops of the poles have tiny holes pierced into them and a small cross bar of smooth steel just inside the hole, across which the 'high wire' turns 90° to exit the pole smoothly. The opposite pole is identical to receive the wire and transmit it back down and under the stage. The high wire is a large endless loop with a wire spring tensioner underneath to keep it straight at all times. I use a monofilament fishing line about the thickness of button thread for the wire itself, as it is very difficult to see it moving.

Underneath the floor a small battery-powered electric motor is sufficient to move the high wire loop. In addition, a reversing switch mounted anywhere on the back of the suitcase – and a degree of showmanship in operating it – is all that is required for an exciting stop/start traverse.

The final part of the mechanism is the equilibrist itself, in this case a small feather glued to a speck of neodymium magnet. This 'flea' stands magnetically on a tiny notched piano wire balance beam. The lead-weighted ends hanging just below the level of the wire ensure it stays on for the duration of the traverse. The balance beam and feather figure should also be able to slip on the wire, so when it reaches the end, the wire can continue its circuit around the poles.

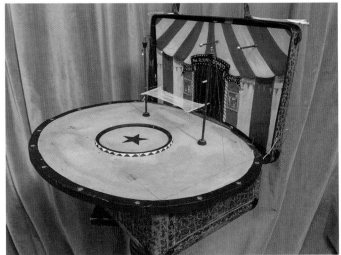

The Flying Starts Flea Circus features some automata elements. In this case the high wire traverse is carried out by a 'flea' wearing a big red feather headdress and placed on the wire at one end. The balance beam and feather make the flea visible at a distance. She teeters from one end to the other erratically without falling off.

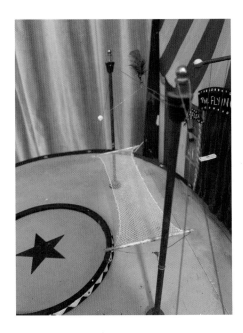

The tiny holes where the wire enters and exits the poles have a short, polished steel bar inserted for the nylon line to turn 90° around so it doesn't fray. Under the stage, larger wooden pulleys are used. Flea circus props were traditionally made by watchmakers for obvious reasons. The safety net is made from a piece of net curtain.

Encore

The Rope Dancer and the High Wire Traverse are two very different approaches to funambulism used in miniature form by automata. The refined rope dancer is an artiste who performs confidently and artistically, carrying out his or her own programme. The high wire traverse is the classic balancing performance, relying on the showmanship of the operator or a cam-operated motor. Both require careful and precise engineering but at least with automata the risk of falling off is much less!

TRAPEZE

TRAPEZE ACROBAT SAND TOY, LONDON, *c.*1860

Leotard Sand Acrobat, *c.*1860, 250 × 180 × 90mm. Based on the real nineteenth-century celebrity 'The Daring Young Man on his Flying Trapeze', this automaton re-enacts Jules Leotard's innovative circus act. The automaton is seemingly simple and is powered by sand. The act of turning the box over recharges the mechanism for a hypnotic and very varied performance.

This glass-fronted automaton is roughly the size of a cereal box. It features an acrobat dangling from a trapeze in the centre of a sparse circus scene. The box is small enough to pick up and the entertainment is started by turning the whole box right round in a clockwise direction and then placing it down upright on the table. The acrobat swings to and fro before climbing right up to spin over the top of his trapeze. He pauses, sitting astride, before diving headfirst forward, catching the trapeze with his toes. Clinging like a bear on all fours to the trapeze he swings round and round before loosing his feet and changing direction mid swing. The performance continues with a myriad of inconceivable variations for up to twenty minutes. The performance is always different, mesmerising to watch and strangely relaxing. If you listen carefully, the spins are accompanied by the faint sweeping swoosh of sand spraying from the spinning wheel hidden inside.

The 1860 Sand Acrobat was made as a tribute to a celebrity, Jules Leotard (1838–1870). The tiny acrobat figure behind the automaton's glass is a miniature portrait of him with his moustache and rigid physique. Leotard popularised the art of trapeze in Paris and achieved fame around the world. His aerial skills were daring yet his fame was not just for his triple somersault but also his eponymous tight-fitting woollen costume – this was so revealing it allegedly caused ladies to faint. The music hall song 'The Daring Young Man on the Flying Trapeze' (1867) was another lasting tribute to his skills.

A tribute to the most famous exponent of the art of trapeze, Jules Leotard. Chaotic motion that includes the following moves:

- Forward and backward spins, splits
- Toe hang (single and double)
- Force out, hollow and sweep
- Long duration movement

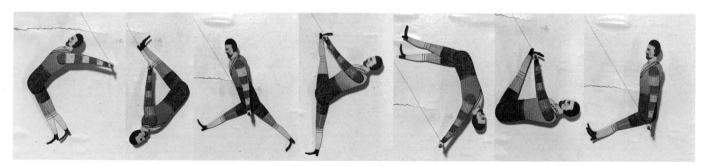

The acrobat swings rapidly from pose to pose, pausing momentarily at every new contortion. There is no set sequence for the different positions. A seemingly infinite number of possible poses are enacted one after the other. In this way the audience's attention is kept by the variety of dizzying circumambulations accompanied by the faint rattle and swoosh of the mechanism.

He'd fly through
the air with the
greatest of ease
A daring young man on
the flying trapeze.
His movements were
graceful, all girls he
could please
And my love he
purloined away.

Powered by grains of falling
sand, it seems impossible
that the unseen stream
of sand could meter out
so many movements
over such a long period,
especially in such a basic
and simple automaton.
The mechanism appears
crudely made of recycled
wood and newspaper stuck
together in a casual manner.

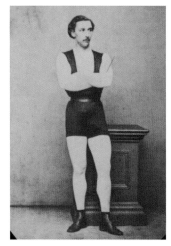

Jules Leotard in *c*.1865. He was the first to wear the one-piece tight-fitting costume that takes his name today, the leotard. The photogenic qualities and aerial skills of Jules Leotard made him a star across many different mediums. As well as the circus, he featured in popular music and early photography. Leotard died of smallpox aged 32.

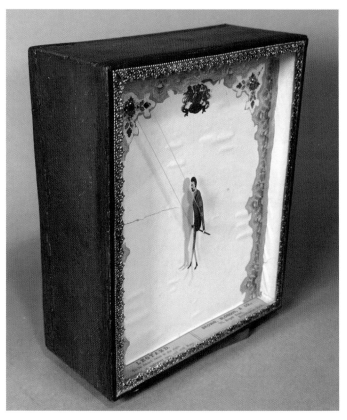

Resting on his trapeze the miniature acrobat is awaiting the spin of the sand wheel. These sand automata are made to a size that is just right to turn over and over in the hands. A clockwise turn will recharge the internal hopper with sand. Metered out grain by grain it can power the acrobat for a surprisingly long time.

In fact, nothing could be further from the truth. This 'toy' of an automaton is perfectly designed for the best possible performance. Deviate from the critical dimensions by a millimetre or use card instead of thick paper for the figure and you will appreciate how good the original is in the resulting performance. I have repaired many sand acrobats and made reproductions of this model. In my experience there is no possible improvement that can be made to the 1860 design described here: it is simply the most perfect of sand acrobats.

THE SECRET

The secret is in three parts:

- The sand falls exactly at the midpoint of a lightweight paddle wheel.
- The acrobat is very light and jointed to act as a chaotic pendulum.
- Glass and tin bearings are used to reduce friction.

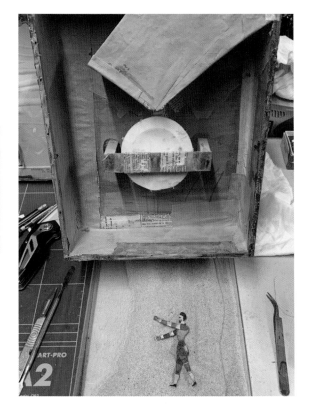

The mechanism appears to be crudely made, using recycled materials like newspaper and packing boxes. In this example the wheel end bearing is a long strip of glass glued to two wooden pillars. In the centre of it is a square of tin, pierced with a pivot hole for the axle and fixed to the glass with strips of glued newspaper.

The mechanism

The acrobat is powered by sand trickling from a hole in a hopper. The mechanism is sealed in the back of a glass-fronted box. The box size can vary but a typical example might measure 250mm high and 90mm deep. The acrobat performs in a 15mm-deep space between the glass and a painted backdrop board, and the trapeze bar protrudes through a hole in the backdrop. It is behind this backdrop that the three main components of the mechanism are located, filling the rear of the box: a cupful of fine sand, a hopper with a hole in it, and a sixteen-vaned sand wheel.

The hopper and wheel

The sand hopper is a triangular-shaped cavity extending over the full width and depth of the box with the point of the triangle downwards. The point has a small hole pierced from the inside outwards, this is so the burrs will not close the hole under pressure of the sand. One end of the hopper is left open, often with a flap or chute to guide the sand to fill the hopper when the box is turned over. Sand in the hopper trickles out of the small hole onto the top of a carefully balanced 12- or 16-vaned wheel. The wheel vanes make compartments for the sand, like a small waterwheel. The axle of the wheel extends through a hole in the backdrop and acts as the trapeze bar at the front. When sand fills the upper compartments of the wheel it overbalances. Which way the wheel turns depends on how many grains of sand fall to the right or left of dead centre. The wheel spins to the heavier side even if just by one grain of sand. The random direction of spin is critical to the success of the performance. Some modern reproductions have the hole too far forward, resulting in the acrobat performing only clockwise spins – not a true Jules Leotard performance.

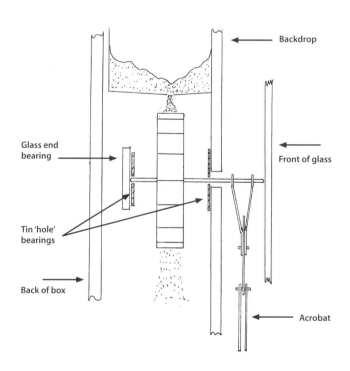

The spindle must have rounded, smooth ends to turn against the glass end bearings. Just as important are the tin holes in which the spindle revolves. If I am replacing one, I punch the hole and then burnish it to size with a smooth broach; the hole should not permit a single grain of sand to enter alongside the spindle.

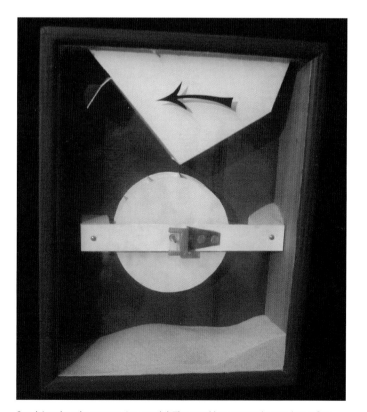

Sand Acrobat demonstration model. The sand hopper at the top has a flap to guide the sand in when rotated. The axle has an end bearing of a small piece of glass held in a bent metal bracket. The front end of the wheel's axle suspends the acrobat by his hands and bears on the inside of the front glass.

The bearings

The bearings are quite particular as the wheel must spin as freely as possible. The card sand wheel is built around a thin axle of small diameter stiff wire, perfectly straight. The axle requires two holes for support and two end bearings to restrict forward and back movement. The support holes are small squares of pierced tin with the hole punched through to allow the wheel to spin freely. The front slip is glued and taped over a larger hole inside the wooden backdrop. The tin slip hole must be large enough for free movement of the wire axle or spindle, but not big enough to allow any grains of sand to pass through to the front where the acrobat performs. Sometimes a tube of paper is glued over the bearing hole, angled downwards to deflect the showers of sand away from the hole. The tin back bearing slip is held by a simple wooden frame around the wheel, again tacked and taped in position exactly in line with the front bearing. The frame also supports the end bearing which is a small piece of glass held in a bracket usually by glued strips of paper. The front end bearing is actually the inside of the glass front of the automaton. The wheel's wire axle then has glass end bearings front and rear with pierced tin holes for support. It should spin very freely.

The acrobat

Thin and insignificant looking, the small, bearded figure looks decidedly rigid for an acrobat. He is in fact made of five pieces of thick printed paper. There are joints at the hips and shoulders. The joints are of two types: pin heads with a paper washer held on by a blob of glue; or thin catgut heated to a ball at each end. The joints must be perfectly loose and free. The arms should be long enough to allow the whole torso to pass through them when required. And finally, the black boots should project at right angles to the lower leg, as they act as 'hooks' for some of Leotard's most entertaining tricks.

The hands of the acrobat are pierced and glued firmly to the wire trapeze (the wheel axle extension). The hands are spaced apart to allow the head and torso free passage between the arms. The acrobat's movements are similar to a double pendulum suspended from his rotating arms. The resulting chaotic motion is randomly affected by changes in direction of the spinning sand wheel and occasional hooking of the legs and feet onto the trapeze. At each complete turn the wheel empties of sand and the weight of the acrobat causes him to tend to hang below the trapeze, only for the wheel to fill up and the chaotic sequence start again.

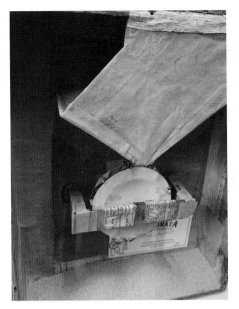

The open side of the hopper allows it to refill with sand when picked up and turned over. This vaned wheel was made of recycled card from the early nineteenth century and revolves in tin bearings, the rear one taped with glued newspaper to the glass strip that forms the wheels back support. All very messy but it works well.

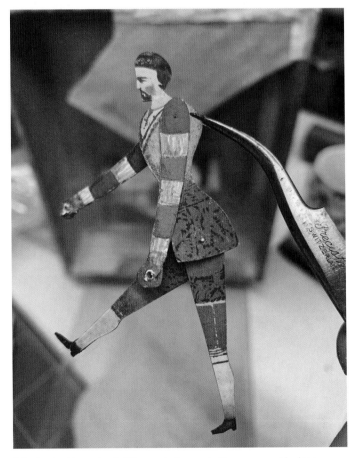

Jules Leotard is made of stiff paper in five parts. The arms must be long enough to allow his body to pass through them when fixed to the trapeze. The arms and legs are held by short pins and swing very freely. Note the attempt at a good likeness and the shoes which act as hooks for some acrobatic manoeuvres.

Other sand automata

In the nineteenth century, many small sand-powered automata were printed in cardboard sheet form to be cut out and assembled by the owner. Épinal was one of the main publishers whose various cut-outs included a range of ambitious sand-powered scenes and dioramas featuring guillotines, the circus and even burning buildings.

The Sand Acrobat can perform for up to twenty minutes continuously. The huge variety of actions entice the viewer to concentrate hard looking for repetition, only to be rewarded by further unique and enthusiastic moves. The pendulum action is chaotic in nature thanks to the joints and hooks and the unseen stream of sand that helps to thwart predictable motion.

Drummer, Paris, c.1860. This small, sand-powered automaton features a very colourful drummer whose arms are moved by wire levers extending through the back board. The wires are lifted and pushed by pins on the sand wheel. One arm beats twice as often as the other to create a soft 'tappet tap' rhythm as the pins strike the levers.

The professionally made glazed box type of sand automaton with a hopper and sand wheel was easily adapted to move multiple wire levers by the use of pins to lift the levers on the face of the wheel. The levers extended through to the scene at the front where they could animate strumming a guitar or drumming.

An interesting version with a hopper and pinned wheel is the Juggler. It uses illusion and momentum to achieve a very realistic juggling action with four balls on wires. With a complex system of levers, the bright yellow balls are perceived to be realistically juggled, especially in candle-light, its original evening illuminant. Like Jules Leotard, it is almost certain that the inspiration for the Juggler was a real performer seen at the circus.

Encore

There are three main elements to the success of the sand acrobat automaton. Firstly, the sand must be fine, clean, and dry (humidity can affect the duration and clog the hole). Secondly, the weight and size of the figure and wheel must be proportionate to each other. The diameter of the wheel should be roughly equal to the height of the figure, head to heel. Thirdly and most importantly, it is vital to make sure the sand falls exactly at the centre point of the wheel. The direction of spin is decided by the number of grains of sand that fall to the right or left of centre. Even a slight direction bias is very disappointing to watch. Without the ability to predict the direction of the acrobat's next trick, clockwise or anticlockwise, the human brain has to allocate that decision to the automaton, thereby increasing the perception of life in the machine.

The Juggler, c.1860. Sand powered. The black wires that support the balls are impossible to see in motion and the resulting movement of four balls, flying in an arc from hand to hand, in both directions at once, is very realistic. The yellow balls are also followed by the eyes of the juggler which move from side to side.

Sand-powered circus to cut out and make. Colourful French Épinal print of *c.*1850. The mechanism uses a cardboard bevel gear, and some skill would have been needed to make the model work. On the right the completed model is drawn. It is quite a game just to identify the components, such as the sand hopper and vaned wheel.

THE MAKERS

The construction of the 1860s Leotard Sand Acrobat appears quite crude. I have often wondered where these sand acrobats were made and how they came to exhibit such variety in the quality of their construction. They all feature identical acrobat figures and similar backdrops with a vibrant green label. Mechanically they all have glass end bearings and the axles rotate in holes pierced through a slip of tin, which is glued to the inside of the backboard and bracket. Some backdrops don't appear to fit properly, and box sizes vary. They use newspaper papier-mâché and some feature more complicated hopper shapes than others. The green labels often state they are made by 'Brown, Blondin, & Co.' of London. I believe this company did not have a factory but used home workers on piece work, supplied with pre-printed parts to cut and glue together. The end result is always a good performance but whoever made them struggled sometimes for uniformity.

DRUMMING

Automata traditionally perform with a hidden musical accompaniment, usually produced by a music box. This self-playing instrument is contained within the automaton and powered directly from the mechanism. In some early automata, music took the form of a group of bells struck by hammers, or a small pipe organ playing music encoded on a rotating cylinder. The music box has a steel comb, the tines of which are plucked by pins on a rotating cylinder. The sound can be very full and rich with impressive musicality. This distinctive instrument is easy to drive from the existing clockwork mechanism inside the automaton, it can be made with the latest fashionable tunes and therefore became the standard musical accompaniment for most nineteenth-century automata.

A very few automata are notable for actually playing real musical instruments. Famous examples are Vaucanson's Flute Player made in 1737 and the Dulcimer Player of Marie Antoinette, 1785. Our automaton subject plays a slightly less refined instrument, the drum, but nevertheless plays it very well.

THE DRUMMING BEAR, PARIS, *c.*1880

The bear is large, standing on the floor, upright on his hind legs. He looks like a small furry man trying to catch your eye, waiting, poised to entertain

- Drumming with rhythm and expression
- Movement of the head and mouth

you. Or, more accurately, to announce you with a loud staccato blast of drum beats. He is made of wood and papier-mâché covered in fur; he has no base and stands on his own carved wooden feet. The upright pose is well sculpted, slightly leaning back to support the weight of the drum at his waist. The clockwork mechanism is hidden within the body with a small protruding brass lever from the chest. When the lever is pressed the bear comes to life. With both arms moving, his drumsticks beat a loud rhythmic 'tune'. The head turns to one side, scanning the room with glinting glass eyes and, most unnervingly, his mouth slowly opens and closes to reveal his red tongue and a full set of pointed white teeth. The repetitive rhythm of the drum sounds at full volume and is like an announcement of a celebration or a grand entrance. It's fair to say the Drumming Bear is best enjoyed in short bursts.

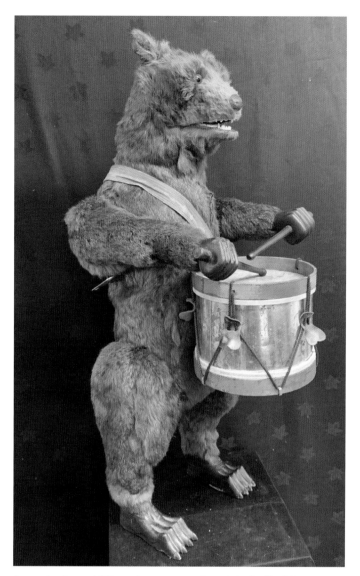

Drumming Bear, *c.*1880, nearly one metre tall, made by Roullet & Decamps at their workshops in the Marais district of Paris. As an after-dinner entertainment its purpose would have been to liven up the domestic piano or poetry recital. In the nineteenth century, actual performing bears would have been a common sight on the streets of most major cities.

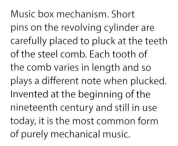

Music box mechanism. Short pins on the revolving cylinder are carefully placed to pluck at the teeth of the steel comb. Each tooth of the comb varies in length and so plays a different note when plucked. Invented at the beginning of the nineteenth century and still in use today, it is the most common form of purely mechanical music.

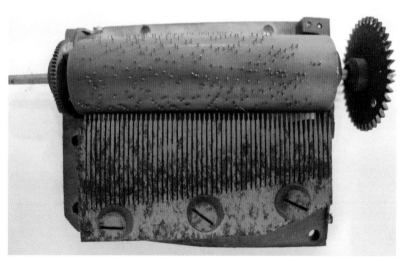

Inside the body, two large star wheel cams are positioned just below each shoulder. The eight points of the star wheel are of slightly different lengths and different spacings. As the star wheels rotate, they lift and release a lever connected to each forearm of the bear, imparting varying strengths and timings to the blows on the drum.

The mechanism

Drumming action

The clockwork mechanism is large and fills the whole torso of the bear. Mounted sideways on to the front of the bear it allows the two side plates of the mechanism to support the upper arms.

On each side of the mechanism extends a shaft with the two star wheels riveted on. Gantries of brass and steel extend out either side around the star wheel and into the arms of the bear. These gantries support the spring-loaded forearms of the bear. The forearms are fur-covered wood with a pair of black clawed hands carved into shape to hold the drumsticks. The forearms have a shaft that extends into the upper arm and pivots at the shoulder. Halfway along this shaft is a side lever extension that is lifted and dropped by the star wheel. The revolving star wheel lifts and drops the lever extension, so rotating the arm by approximately a quarter turn. The lever from the

There is a very similar version of this fur-covered drumming bear made in Germany in 1625 and now exhibited in a museum in Dresden. It is quite possible that the maker Roullet & Decamps knew of this example and based their automaton on it. Certainly, the scale is unusual, much bigger than the other animal automata made by the firm.

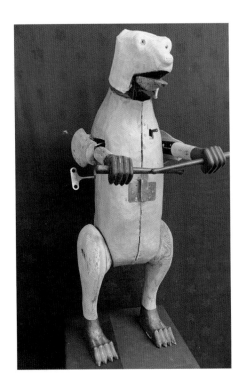

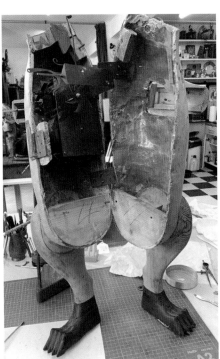

During restoration the fur was replaced. This picture shows the papier-mâché body and wooden arms and legs of the bear. The head and forearms are separate components fixed onto the body and hinged to turn smoothly on steel shafts. The second picture shows the body separated. The large clockwork mechanism has gantries that extend out into the upper arms.

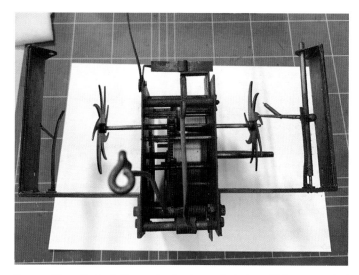

Removed from the body the mechanism is seen to be beautifully symmetrical and entirely made of steel. This top-down view shows the two star wheel cams and the gantries that extend into the upper arms. The star cams lift and drop the arm levers (only the right lever is in place) allowing the drumsticks to make glancing blows on the drum.

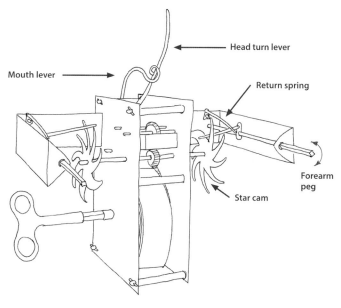

The mechanism is beautiful to watch working on its own. The 'click, click' motion of the arm levers dropping off the points at irregular intervals is hypnotic. The return springs add impetus to the drop-off and give the momentum needed for a glancing blow on the drum. On top, the head and mouth lever extend up into the head.

forearm shaft enters the body sideways from the arm, just above the elbow. This could be a problem in other automata as it would be visible in this position, but with the bear it is hidden by the long fur that covers him.

The arm levers are each lifted against pressure from a strong leaf spring that acts to push down on it. This is crucial to the snappy drumming action required; gravity alone will not provide the right sound from the drum. In order to sound correctly the stick must also stop clear of the drum skin and use its momentum to provide a glancing blow on the drum. The varying heights of the star wheel points provide for hard and soft blows on the drum as the arm is lifted and released by a varying amount. The musical timing of each blow is provided by the variations in spacing between the star wheel points. Both these factors are coordinated between the two arms of the bear before the star wheels are riveted on in their respective positions.

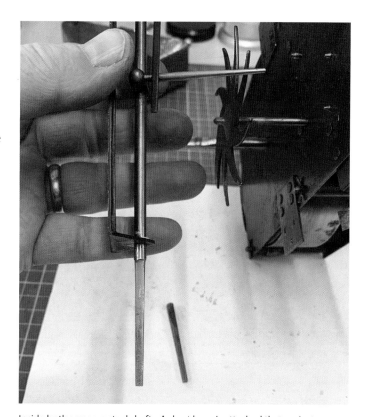

Inside both arms are steel shafts. A short lever is attached that projects sideways and rides along the edge of each star wheel. The lever is lifted and dropped from the points of the star. The wooden forearm is pushed onto the tapered square of the shaft. Note the leaf spring acting to accelerate the downward strike onto the drum.

Head turn and jaw open

The bear turns his head 90° to the right and opens and shuts his jaw, displaying his fearsome pointed teeth. The diagram shows two levers extending up from the mechanism. The levers are moved to and fro by a pin on the main wheel of the mechanism. This pin pushes them forward against a small return spring turning the head. The movement of the levers is small at the pin end but amplified by their length to approximately 20mm to and fro in the neck of the bear. The 'head turn' lever enters a wire loop in the neck to turn the head. The jaw lever pulls down a string which is attached to the underside of the jaw, opening the mouth. These are important additions to the drumming action, and allow this ursine entertainer to engage properly with his audience.

Other musicians

The making of an automaton that plays its own musical instrument has been a challenge that only the best makers have succeeded in. The following are two notable examples.

THE FLUTE PLAYER

In 1737 Jacques de Vaucanson exhibited three automata: a mechanical flute player, a life-sized figure of a shepherd that plays twelve tunes on a tabor and pipe, and a duck. The flute-playing automaton fingered the pipe with both hands, each finger achieving a seal over the required hole, and blew the pipe with varying strengths of wind from the mouth. This was a remarkable achievement, but Vaucanson became famous for his automaton duck, which he claimed effectively digested and excreted its food, exactly as in the living duck.

The Flute Player, the Digesting Duck and the Tabor and Whistle Player created by the French inventor Jacques de Vaucanson in the early eighteenth century. These automata are now lost, yet the fame of the duck has eclipsed Vaucanson's other inventions, which include the first automatic weaving loom, linked metal drive chain, and the first successful application of rubber tubing.

The Lyre Player by Gustave Vichy, Paris, c.1880. Although her harp is missing, this bust automaton has hands sculpted specifically to play the instrument. Despite her poor cosmetic condition she works perfectly, turning and nodding her head as both arms move gently up and down while the music inside the mechanism plays.

THE DULCIMER PLAYER

Built in 1784 by cabinet maker David Roentgen, this belonged to Marie Antoinette, wife of King Louis XVI of France. The beautiful portrait automaton plays by striking the stringed instrument with handheld hammers. The head and eyes follow the hands as they move to and fro across the strings playing a selection from eight possible tunes. The mechanism is not too complicated in principle.

It requires movement side to side and up and down for each hand. This is achievable with a cam and lever for each of these axes. What is particularly notable is the accuracy of construction that was achieved: the movement is transmitted across all the joints and linkages which change direction many times en route to the hammer head. If there is wear or free play anywhere along the linkages this will result in a missed note struck by the hammer.

The Dulcimer Player automaton combines complexity and craftsmanship with great beauty and a royal provenance. The figure actually plays music on a miniature dulcimer, delicately striking the strings with her hammers. The music is programmed onto a stapled drum in the base. The automaton is one of the treasures on display at the Musée des Arts et Métiers in Paris. (PHOTO: JEAN-PIERRE DALBERA, CC-BY-2.0, CONSERVATOIRE NATIONAL DES ARTS ET MÉTIERS)

MASTER TIPS

To really bring an automaton to life there are a number of simple techniques and clever devices that can be incorporated at the design stage. I often look at an automaton in a museum or on the restoration bench and notice that the master makers did not just rely on movement alone to suggest life, they included simple features and little nuances that signify life. Sometimes these are so obvious we take them for granted in living things. This chapter explores eight different features that the master makers frequently used to make their automata stand out, these features change actions into stories, which is in fact the first master tip.

1. THE STORY

The technical challenges of making an automaton can overwhelm the project and easily become the main purpose of creating the automaton. This can result in a finely made moving figure with little to interest the viewer. There is no 'story' in a straightforward movement, a figure just waving its arms or turning might be classed as an automaton, but not an interesting or entertaining one. The automaton is a character in a small show, and as such should have some extra narrative quality or purpose – perhaps humour, irony or surprise. A good rule of thumb is to consider: would it be interesting or entertaining to watch as a real-life action performed by a person? If so, it would probably make a good automaton.

Clown Teasing the Moon with a Beetle, Roullet & Decamps, Paris, c.1890. The winged clown has flown up to the moon and dangles a beetle on a thread in front of the moon's nose. The moon crosses its eyes and wags its tongue from side to side. The eye and mouth movements in this case are opposite to normal. (PHOTO: © AUCTION TEAM BREKER, GERMANY)

2. THE LOOSE PART

Most machines are assemblies of parts firmly attached to each other and working together. When an automaton interacts with an external loose part, unconnected to anything, it immediately seems more lifelike. Here are three examples of loose elements manipulated by three different automata, an arrow, a chair, and a top hat.

THE ARCHER, DAVID SECRETT, 1979

A seated wooden figure of a man holding a bow. The clockwork motor causes him to wink, nod, turn his head, stick out his tongue, reach back to pick up an arrow from

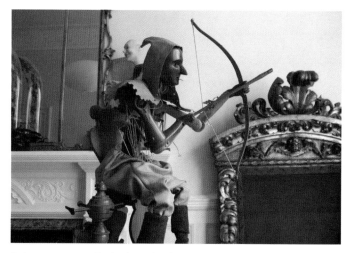

Archer automaton. Made of wood and driven by clockwork, the seated figure takes one arrow at a time from a stand beside him and fires it from his bow before stamping his foot in delight and repeating the process four times. David Secrett made a series of about thirty archers, which were inspired by a nineteenth-century Japanese archer automaton.

a quiver, place the arrow on the string of the bow, draw the bow, aim and fire the arrow across the room. After firing the arrow he stamps his feet in glee and proceeds to take another arrow and shoots that too. Four arrows are fired in succession before the automaton eventually clicks to a sudden stop. The automaton is handling a loose part, the arrow, and dexterously manipulating it with precision and power.

CHAIR ACROBAT, VICHY

Another example of a 'loose part' is the chair acrobat by Vichy, who can pick up a freestanding chair in one hand holding it out in front of him, before replacing it back on the floor and using it to perform a handstand.

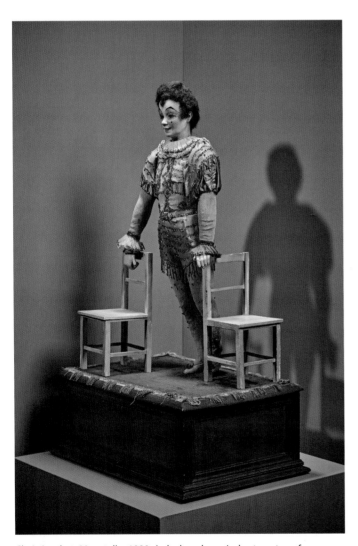

Chair Acrobat, 90cm tall, c.1880. A clockwork musical automaton of an acrobat. One of the chairs is loose, not attached to the base or the acrobat. He picks it ups and puts it down with ease before performing a handstand on the back of it. When upside down he lifts one hand up to balance single-handed. (PHOTO: EUAN MYLES)

BOB AND THE FROG, VICHY

This automaton features a clown who can lift his leg and remove his top hat (the loose part) with the toe of his shoe. The hat is then lowered before it is replaced back on his head with his foot. A small frog holding a rod and standing on the clown's knee has a quick fish in the hat when it is lowered but that's a complication too far now!

3. SURPRISE

The automaton does something unexpected, causing surprise.

THE LADDER ACROBAT, VICHY, c.1890

This is described in detail in Chapter 6. The acrobat balances on a freestanding ladder and then performs a handstand. What he goes on to do next is the fantastic surprise: he lifts one hand up, clear of the top of the ladder. The whole act seems impossible, yet just when the performance is apparently at its climax the automaton adds the hand lift as a surprise feature.

Ladder Acrobat. A gasp of surprise is always heard when he lifts one hand off the top of the ladder, because the marvellous feat of the handstand on top of the ladder is assumed to be the climax of the performance. At over 2 metres tall when performing on a table, this acrobat is looked up to by his audience.

THE RABBIT IN A CABBAGE

This musical automaton is slightly barmy; it shows a very timid, fluffy rabbit rising slowly out of the top of a small cabbage. The rabbit chews, raising its ears listening and looking over the side of the cabbage, then … bang! It disappears back down into the cabbage with spring loaded force. This is one of the most popular French automata ever made, a true bestseller for Roullet & Decamps for over a hundred years. Delightful, musical and surprising, they are usually passed down by owners through the generations until finally they stop working. Even today I have a waiting list of prospective buyers eager for an opportunity to buy this rare and expensive antique.

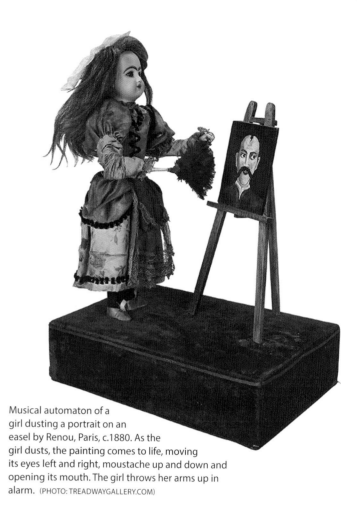

Musical automaton of a girl dusting a portrait on an easel by Renou, Paris, c.1880. As the girl dusts, the painting comes to life, moving its eyes left and right, moustache up and down and opening its mouth. The girl throws her arms up in alarm. (PHOTO: TREADWAYGALLERY.COM)

Rabbit in a Cabbage. Strangely popular action of a nervous rabbit rising slowly and darting back down suddenly, into the cabbage. We have handled more examples of this automaton than any other, yet they rarely come onto the market. Every rabbit had a different character – sweet, eager, cunning, funny or frantic – but they are consistently the most fun to demonstrate.

THE DUSTER, RENOU

The element of surprise is also used to good effect in The Duster by Renou. This automaton of a lady dusting a portrait of a man on an easel, as her feather duster touches the painting the moustache twitches and the eyes roll. The lady flings her arms up in surprise.

THE LEAPING TIGER

The biggest and most blunt of surprise actions probably belongs to the Leaping Tiger (*see* Chapter 3), whose high jump is often matched by the terrified reaction of an unsuspecting viewer.

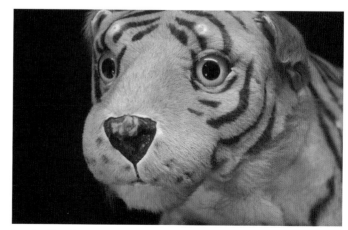

Leaping Tiger by Roullet & Decamps c.1890. The tiger's hypnotic green glass eyes stare straight ahead, his purr turns into a rumbling growl and then he leaps up into the air. This clockwork automaton often requires a quick catch in mid air to stop him leaping off the table completely.

Automata are not just faithful reproductions of moving things but scenes and dioramas that portray stories full of imagination. One of the most successful ways of doing this is to distort reality by exaggerating proportions or including fantastical physical features.

MOON MAN, VICHY

There is a golden rule that the head on a figure must never be smaller than the proportions of the body merit. In fact, it can be very successful if made larger. An oversized head bearing no relation to the proportions of the body like that of the fin de siècle Moon Man by Vichy is particularly successful (there is a photograph at the end of this chapter).

The larger size attracts most of the attention and the face is full of character. In automata, a bit like caricatures and cartoons, there seems no limit to the extent that heads can be made larger whilst still being acceptable to the audience.

THE ORGAN GRINDER

Another pleasing distortion found in some automata are the use of figures like the Organ Grinder, who plays while tiny dancers the size of pixies whirl on the ground and on a stage behind his organ. This mix of scales is romantic and fairytale-like. Other dioramas have no such excuse but are just as successful, an example being the glass dome containing a miniature swan 'swimming' on a mirrored pond while just above him is a taxidermied finch, three times his size, singing in a tree. To make the scale match is

Big Hands, *c*.1890, 55cm tall, Germany. Clockwork advertising automaton with turning oversized head and 'following' eyes. Made with extraordinarily big hands to emphasise what he is holding, and what he is pointing at. The shop would select the item held, possibly a fruit. The eyes move from side to side and the head turns to follow his gaze.

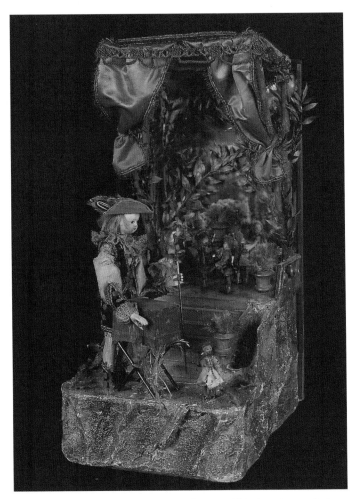

The Organ Grinder with Dancers, *c*.1890, Germany. This charming musical automaton features an organ grinder with monkey in a rural setting. The scale of the dancers behind the organ grinder is tiny compared to his size. The fairytale elements of this piece are emphasised using various scales mixed together and a mirrored background to multiply the number of dancers. (PHOTO: JON AND ANDREA ROBERTSON)

not as important in the elements of an automaton diorama as it might be in, say a painting. On the whole, requiring the audience to suspend their disbelief is often a good idea in telling stories and automata are no exception.

5. ODD FUNCTIONS

There are classic automata that exhibit slightly odd or unexpected movements and sounds. A 1980s life-sized portrait head of the renowned automata dealer Jack Donovan belches realistically using bellows. A lamb that bleeds continuously (religious of course) using a string of red beads on a loop, and many automata that shrug their shoulders and stick out their tongues. All of these features attract attention and a reaction if witnessed in real life and the effect is magnified further when these odd functions are performed by an automaton.

6. MUSIC

Music either accompanying or as part of the automaton's action is the traditional way to enliven interest in an automaton. The senses of sight and sound together increase the immersive quality of the automaton's performance. The sound can take the form of a well-timed bell, whistles blown by bellows or pump, a cylinder music box playing along or just by emphasising the sound of the mechanism itself, leaving the twangs, creaks and groans as deliberate sound effects. The musical movements in most antique automata are either driven from the main clockwork drive motor or they can be independent with their own mainspring and winding key. If they have their own mainspring, they can be used to drive the automaton itself. The power produced is very limited so they are only suitable as a drive motor for lightly loaded automata, such as rocking ships and dioramas with paper moving parts like the Dancing Cats below. Unfortunately small music box movements are also often used in fake antique automata; they are a cheap and readily available drive motor but struggle to power full-sized dolls and figures for long.

Country Lamb, 2004, Paul Spooner. Exhibited at 'A Day at the Butchers'. The flow of blood is started by turning the handle which is connected to a stout square shaft inside the base. The loop of red beads makes three turns around the square shaft ensuring a continuous flow up into the tail and across to exit at the chest. (PHOTO: CABARET MECHANICAL THEATRE)

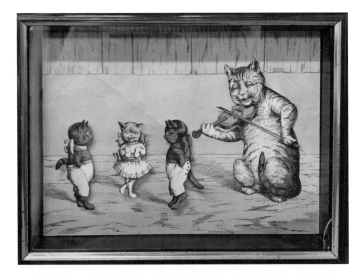

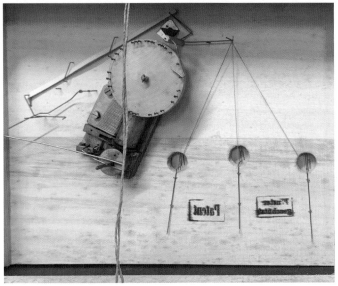

The Dancing Lesson, c.1880, Germany. The musical mechanism powers dancing kittens, who jump up and down in time to the music, as the dancing master bows his violin with gusto. In this whimsical scene the mechanism is very lightly made of pins and threads lifting cardboard figures on fine wire links. The pins are spaced to create the rhythm.

Honeymoon Bed, 1995, Fourteen Balls Toy Company. This automaton has one of my favourite sound effects, a short nylon bar revolves and plucks repeatedly at the end of a stiff brass beam (like twanging a ruler). It is loud and timed to accompany the rhythmic rise and fall of the empty bed. Designed by Paul Spooner and made by Matt Smith.

For a reasonable volume consideration should be given to the location of the musical movement. It is possible to amplify the music considerably using the wooden base or floor as a sounding board and conversely if positioned within the figure, take care not to muffle the music by enclosing it within the clothes and padding of the automaton. Many French dioramas and dome automata are provided with a separately wound and activated musical movement firmly screwed to the baseboard; they sound rich and loud and are usually wound and started by a pull cord and start button. This allows the music to be an optional accompaniment to the performance and I often find this a useful feature. The Archer automaton featured earlier was constructed by its maker (who liked a joke) to play Brahms's Lullaby on a music box at every shot. When I restored it I separated the controls to allow it to perform without the torturous music if required.

Automata are entertainers, performing animated dreams and fantasies. The value in watching them perform can be measured on one level by wide eyes and gasps or more prosaically in the purchase price. To be successful, an automaton must be made and sold, and to help them on their way many makers used fantasy figures and impossible subjects to sell not just a machine but a dream. The following three fantasy subjects have been very successful for their makers:

THE MASK SELLER, ROULLET & DECAMPS

A colourful clown figure who holds up a row of different masks tied to a long ribbon. Each mask comes to life with moving eyes, mouth or moustache. Then the Mask Seller raises his right leg towards you to reveal that on the sole of his shoe is a face that sticks out its tongue.

CLOWN WITH UMBRELLA, VICHY

The clown, embroidered with a large sun face on his chest, is particularly surreal and subtle, as the smiling Sun's eyelids blink (*see* page 51 for details of eyelids). In another large automaton of Punchinello, the distended chest opens down the middle to reveal two small dancing figures within the chest cavity.

THE MOON MAN, VICHY

One of the most enigmatic automatons produced in Paris is the smoking Moon Man by Vichy known as 'Fin de Siècle'. Made in 1898, it is a comment on the end of a decadent age and celebrates the dawn of the twentieth century. The moon head is impossibly large and surreal, with fine glass eyes that roll upwards as the figure blows out long plumes of smoke. I have worked on several examples of these antique automata and am always awed by the maker's imagination in creating a full moon as a very human character leaning on the broken pillar of the past.

The Moon Man demonstrates one last small and subtle feature, the overlap. He wears long pointed silk slippers, the toe of which drapes over the edge of the plinth, suggesting he doesn't belong to the plinth and is detached from it. The same effect is used with small figures apparently sitting on the edge of their plinth or on the edge of a picture frame, legs dangling down, as if not at all attached to their mechanism. It is a simple and effective device.

Fin de Siècle, 1898, Vichy, Paris. A smoking dandy moon figure dressed in fine silks. The figure is obviously surreal but moves and smokes, tilting his head and rolling his eyes. The lifelike nature is emphasised by the shoe overhanging the base. This clever device makes it appear as if he could step off the pedestal and walk away. (PHOTO: © AUCTION TEAM BREKER, GERMANY)

CONCLUSION

My aim was to share the discoveries I have made about unusual mechanisms in my job as a restorer of antique automata. I hope I have been able to explain these 'secrets of automata' sufficiently well for some use to be made of them, perhaps in new creations and the restoration of the old. I have tried to explain the mechanical principles in enough detail to illustrate how the movements were achieved, but not in the manner of a 'how to' book. The temptation to include dimensioned drawings and instructions was quite strong at times but would only have been possible for specific mechanisms and that would have diluted the scope of what was possible for me to describe. Indeed, I wrote quite detailed instructions on how to make birdsong bellows before I realised the chapter had stealthily outgrown its remit. I was also aware of a growing list of automata movements I had to leave out because of space concerns, but I think that is right. If everything was included in this mechanical microcosm it would mean there would be nothing left to discover, and discovery for me has been quite a sweet thrill over the last thirty years. I am very lucky; the subject of automata has been a world within a world for me. I cannot claim to be master of it, but I know that I am closer to fully understanding the automata around me than I am of the real world, and it's that possibility that makes automata so exciting.

FURTHER INFORMATION

Videos showing most of the featured automata are online at:

YouTube Channel: 'The House of Automata' - Playlist: 'Secrets of Automata'

Useful Internet Search Terms: Automata or Automaton, prefixed by antique, vintage, clockwork or wind up.

PLACES TO SEE AUTOMATA

The Bowes Museum, UK: Silver Swan and Maillardet's Caterpillar
Cabaret Mechanical Theatre UK & USA: travelling exhibitions
The House of Automata, Scotland, UK: automata exhibition and workshop
MAD Museum, Stratford upon Avon, UK: kinetic art
Novelty Automation, London, UK: modern automata, Tim Hunkin
The Science Museum, UK: Secret Life of the Home
The Victoria & Victoria & Albert Museum, UK: Tipu's Tiger

Boy Throwing the Moon up to the Sky, Vichy, Paris, 50cm high, *c*.1880. This portrait head of a young clown has an apprehensive expression. He is engaged in balancing the crescent moon on the end of a short stick, and is attempting to throw the moon back up into the night sky. An automaton that combines poetry and fantasy. (PHOTO: EUAN MYLES)

Musée de la Magie et Automates, Paris, France: magic
 and automata

Musée de l'Automate, Souillac, France: Roullet &
 Decamps Collection

Musée d'Art et d'Histoire, Neuchâtel, Switzerland: Jaquet-
 Droz androïdes

Musée d'automates et de boîtes à musique, Sainte-Croix,
 Switzerland: automata collection

Museum Speelklok, Utrecht, Netherlands: mechanical
 music and automata

Siegfried's Mechanical Music Cabinet and Mechanicum
 Museum, Rüdesheim, Germany

Hellbrunn Schloss, Salzburg, Austria: trick fountains
 and grottos

Museu d'Autòmats, Tibidabo, Barcelona:
 automata exhibition

Nosaka Automata Museum, Japan: European automata

Museum Collection, Moscow, Russia: automata collection

The Morris Museum, USA: Guinness Collection
 of Automata

The Franklin Institute, Philadelphia, USA:
 Maillardet's Writer

BIBLIOGRAPHY

Alexander, Gary, and Lawrence-Onn, Aidan, *Cabaret
 Mechanical Movement*. London, CMT, 1998.

Altick, Richard D., *The Shows of London*. Belknap
 Press, 1978.

Bailly, Christian, *Automata: The Golden Age 1848–1914*.
 Sotheby Publications, London, 1987.

Bailly, Christian and Sharon, *Flights of Fancy*,
 Antiquorum, 2001.

Beyer, Annette, *Faszinierende der Automaten*. Callwey,
 Germany, 1983.

Chapuis et Droz, *Automata*. Éditions du Griffon, 1958.

Chapuis et Gélis, *Le Monde des Automates*. 2 vols,
 Paris, 1928.

Daniels, George, *Watchmaking*. Sotheby Publications,
 London, 1981.

Hillier, Mary, *Automata & Mechanical Toys*. Jupiter Books,
 London, 1976.

Hopkins, Albert, *Magic, Stage Illusions and Scientific
 Diversions*. Sampson Low, Marston & Co., London, 1897.

Kazuo, Murakami (trans.), *Japanese Automata*. Japan, 2012.

Kolumbus-Eier, Union Deutsche Verlagsgesellschaft,
 Berlin, 1890.

Krafft, Barbara, *Traumwelt der Puppen*. Kunsthalle,
 Germany, 1992.

Kugel, Alexis, *A Mechanical Bestiary*. J. Kugel, Paris, 2016.

Mayson, G., *Mechanical Singing-bird Tabatières*. Hale,
 London, 2000.

Selznick, Brian, *The Invention of Hugo Cabret*. Scholastic,
 New York, 2007.

Spilhaus, Athelstan and Kathleen, *Mechanical Toys*. Hale,
 London, 1989.

Woods, Gaby, *Living Dolls*. Faber & Faber, 2002.

If I could own only four books on automata they would
be, in order: Hillier, Bailly, Chapuis and Droz, and
Chapuis and Gélis.

Acrobat with Chairs, Vichy, Paris, c.1880. The acrobat lowers his right arm
to pick up a loose chair which he then holds straight out in front of him.
Replacing the chair on the floor he performs a handstand using both
the chairs. When upside down he lifts the chair out in front of him again,
balancing now on just one hand. He replaces the chair on the floor and
returns to the upright position, lets go of the chair and salutes the audience.
(PHOTO: EUAN MYLES)

INDEX

ACKNOWLEDGEMENTS

I am indebted to the late Sue Jackson of Cabaret Mechanical Theatre whose Covent Garden exhibition inspired me back in the 1980s to believe that machines were fun. Horologically trained, I bored my family to bits with clocks and clock talk until the 1990s when a dealer in the Portobello Road helped me to transition to restoring antique automata; that was Jack Donovan, who supplied me with parts and customers. Jack's collection went on to form The York Museum of Automata set up by Jon and Andrea Robertson, who have supported and encouraged me over the years. Dealing in automata brought me into contact with Christian Bailly, who lives for automata and with whom every moment I spent was exciting. I must particularly thank my good friend Nick Hawkins whose passion for automata is matched by an encyclopaedic knowledge which he has readily shared with me. The auction houses, particularly Chartre in France, Potter & Potter in the USA and Breker in Germany, whose catalogues and assistance over the years have brought the world to my workshop and supplied some of the rare images for this book. I am also indebted to the collectors who have entrusted their precious automata to me for restoration. They are an eclectic group of people, as varied as the objects they collect. I will never forget Walter G. who arrived at my house one day with my first really precious gold bird box to repair: it was by Jaquet-Droz, c.1810, and it had never worked; he would only agree to leave it with me for one day. I worked through the night to repair it and when he returned the next day, he touched the tiny pearl button to start it, the bird popped up, fluttered its wings and sang such a beautiful song. Hearing it for the first time in years of ownership, he was in tears. All of my customers have been wonderful, each in their different ways, and I thank them all.

I also would like to thank Harold Benker of Auction Team Breker for his excellent photography, Sarah Alexander of Cabaret Mechanical Theatre for keeping modern automata thriving (and for the photos), Shasa Bolton, Gabe Fajouri, Thomas Kuntz, Steve and Jere Ryder. Tim Hunkin, Sean Lusk, Euan Myles, The Musical Box Society of Great Britain, Laurence and Angela St Leger, Paul Spooner and Richard Wiseman – all have helped me.

I am lucky to have a talented family of artisans: my children Hector the Restorer, Maud the Journalist and the extremely erudite Arthur have all helped me with useful critique of various chapters of the book. And my dear wife Maria a talented restorer, who supports me in all I do, who read it with pedantic zeal and keeps me human. Lastly a group whose assistance was integral to writing this: Nancy, Heba, Heather, and all the other automata who have allowed me to be a part of their long history.

First published in 2023 by
The Crowood Press Ltd
Ramsbury, Marlborough
Wiltshire SN8 2HR

enquiries@crowood.com
www.crowood.com
This impression 2024
© Michael Start 2023

British Library Cataloguing-in-Publication Data

A catalogue record for this book is available from the
British Library.

ISBN 978 0 7198 4305 1
Cover design by Sergey Tsvetkov

Graphic design and typesetting by
Peggy & Co. Design
Printed and bound in India by Parksons Graphics Pvt. Ltd.